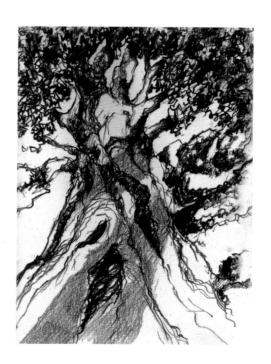

spirit
OF drawing

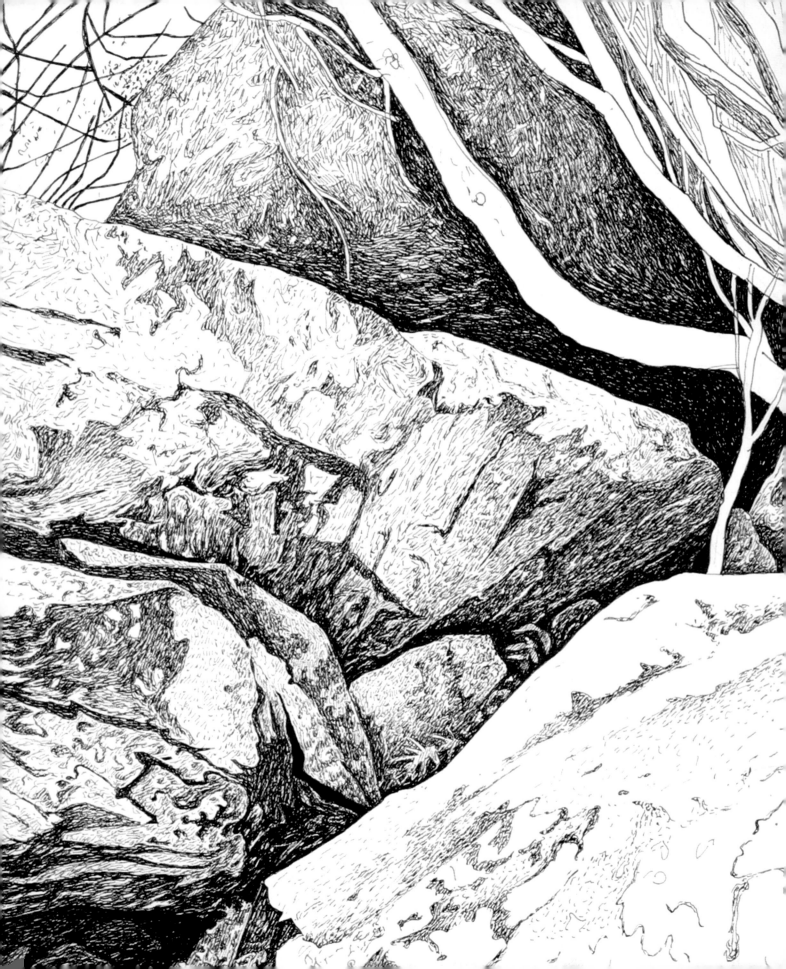

spirit
OF drawing

A SENSORY MEDITATION GUIDE
TO CREATIVE EXPRESSION

CONNIE SMITH SIEGEL

Watson-Guptill Publications/New York

First published in 2007 by Watson-Guptill Publications,
Nielsen Business Media, a division of The Nielsen Company
770 Broadway, New York, NY 10003
www.watsonguptill.com

All photographs by Connie Smith Siegel, unless otherwise noted.
All images used by permission of the artist, unless otherwise noted.

Page 1: Jean Woodard, *Tree Ascending*
Page 2: C. S. Siegel, detail of *Gregory Canyon,* pen and ink, 23 × 13 in.
Pages 6–7: C. S. Siegel, details of *The Sound of Our Own Voices,* oil crayon, 18 × 24 in., 1973

Library of Congress Cataloging-in-Publication Data

Siegel, Connie Smith.
 Spirit of drawing : a sensory meditation guide to creative expression / Connie Smith Siegel.
 p. cm.
 Includes bibliographical references and index.
 ISBN 978-0-8230-3212-9 (alk. paper)
 1. Drawing—Technique. 2. Drawing, Psychology of. 3. Creation (Literary, artistic, etc.)
4. Meditation. I. Title.
 NC730.S435 2007
 741.01'9—dc22

 2007015545

Executive Editor: Candace Raney
Senior Development Editor: Michelle Bredeson
Art Director: Gabriele Wilson
Designer: Areta Buk/Thumb Print
Production Director: Alyn Evans

Printed in China

1 2 3 4 5 6 7 8 9 / 15 14 13 12 11 10 09 08 07

acknowledgments

I am grateful for the large web of support that has nurtured and sustained me, from my early teachers in public school to university mentors in art, such as Roland Reiss, Donald Weygandt, and Richard Conklin, to friends and drawing companions Helen Redman, Genie and Joe Patrick, and Beverly Cassell. I am grateful for my long-term Sensory Awareness meditation teachers, Charles Brooks and Charlotte Selver. I have been touched by the wisdom of Buddhist teachers Trungpa Rimpoche and Jack Kornfield. Artists/therapists Natalie Rogers, Virginia Veach, and Leon Siegel helped me access and understand deep feeling states. The poet John Fox and the singer Christine Hodil were among many who nurtured my expression in writing, voice, and movement.

I am grateful for the many students who have worked with me over the years—especially those long-term participants who became my real teachers and creative family: Lynnelle, Patrick, Regina, Ayumi, Patricia, Jean, Jan, David, Beatrice, Sandy, and the many others whose work appears in this book. Susan Brayton, Carol Griffin, Audrey Wallace Taylor, and Karen Valentine have taught others as well.

I wish to thank the museums and agencies that provided the master drawings, and Lynn Scott and Linda Moore, who assisted me in the search for these images. The technical assistance of Robin Collier, Barbara Lawrence, Zea Morvitz, and editors Nancy Adess and Holly Hammond have contributed to the production of the book. I am especially grateful to artist and graphic designer Linda Larsen who patiently worked with me through many seasons to create a coherent design. Japanese scholar Roger Keyes and editor Julia Moore have provided important insight and support. Long-term artist Art Holman has kept me in touch with aesthetic form.

I appreciate the expertise and experience of editors Candace Raney and Michelle Bredeson and designer Areta Buk at Watson-Guptill Publications, who have expanded the book in significant ways.

Throughout it all, the intimate connection with the natural world through drawing and painting has supported my creative evolution, constantly reminding me of the abundance and wisdom of my own nature.

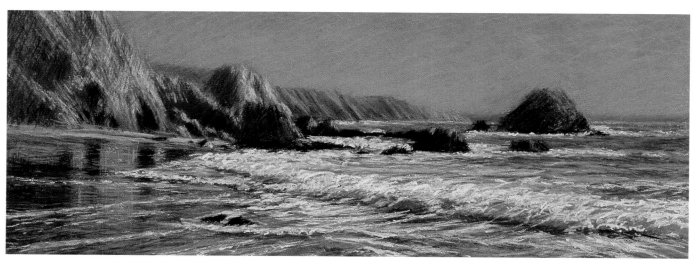

C. S. Siegel, *McClure's Beach, Late Afternoon,* pastel, 13 × 36 in.

contents

introduction

Sitting in front of a large window as I write, I can see the changing seasons in my backyard. Twisted branches of wisteria, now dark from the winter rains, become cascades of purple flowers in the warmth of spring. The old pear tree will explode in white blossoms that turn into golden pears in August. As I watch these changes I can hear the words of the painter Milton Avery—"Why talk when you can paint?"—reminding me that I would rather be outside, drawing and painting.

Matisse even advised artists to "cut off their tongues," but still I dare to write this book because the books of teachers I have never met opened a world to me. Johannes Itten's book *The Art of Color* (Wiley, 1997) introduced me to the intuitive heart of color, and Kimon Nicolaides' book, *The Natural Way to Draw* (Houghton Mifflin, 1990), gave me a structure to explore drawing at its perceptual source, which he defined as "a physical contact with all sorts of objects through all the senses."

Continuing this emphasis on physical contact, in this book we will move even further into the vividness of your own experience through the meditation practice of Sensory Awareness. By combining this practice with my university teaching, I have expanded the work even further into the evolutions of individual style and the realm of personal growth. This is a new approach to learning that rests on a simple but little-known reality I have observed through decades of teaching: Everyone, just by virtue of being alive in the world, is able to express themselves through drawing. The enthusiastic impulse to make marks that we see in the very young is as instinctual as walking and is inherent in adults as well. Reclaiming this basic impulse not only frees the creative spirit in drawing, but it evokes the elemental power and deep sense of peace and vitality we find in nature. As you work with the practices presented here, you can discover this creative power for yourself, through a natural visual language you already know.

We shall not cease from exploration
And the end of all our exploring
Will be to arrive where we started
And know the place for the first time.
T. S. Eliot
Little Gidding, Four Quartets

This Book Is Written for Everyone

I have written this book for people of all levels of experience and for all ages. It is written for the children who run over to watch me as I paint in the park: the little boys who ask me if I sell my paintings, and the little girls who watch for a long time, then shyly but proudly say, "I am an artist, too." I am especially writing for their parents, who so often say, "I am not an artist; I wish I could draw, but I'm not creative." When I hear this, I want to stop painting and exclaim, "You can draw! Creative expression is much closer than you think!"

But I am hesitant to speak because the promise of this innate capacity is often greeted with the same skepticism

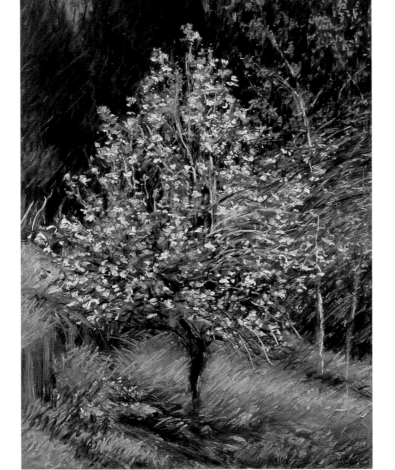

C. S. Siegel, *Spring Pear Tree,* pastel, 21 × 15 in., 1997

elicited by phone offers for free gifts. I felt this hesitation when the technician working on my stereo admired my paintings but firmly declared that he wasn't creative and couldn't draw at all. When he made a very clear detailed diagram to help me with the final installation, I was tempted to point out his drawing ability, but I knew it would challenge a widely held, almost sacred assumption that drawing is a special skill for representation that must be done perfectly or not at all.

You may have overcome these assumptions and have a clear yearning to express yourself but don't know how to get started. Or you may have started and are finding your way alone, or with books. You may have enrolled in university art departments and are drawing in classes, dealing with fundamental questions: Who sets the standards for excellence? Is drawing even relevant in this age of information, with its advanced technologies of photography, film, television, and computers? Is art a socially relevant occupation?

Long-time artists, like me, who have lived their lives through color and form know full well the intrinsic value and power of drawing and color. The regenerative, balancing power of creative expression is necessary for our survival. But this secret joy we share is not only the province of those who are gifted or experienced. It is an entitlement for everyone, by virtue of being human, by our miraculous "talent" for being alive. Whether we are fluent in the visual language, or just starting, we are all beginners as we offer ourselves to the mysteries of the creative process.

Exploring the Source

Spirit of Drawing is written as an invitation to adventure—not as a manual of instructions or techniques for improvement, but as a map of discovery. Much like Nicolaides, who wanted his students to "have an experience" as they approached drawing, I will emphasize direct sensation as the source of artistic creation. Working with very simple art materials and using our own sensations as guides, we will track the inner workings of that intimate, awesome phenomenon called creativity.

We will explore these inner dynamics for their own sake, as we might approach unknown mountain ranges, lakes, and hidden valleys. Just finding these natural places is enough—we do not expect anything in return. But, over time and in unexpected ways, our discoveries can lead to more potent, visually compelling drawings and paintings, or expression in any visual medium or style. Our exploration can extend to the other arts—writing, movement, and sound—as well. The effect is even wider than the arts. Exploring the sources of your creative process can lead to changes in every aspect of your life: living more vividly, even addressing issues of personal integration and healing.

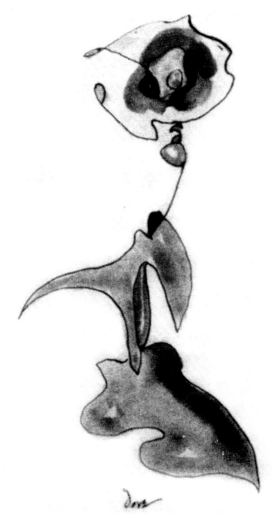

Arthur Dove, *Hollyhock*, crayon and watercolor wash, 9 × 6 in., 1935 (Private collection)

Theories have been outgrown, the means is disappearing, the reality of the sensation alone remains. It is that in its essence which I wish to put down. It should be a delightful adventure.

Arthur Dove

Lynnelle, moving figure, charcoal, 24 × 18 in. (top); *Seal Moon,*
acrylic on canvas, 48 × 54 in., 1986 (bottom)
The characteristic lines and shapes that have emerged naturally
from Lynnelle's movement drawing of a figure appear again in
the more fully developed acrylic painting called *Seal Moon.*

Discovering a Natural Language

Creative expression and healing may seem very different in their
intent, but they come together in the simple approach to drawing
presented in this book. Based on the meditation practice of
Sensory Awareness, the drawing processes invite you to sink below
the conscious mind and give yourself to the simple activity of
being present in the moment: to experience your breathing, your
sense of touch, and the other sensations inherent in everyday life.
By allowing these sensations to directly influence the process of
drawing and choosing color, you will discover a natural language of
lines, shapes and colors that can express your state of being with
the same immediacy as a cry, a yawn or a sigh. In discovering this
elemental language you'll come to realize that "abstraction" is not
an esoteric style that only artists and critics understand. Rather it
is an innate means of expression—a deeply personal form of
communication that can enrich our lives and restore us to balance.

It is this expression of primal life force that underlies master
drawings as well. Although the development of skills, or technical
mastery within traditional disciplines, is important, it is the sense
of vitality and presence carried by abstract forms that has brought
us masters such as Michelangelo and Goya over the centuries. Like
native shamans/healers, these artists have revealed the awesome
power of the elemental world, making dark forces visible, as with
Goya, or capturing the transcendence of light, as with Monet and
the Impressionists. Their work has created a rich vocabulary of
shapes, colors, and images that have expanded the visual language,
constantly renewing our vision of the world.

And, yet, expectations of excellence built into our traditions of
painting and drawing can inhibit creative expression as well as
inspire it. The forms and colors that flow so naturally when one is
working from inner sensations are often stifled in the face of the
question, "But is it art?" Excitement and curiosity can turn to
embarrassment, even shame, if people compare their vital yet
vulnerable work with that of experienced artists. Standards of
excellence set by the visual tradition can seem to exclude the work
of all those not "gifted" or specially trained.

This exclusion has been a significant loss for all of us, because the
joy of drawing and interacting with color is a creative birthright
for every individual. When this creative language is not used, a part
of our humanness is lost, because we are not only drawing and
painting, we are reclaiming our natural self. Freed from conven-
tional expectations, the language of drawing and color is a universal
and sacred one; it reflects the forces of nature, and it speaks of our
passion for life. My hope is that this book will help you rediscover
this natural language and find your own creative source.

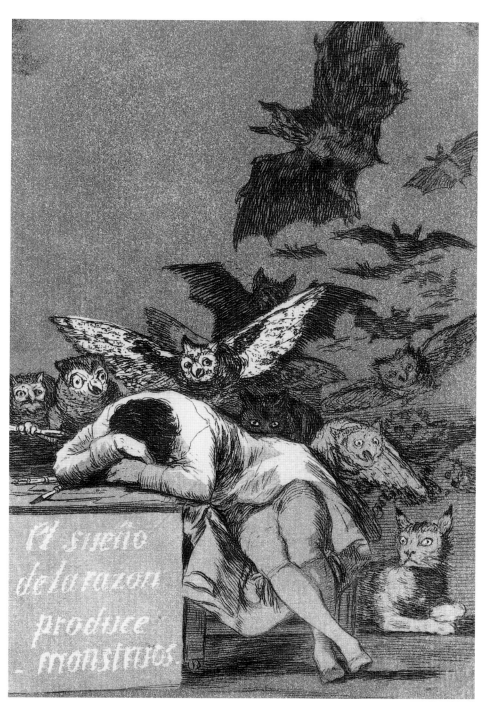

Francisco Goya y Lucientes (Spanish, 1746–1828), *The Sleep of Reason Produces Monsters,* etching and burnished aquatint, 11 $^{13}/_{16}$ × 7 $^7/_8$ in., 1797–1798 (Museum of Fine Arts, Boston, bequest of William Perkins Babcock [B4165.43]. Photo © 2007 Museum of Fine Arts, Boston)

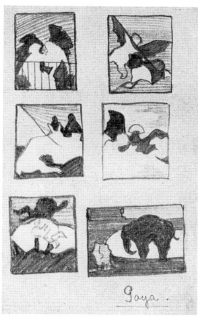

Emil Nolde, *Studies in Composition after Goya,* drawing, 1899 (© The Ada and Emil Nolde Foundation, Seebüll, Germany)

The characteristic bat-like forms in Goya's etching underlie his other work, as revealed by Emile Nolde's abstract value studies. Forms such as these give life and meaning to masterworks.

Patrick Maloney, *Improvisation,* compressed charcoal, 17 × 14 in.

The abstract forms in Pat's drawing echo the shapes in Goya's etching, reflecting the untamed elemental powers in the universe. Discovering your own forms provides a link to the inner source of past and modern masters.

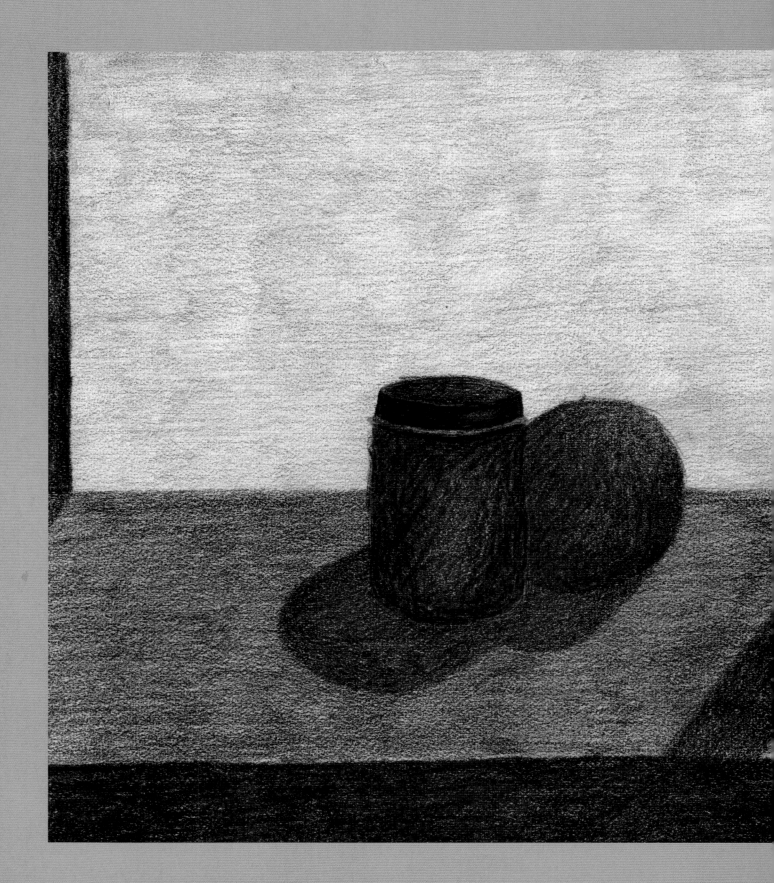

the source
of creativity:
a personal
journey

This chapter describes the evolution of the creative sources that underlie the explorations in this book. A most important source is the powerful and vital language of abstract forms of past and modern masters, as well as mentors such as Richard Conklin, whom I encountered as a university student. Another essential source is the meditation practice of Sensory Awareness, based on attention to the present moment. The drawing process that grew from this practice revealed an innate potential for personal abstraction, present in everyone. Through this process I discovered a language of abstract forms emerging as a natural expression of being alive.

Richard Conklin, *Still Life,* graphite, 9 × 11 ¹/₂ in., 1959

Many years ago I worked as a professor of art at a large university. This was a wonderful and nurturing environment for my growth as an artist and a teacher, but I gradually became dissatisfied with it. Although I was doing what I loved to do, many personal and spiritual questions were left unanswered. My dissatisfaction with the university art world increased as I watched commercial techniques and intellectual constructs replace the values of abstract composition and personal expression—the values I had always treasured in painting.

Painting and its tradition of personal expression had long been a primary source of meaning in my life. From high school to graduate school, wonderful teachers had shared their love of past and modern masters and their principles of abstract composition. These visual principles became a language of personal growth for me—an initiation into a very special, even spiritual, fellowship with the artists I most admired. As I began to see the silent power of the abstract shapes, spaces, and colors behind the images of artists such as Bruegel, Poussin, Gauguin, and O'Keeffe, their paintings became doorways to larger forces in the universe. Sometimes the abstract shapes and color relationships in these paintings reflected the force of gravity—stable and balanced. Other times they reflected the complexity of dynamic movement and the intensity of emotional response.

The paintings of these master artists, along with those of university mentors, strongly influenced my own work. When I began teaching, I emphasized abstract shapes and color relationships rather than representational guidelines. As students

C. S. Siegel, *Figure and Drape,* Conté crayon, 18 × 12 in., 1961 (above); Nicolas Poussin, *Holy Family of the Stairs,* brown ink, wash, charcoal, and pen, 7 1/8 × 9 5/8 in., 1646 (Louvre, Paris. Photo by Michele Bellot. Photo credit: Réunion des Musées Nationaux/Art Resource, New York) My early drawings were influenced by the abstraction of master painters from Poussin to Matisse.

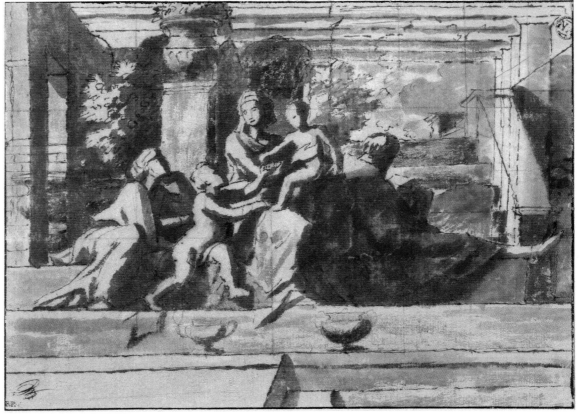

worked with exercises in drawing and color composition, their work grew stronger and more unique. I witnessed over and over the miraculous birth of that rare synthesis of shape, color, and space that we call personal style. These creative breakthroughs in form and color affirmed each student's individual value and place in the world.

But trends in art were moving away from individual style. As personal expression, abstract composition, and even painting itself were increasingly disregarded by many students and colleagues in the art department, I felt the ground disappear under me. Profoundly unsettled and confused by the changing trends, I found myself turning away from the art world, and even the tradition of painting itself, searching for meaning in nature and spiritual reflection.

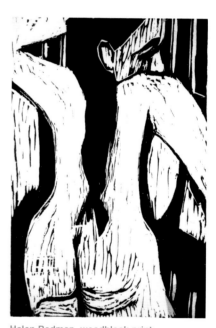

Helen Redman, woodblock print, 18 × 24 in., 1962
My early mentors and friends were inspired by the emotional intensity of the German Expressionists and the dynamic color of Matisse.

We discover the meaning of painting in the way in which it is made more than any other way. It is a visual record of your psychomotor rhythms. It's a physical activity. . . . Painting is about being: my way of being in the world. . . . It represents "everything I am."

Roland Reiss

Roland Reiss, *Figure Studies,* pen and India ink and airbrush, 30¹/₂ × 25¹/₂ in., 1961
A dynamic drawing by my teacher and mentor, Roland Reiss, exploring complexity and excitement.

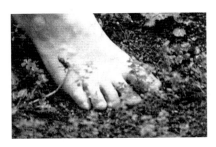

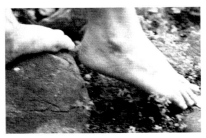

Charles Brooks, photographs (Courtesy of
the estate of Charles Brooks)

*Our bare feet, practiced in classes,
are now awake to find the shape of
rocks and grasses to which we can
give our weight, finding contact and
using the support for standing freely.*

Charles V. W. Brooks
Sensory Awareness

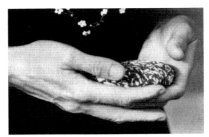

Charles Brooks, photograph (Courtesy of
the estate of Charles Brooks)

What can we learn of a stone?

Charles V. W. Brooks
Sensory Awareness

During my summer break in 1966, my search for meaning brought me to Monhegan Island, a wilderness ten miles off the coast of Maine where artists had come for many decades to renew their creative energies. My experience there changed my entire approach to painting and teaching—indeed, it changed my life.

After some weeks on the island I took a workshop called Sensory Awareness, led by Charlotte Selver and Charles Brooks. Their literature described this work as a study of consciousness emphasizing "direct perception as distinct from intellectual or conceptualized knowledge." The practice of Sensory Awareness was an invitation to study human nature, using our own sensations as a means of investigation.

I was skeptical but intrigued enough to join the two-week course. In many ways the work resembled Buddhist meditation, but instead of the more traditional form of sitting practice, we worked with "experiments" that included activities of everyday life. An experiment could be as ordinary as raising an arm, then letting it come down, noticing the effect this simple movement had on us. We would walk or lie on the grass mats covering the floor, or lift a rock and put it down again, noticing in each distinct action the powerful but often subtle sensations of gravity. We spent one class just preparing to lift a rock, noticing the influence on our breathing.

On one of our outdoor excursions, walking barefoot in the woods over the soft trails and moss-covered stones, an afternoon shower interrupted the class. Instead of covering ourselves and rushing home, we were encouraged to stay. We stood together in silence, experiencing the sensation of raindrops, surprisingly warm, touching our clothes and skin. In such simple ways we were invited to be aware of the ordinary but powerful sensations of nature and everyday life.

As the workshop progressed, my initial skepticism at the simplicity of the practice turned to fascination as the sounds, smells, colors, and tactile sensations, already heightened by my being on the island, became even more vivid. As if for the first time, I became aware of the pungent smell of grass mats on the schoolhouse floor and the sound of foghorns on a damp morning. I began to notice the vast world of small creatures in the tide pools under the cliffs and the intricate web of plant forms covering the island. I felt a closeness with the group, along with a very tangible kind of inner peace—more ordinary than what I had imagined spiritual awareness to be, but deeply satisfying.

When the workshop was over I remained on the island to draw the old-growth forests and the grassy meadows meeting the granite cliffs and surf. In hiking the trails and drawing the profusion of natural forms, I found my creative center again.

Since then I have continued to draw and paint from natural places. I continued in the study of Sensory Awareness as well, following Charlotte and Charles to Mexico in the winter and Monhegan Island again and again, in long-term work. This subtle but powerful work continues to affirm a deep capacity for creativity and positive change, even as I attended a series of weekly classes forty years later in California. Charlotte, at 101, was still a model for all of us, living and sharing each moment with enthusiasm and quiet vitality.

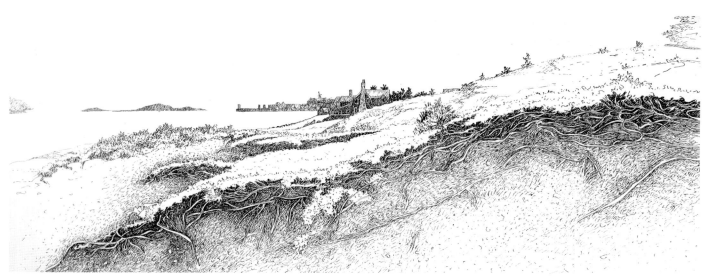

C. S. Siegel, *Monhegan Island, South Shore, in Fog,* pen and ink on vellum, 11 × 29 in., 1966

As the setting of my first experience with Sensory Awareness, Monhegan Island was a natural dictionary for me, a microcosm that contained all of nature, remote and perfectly formed.

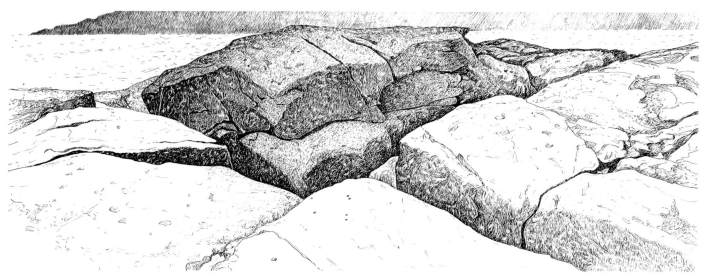

C. S. Siegel, *Granite Crevice, Monhegan Island,* pen and ink on vellum, 11 × 29 in., 1966

With my sense of seeing renewed, I felt closer to the natural world I was drawing.

other forms of meditation

The power of the ordinary yet profound recognitions that I experienced on Monhegan Island led me to explore other forms of meditation, particularly the practices of Zen, Tibetan, and Vipassana Buddhism. Underlying their different traditions I found a shared intent: to pay attention to tangible sensations in the present moment with no judgments, no expectations, and no goals.

While lecturing on the precepts of Tibetan Buddhism, my meditation teacher, Trungpa Rinpoche, was interrupted by the question, "But what is meditation?" Beaming over the crowded room, Rinpoche paused and answered, "Simply seeing things as they are." By relating the perception of seeing to the process of meditation, the simplicity of Rinpoche's definition bridges meditation with creative expression, affirming the senses and valuing perceptual awareness just for its own sake.

I found yet another bridge between creative process and meditation in 1971 in a three-month training residential workshop with Virginia Veach, a pioneer in combining art, healing, and Gestalt therapy. As we drew first thing in the morning under the influence of our dream states, I found myself drawing the same abstract shapes I had discovered years before in the Monhegan rocks and tide pools. These shapes emerged by themselves from my subconscious. Discovering the inner source of these distinctive forms was a validation of my own "pure quality," as the Zen master Suzuki Roshi said, and it opened the way for me to encourage this quality in others.

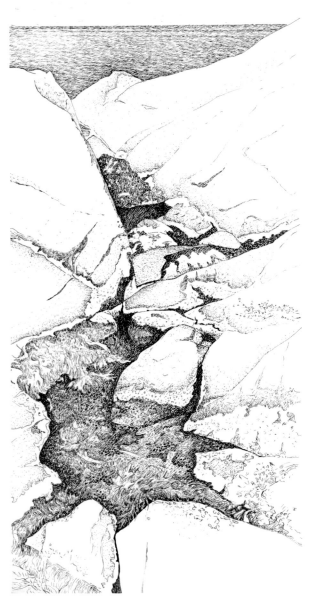

C. S. Siegel, *Tide Pool, Monhegan Island*, pen and ink on vellum, 26 × 12 in., 1970

So try not to see something in particular; try not to achieve anything special. You already have everything in your own pure quality.

Suzuki Roshi
Zen Mind, Beginner's Mind

C. S. Siegel, morning process drawings, pencil, 18 × 12 in., 1971
The forms I had drawn from Monhegan cliffs and tide pools began to emerge by themselves in my abstract drawings.

meditation into art:
a new approach to learning

I began to integrate meditation practice with teaching art when I left my teaching position at the University of Colorado in 1972 to join a nine-month study group in Sensory Awareness, starting in Mexico. Several members of the group were interested in drawing, and I agreed to teach a weekly drawing class. Although my teaching methods were well established by then, I was not prepared for the nervousness I felt on beginning the first class. As we gathered on an open porch in the small mountain village of Tepotztlan, with roosters crowing, dogs barking, and the wind blowing the drawing paper, I realized I was no longer the all-knowing professor backed up by the credit system and lofty campus buildings.

I had carefully prepared for the class beforehand and I was somewhat annoyed when my students' attentions were diverted to a funeral procession coming down the street right under our porch. We watched in silence as people of all ages passed. By the time the procession ended, I had forgotten my annoyance, and I knew my lesson plans were irrelevant. Instead, I suggested that we simply close our eyes to notice our own feelings, touch the paper, and let the drawings happen by themselves. As we shared the drawings later, I was startled by their intensity. It was clear that everyone had been deeply moved by the procession; the recognition of death and life was reflected clearly in the work and personal discussion that followed. I realized I had been a witness to, not a teacher of, this first class.

The classes that followed in the next months were equally unpredictable but fascinating, as we explored the origins of creativity with the same passionate curiosity of naturalists searching for the source of the Nile. Accustomed to the slower pace of meditation practice, we now noticed the subtle sensations inherent in the drawing process itself: changes in breathing as we picked up a crayon, and the tactile sensation of the crayon meeting the paper and exploring its surface and edges.

It is usually a surprise to the person that he can learn directly through his own sensations, that right within him is the best source of orientation.
Charlotte Selver

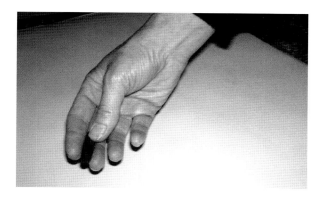

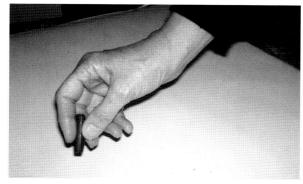

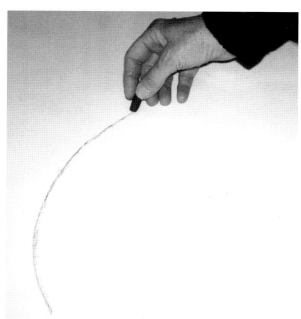

Through meditation we can notice the tactile sensations inherent in drawing—from holding the crayon (top), to touching the paper (middle), to moving the crayon (bottom).

tracking the source of
creative expression

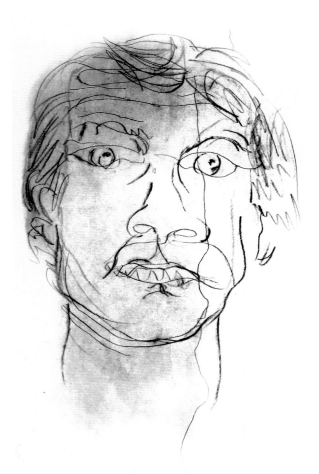

**Hannah Woods, portrait, beginning with touching,
24 × 18 in., 1974**
The experience of touching influenced this portrait.

Exploring drawing as an extension of Sensory Awareness led to a whole new approach to learning. At the university I had always begun with exercises, describing them one step at a time, showing examples, then encouraging or correcting students as they worked. In Mexico, instead of exercises, I introduced more open-ended "experiments" in Sensory Awareness and drawing and then worked alongside everyone else. We would draw for a while and then share what had happened as equal participants in ongoing research, one experiment growing unpredictably from the next.

As we worked, the sights and sounds and smells of the bustling Mexican village found their way into our drawings. As a class we focused on these familiar sensations one at a time, noticing the influence each had on our drawings. For example, we might "see" a plant or a shoe for ten minutes and draw directly afterward. We discovered the distinctive power of sensations other than seeing, as we drew directly after touching a plant or a shoe with our eyes closed, or after peeling and eating an orange or smelling a flower or a pickle. We found shells on the beach in Barra de Navidad and drew as we held them in our hands, still hearing the sound of the waves.

Sounds were an important creative source—not only the sounds we heard in the village and on the beach, but the sound of our own voices, accompanying the lines as they flowed from the crayon. Even the sound of the crayon itself, as it moved on the paper in different ways, could influence the forms that appeared in the drawings.

Inner changes and personal upheavals often influenced the drawings, but one day we were all unsettled by nature's upheaval: an earthquake that occurred shortly before the class. The lines we drew conveyed without words the violent movement we had just experienced; the earth was still moving in our drawings.

But whether our experiences were dramatic or ordinary, visual or tactile, we always began our experiments with the simplest act of touching the drawing paper and then allowing the marks to come by themselves. Every sensation, every event, left distinctive marks on the paper, which could grow into a wealth of lines, shapes, and colors relevant to the moment and unique to each person. The ability to draw abstractly, which I had cultivated in my university art students through exercises and special instruction, was emerging by itself as an inevitable expression of being alive, by paying close attention to our sensations and the world around us.

We had tracked the origins of creative expression in drawing and color back to those simple yet essential sensory perceptions that weave the fabric of daily life.

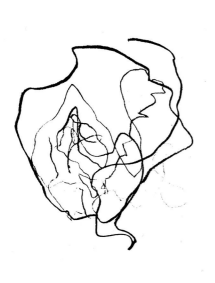

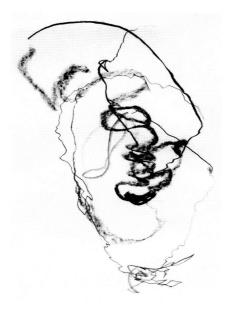

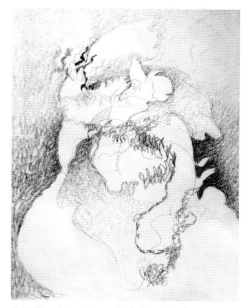

Leon Siegel, study of oyster shell, pencil, 17 × 14 in., 1973 (left); Virginia Veach, study of oyster shell, charcoal, 17 × 16 in., 1973 (right)
These oyster shells were drawn with eyes closed using only touch.

C. S. Siegel, touching a foot, then drawing, charcoal, 24 × 18 in., 1974
Nonvisual sensations create powerful forms.

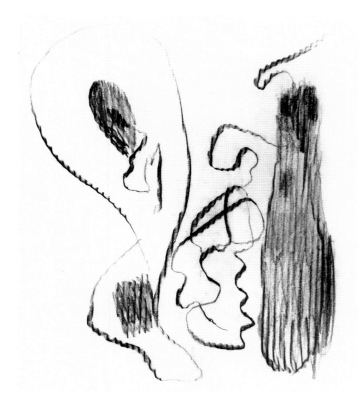

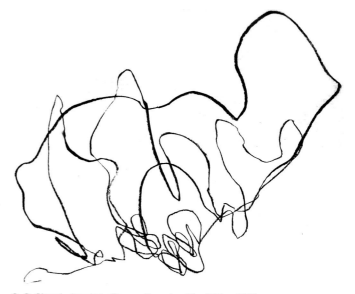

C. S. Siegel, drawing after earthquake, 18 × 24 in., 1974
Following an earthquake, the earth was still moving in our drawings.

Charles Brooks, sensing improvisation, oil crayon, 24 × 20 in., 1980
The texture of cardboard under the paper influenced these distinctive lines and shapes.

an invitation to adventure

C. S. Siegel, *Trees in Afternoon Light,*
charcoal, 24 × 18 in., 1995
This drawing reflects a sense of inner
movement.

The initial experiments with art and meditation I have described came from a sense of adventure and curiosity. If you are curious about these drawing explorations, I invite you to join me, using the suggestions and simple procedures in this book to discover your own unique perceptions and creative source. From the examples of my students and colleagues and well-known master artists, you will learn the many routes creative expression can take. These examples may suggest possibilities and offer inspiration, but they aren't meant to be models of correctness. You will set your own standards for yourself as you work.

My primary intent is to offer a space for you to discover your own path, free from expectations and judgments. To support the spirit of discovery, the working processes in drawing and color will be presented in the form of experiments, not exercises. Exercises usually have a definite goal, or a specific purpose, whereas experiments are always open-ended, accepting of any result, no matter how unexpected. Our purpose is not to improve our natural impulses, only to see them more clearly and to allow them to flourish.

The Basic Process

To explore our natural impulses we will begin in the simplest way, with experiments based on the meditation practice of Sensory Awareness. We'll explore the source of drawing in the tangible meeting of hand, drawing media, and paper, allowing the drawing to unfold by itself from this tactile connection, often with eyes closed. The lines and shapes from these improvisations will not only reveal your personal uniqueness but will create a natural language that reflects vital elemental forces.

Drawing the World

As you progress through the book, this language created by your unique rhythms and shapes can lead you naturally to draw the forms you feel and see in the world. As you enter into the excitement and challenge of representational drawing, you will explore the expressive power of the sensations of touch, weight, seeing, and space, noticing the different effects these everyday sensations have on your drawing style. Finding your affinities for certain perceptual modes will affirm your sense of self and your connection with what you see and draw.

Composition for Painting

Finding your perceptual affinities through drawing will not only increase your connection with yourself and the world; it can be an essential foundation for composition and expression of color in painting media. We can see the perceptual source of composition in the passionate movement of van Gogh's drawings and

paintings, the dark power of weight in Goya's work, and the evolution of space into color in Cézanne's painting. From these examples you can understand the source of masterworks, from the inside out.

The Healing Spirit of Drawing

Drawing not only underlies composition for painting; it can be a transformative force in your life as well. The basic process in drawing and Sensory Awareness not only expresses our inner elemental forces, but it can balance them, revealing our deep powers of integration and healing. Each of the different perceptions we explore through drawing—from the energetic rhythm and vitality of movement to the intimate contact of touching to the stabilizing power of weight to the transformative unity of space—can awaken the natural wisdom in the body. We will explore the healing potential of seeing as well.

An Appetite for Creative Expression

Like trails in the wilderness, the experiments in the book will lead you, one step at a time, in a logical progression from simple to more complex discoveries. But the wilderness itself can lead you as well. Just the presence of a few materials and your own curiosity can initiate a wealth of creative discoveries. For example, for several years I have joined several families for a potluck Thanksgiving dinner. After dinner we have a kind of second dessert as we put a basket of paper color chips, oil pastels, and drawing paper on the cleared tables. Although sated with food, our appetite for creative expression is strong, and we begin choosing colors and/or drawing. As we work for the next hour or so each person follows his or her own creative agenda. Some people work with images and symbols. Others just play with colors and shapes. One year, one young girl made Christmas cards, and her friend drew a favorite horse. One man spontaneously distilled his original pile of colored papers down to a distinctive few, amazed at the power of his own choices. Another man drew a landscape that included all the elements of the earth. At the end we all speak of our work, sharing our feelings and lives as generously as we had shared our food earlier.

EXPERIMENT: Open-ended Exploration
Especially if you haven't worked with visual materials before, I invite you to try something of this open-ended exploration for yourself, alone or with a group. With a box of basic drawing materials, oil pastels, and paper, work as if you were exploring a new wilderness area, led by curiosity alone. This exploration may take a few minutes, hours, or days. When you feel ready to try the experiments in the next chapter, it will be a continuation of an adventure you have already begun, a deepening and expanding of a creative path that is already evolving in you.

Lynnelle, drawing hand after touching, charcoal, 18 × 18 in., 1976
The power of touch is evident in this drawing.

CHAPTER TWO

drawing from the inside

In this chapter we explore the process of drawing as a natural impulse, an expressive birthright we all share. We will begin in the simplest way, exploring the source of drawing in the tangible meeting of hand, drawing media, and paper, allowing the drawing to unfold by itself. The abstract lines and shapes that emerge will reveal not only your personal uniqueness, but the archetypal forms of the four elements—the foundation of personal expression in all creative media. We can see this universal language all over the world, from ancient petroglyphs to stained glass windows to contemporary Abstract Expressionism.

Patrick Maloney, sensing drawing, oil crayon, 18 × 24 in.

a new approach to drawing

D. Campbell, sensing weight, Conté crayon
The sculptural feel of the model is evident
in this drawing.

*The impulse to draw is as natural
as the impulse to talk.*

Kimon Nicolaides
The Natural Way to Draw

Drawing is a language available to all of us. It is an intimate language that can communicate our deepest impulses and our own unique perceptions. Although I know this now, when I was an art student struggling through life-drawing classes, drawing was mainly a source of frustration. After hundreds of hours of life drawing, a tangible sense of reality still eluded me. I felt inadequate when I compared myself to more "gifted" students.

As I began to teach drawing to beginning students, I saw the same sense of frustration in them, as they struggled with drawing a nude model posing across a crowded studio. Out of curiosity I introduced an exercise I found in Nicolaides' book *The Natural Way to Draw,* in which people are encouraged to draw as if they are actually touching the model, sensing the weight and sculptural feel of the model's body. The effect of this exercise was dramatic; not only did the drawings look more realistic, but the students felt a connection to the model. The drawing process itself created a tangible sense of contact.

Realizing the effectiveness of this exercise, I incorporated more of the Nicolaides exercises into my teaching and used them in my own drawing as well. Encouraged by the emphasis on direct experience, I began to draw more from everyday life—self-portraits and friends in natural surroundings. Drawing soon became a perfect traveling companion, intensifying my contact with nature as I walked in the fields and mountains of Colorado and explored islands off the coasts of Maine and Canada.

And in addition, drawing became an invaluable guide as I explored my inner world through the meditation practice of Sensory Awareness. I discovered that drawing not only expresses our feelings and perceptions; it can change them as well. When drawing arises directly from inner sensation, it can be a remarkable agent for healing.

This view of drawing as companion and healer may seem contradictory to the general view of drawing as a special talent or skill to be developed. Drawing has been equated with "making a likeness"—a task that seems to demand the visual exactitude and ideal of classical perfection that we see, for example, in the drawings of Renaissance masters such as Leonardo da Vinci and Raphael.

Somehow the ability to represent with exactitude has been identified with creativity. The statement "I'm not creative" is usually followed by "I can't even draw a straight line!" The prospect of drawing even a simple object wakes up the fears associated with public performance.

The truth is that everyone actually *can* draw simple objects, but this native ability is often buried in clouds of doubt and frustration, even shame, at not "getting it right." Because of these doubts and fears, it is important to find new approaches to drawing that leave the classical ideals and our inner critics behind. We will come to the classical tradition again, but on our own terms, with a new approach.

If we give up the need to "produce a likeness" for a while, we can find another, more basic definition of drawing that art conservators know very well—the tangible reality of the powdered pigment in pencil or crayon applied to paper. As we explore drawing at this basic level, we not only find new possibilities in drawing materials but a new appreciation of the hand that applies the pigment. In this very tangible connection of hand, materials, and paper, a whole world of expression is waiting.

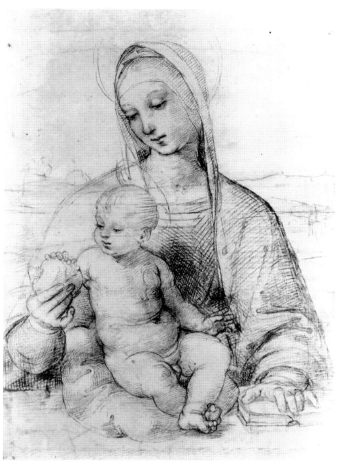

Raphael, *Study for the Madonna and Child,* dark gray chalk,
16 ¹/₈ × 11 ¹/₄ in., 1504 (© Albertina Museum, Vienna)

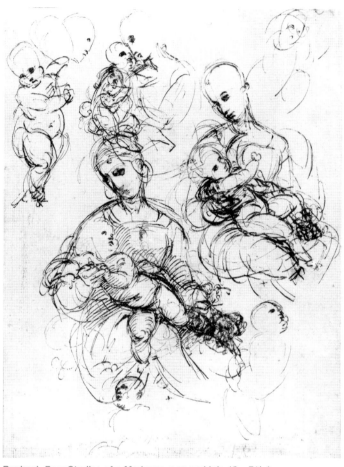

Raphael, *Four Studies of a Madonna,* pen and ink, 10 × 7 ¹/₄ in.,
circa 1505–1508 (© The British Museum, London)

C. S. Siegel, healing process drawing,
oil pastel, 18 × 24 in.

The classical perfection of Raphael's
Study for the Madonna and Child and the
final drawing of a healing process are
centuries apart, and yet the underlying
circular movements are remarkably similar.

These circular movements are seen
more clearly in Raphael's *Four Studies of
a Madonna,* an intimate glimpse of his
working process, immediate and vital.

There is a great range of drawing materials and papers available. Each has its own particular qualities and limitations. Although it is fascinating to explore this whole range of media, it takes only a few basic materials to follow the experiments in this book. To begin, I suggest acquiring some of the more commonly used media, briefly listed here and described in more detail in the Appendix. Each of these media can produce very different effects on the paper, just as different kinds of shoes can influence our walking. Experience these qualities for yourself, in a free-form kind of experimentation.

These are the minimum supplies you will need:

- Box of oil crayons and/or soft pastels (24 or more)
- Soft pencils (5B and 6B), soft and hard charcoal, Conté crayon
- Pad of 18- by 24-inch rough newsprint or bond paper
- Pad of Bristol paper and sheets of colored paper
- Pen and India ink
- Kneaded rubber eraser

We certainly set down a self-portrait of our own inner feelings with everything we do, and how much finer to have the means of expression in harmony with these feelings.

Arthur Dove

EXPERIMENT: Exploring the Materials

Start by spreading out the materials and paper on the table. Pick up a stick of pigment—for example, an oil crayon. Can you feel its particular quality and know that it has a distinctive voice, like no other? It sits in your hand, already waiting to touch the paper in a special way. Ignoring the ways this crayon "should" be used and techniques you could learn to obtain certain visual effects, just try using the crayon as if for the first time.

Let your hand be guided by curiosity, noticing the tactile quality of the first marks you make with it. From these first marks, notice how the crayon moves, following the path that it wants to make on the page. Giving up expectations, simply notice what is happening. Explore the possibilities of this oil crayon as if no one had ever used one before.

Jean Woodard beginning a drawing using an oil pastel (above). Notice the tactile quality of the first marks and how the crayon moves. The path of the crayon creates the drawing.

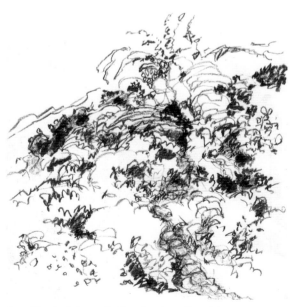

Jean Woodard, improvisation drawing, oil pastel

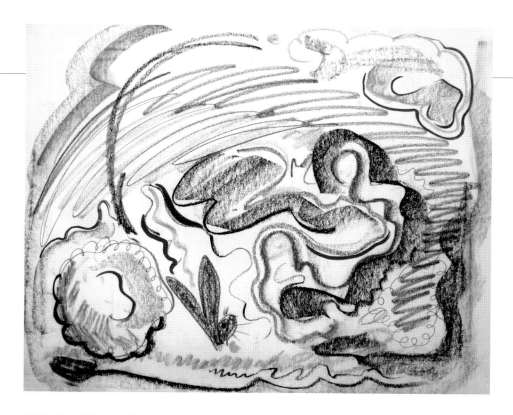

Barbara Lawrence, free-form experimentation, oil pastel, 18 × 24 in.
Free from the obligations of representation, we can try anything.

EXPERIMENT: The Birth of Technique

After getting a sense of the oil crayon, you might try another kind of medium—for example, charcoal. How is it different from the crayon? From here you might want to try out several kinds of charcoal, as well as other media, noticing their different effects. You might be delighted with some of the spontaneous marks that emerge from these materials and want to repeat them. This is the birth of technique itself and can open up a world of personal expression in your work.

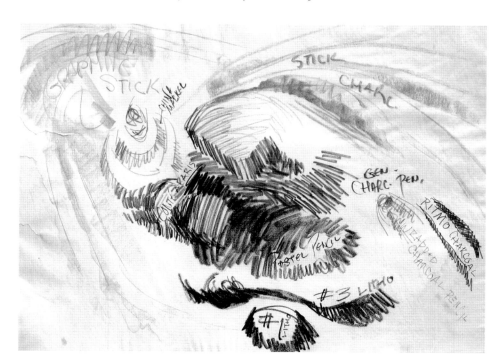

Pat Kriegler, experiments with litho crayon, charcoal, and other media, 18 × 24 in.
Each medium makes its own path on the paper.

After a time of experimenting, you will begin to see the differences among media, and you will most likely come up with favorites. If you are working in a group, you may begin to notice another kind of difference: the very interesting variations among people and the distinctive marks they make. When we give up striving for particular results and are simply experimenting, the rich diversity of our unique lines and characteristic rhythms of movement emerge by themselves. These are the qualities that ultimately account for expressive power and individual style in drawing.

Finding just the right media and paper to match our unique characteristics and the subjects we draw could take years. For now it is enough to know some of the possibilities in the drawing materials and to discover the joy of exploration for its own sake. These materials have a life of their own, aside from our agendas for them. When we release the life inherent in each different medium, we uncover our own life force as well. To remember your discoveries in media, identify them either on the front or the back of your drawing.

LITHOGRAPH CRAYON

GENERAL'S CHARCOAL PENCIL

KOHINOOR CHARCOAL

CHINA MARKER BOHEMIA
 GRAPHITE PENCIL

CONTÉ CRAYON

CHARCOAL PENCIL

VINE CHARCOAL

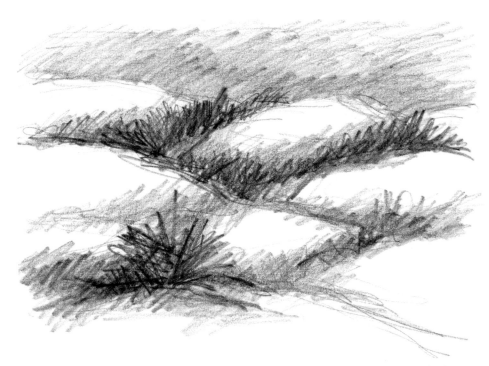

Kathryn Callaway, experiments with different media on illustration board (left); spontaneous landscape, Bohemia graphite pencil on illustration board (above)
Each medium has its own distinct voice. Throughout all the different media (left), Kathryn's distinctive stroke is clear. From these many voices, a graphite pencil is chosen to fill a whole page, spontaneously creating the landscape above.

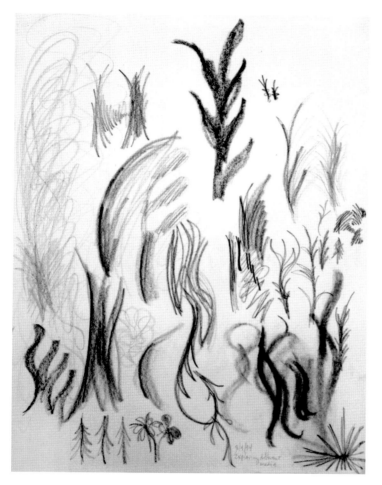

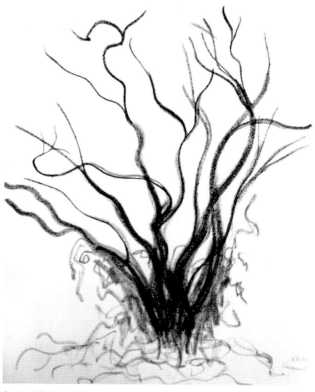

Audrey Wallace Taylor, experiments with media, 17 × 14 in. (left); improvisation, charcoal, 17 × 14 in. (above)

Along with the medium we choose, our unique lines and rhythms account for individual style and choice of subject in drawing.

Linda Fries, experiments with charcoal, white lines erased (left); rock study, charcoal, 18 × 24 in. (above)

The innovative use of compressed charcoal in the experiments is seen later in the study of rocks.

the inner source of drawing

Although there is a world to explore in the simple reality of paper and pigment, there is yet another world waiting in the hand that touches the paper and moves the crayon across it. In taking the time to explore this reality, we can unlock yet another dimension of creative expression.

My first teacher of Sensory Awareness, Charlotte Selver, speaks of her work in awareness as "before A." Before the alphabet there is sound, before sound there is breath. Before breath there is our life force, insistent and continuous. Before a drawing depicts an image of anything, there is paper and pigment, and before paper and pigment there are sensations such as breathing, touching, and movement, coming from our own sense of being alive.

Our materials are an important source of inspiration and expressive power, but the most basic foundation and the ultimate source of drawing is within ourselves—the actual quality of our being, the experience of living, moment by moment. The invitation to focus on these moments brings us to meditation: awareness for its own sake with no judgments, no expectations, and no goals. This is the ground from which creative expression grows.

Something that grows out of nothingness is naturalness, like a seed coming out of the ground. The seed has no idea of being some particular plant, but has its own form and is in perfect harmony with the ground, with its surroundings. . . . When what you do just comes out of nothingness, you have quite a new feeling.

Suzuki Roshi
Zen Mind, Beginner's Mind

Lauren Herzog Schwartz, drawing improvisation, charcoal
Before paper and pigment, a drawing comes from our sense of being alive.

EXPERIMENT: Exploring the Ground

To experience your own ground of being or inner life force, close your eyes and notice what is happening for several minutes, without the distraction of seeing. When you are not doing anything, what do you experience with your eyes closed? If I were to ask the question, "Are you alive?" you would probably answer, "Yes." But what is your actual experience of living, right now, in this particular moment?

Like seeing the marine life in a tide pool when the water is still, with quiet attention our own wealth of inner sensations become clear—the movement of breath, the pulse of the heart, tingling, hunger, even pain.

EXPERIMENT: Sensing Your Environment

You are in a place. What do you experience of this place with your eyes closed? Can you sense the presence and support of the floor under your chair, under your feet?

Can you sense anything of the air that surrounds you? Does it have a particular quality? Sounds might come to you in the air, and in time you might feel the air as you breathe it in.

When we take the time to experience life moment by moment, the most ordinary sensations become very special.

When you are concentrated on the quality of your being, you are prepared for the activity . . .
Suzuki Roshi
Zen Mind, Beginner's Mind

EXPERIMENT: Touching the Paper

Even the simple activity of touching the paper can be a dramatic event. To prepare for this, get a pad of 18- by 24-inch bond paper and place a crayon beside it.

Close your eyes again and reach out to touch the paper with your hands. Does anything change inside you because of this contact? Instead of being a blank sheet waiting to be filled, the paper could influence you.

The paper can become a new, even mysterious territory, having a surface, four edges, and a particular presence all its own. With your eyes closed, your hands can receive this presence, exploring a world that is limited by its four edges. Explore this world as though it were a new, yet undiscovered island, every inch unknown, every corner a surprise.

The process of exploring the surface of the paper does not end with your hands. You are touching the paper with your whole body. And you are touching more than the paper—under the paper is the table, under the table the floor, and under the floor is the earth.

As you move your hands on the paper, your entire being is in contact with the earth. Could you touch the earth as if it is a loved one?

If you had explored the paper with pigment on your fingers, you would have created a record of your exploration. But even without the record, you are touching the "ground" of drawing.

A wonderful painting is the result of the feeling in your fingers.
Suzuki Roshi
Zen Mind, Beginner's Mind

With your eyes closed, reach out and touch the paper with your hands.

You might discover a new, uncharted territory between the four edges of the paper.

EXPERIMENT: Adding Crayon or Charcoal

Adding crayon can bring another dimension to your exploration, but it does not have to interrupt your contact with the paper.

Keeping your eyes closed if possible, pick up the crayon. After feeling the particular shape or weight of this crayon, how does it want to rest in your hand? It might be in a very unexpected way.

What would happen if the crayon touched the paper? Wait until you have a curiosity for the paper, even a desire, as in tasting a new kind of food.

When you do touch the paper with the crayon, how does it change your touch, and what is the movement now?

EXPERIMENT: Drawing as Exploring

You can give the event of touching the paper with crayon the same kind of attention you give as you wait for the first contact of wheels on the runway after a long flight on a jet plane. That moment of meeting the earth can be so poignant, so welcome.

Keeping your eyes closed, let the touch of the crayon lead the way across the surface of the paper, moving in any direction, at any pace that feels right.

There is no right way to touch the paper; there is only the reality of the moment. It is just exploration, nothing more, and there is nothing you can do wrong.

When the movement of drawing comes to an end, you might wait in stillness for a while, as there may be echoes of the experience left inside you.

EXPERIMENT: After the Drawing

If the first drawing feels complete, you could leave it as a record of your first immediate impulse and take some time to see what happened. Or you could begin another drawing, letting it evolve in the same manner, eventually creating a series of three or more, each drawing changing according to your experience of the moment.

Another option is to work further with the original drawing, using it as a launching pad for additional explorations of shape, color, and perhaps even images.

As you work, it is important to maintain a sense of trust, following whatever impulse seems right, watching the simple drawing grow and develop. You can make no mistakes, as there are no rules in improvisation—only allowing what comes next.

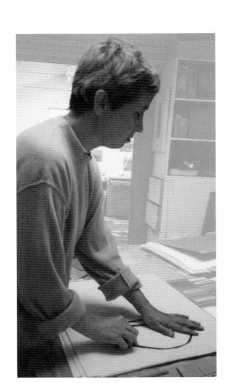
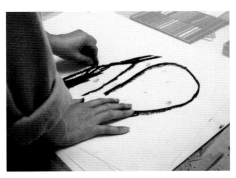
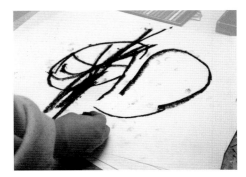

Regina Krausse in different stages of the first drawing. Let the drawing evolve from your contact with the paper, moving in any direction. When the drawing is complete, you could continue with a series, each drawing evolving from the one before. (Regina's three drawings from this series are shown on page 53.)

In improvisation we are all equal, whether drawing for the first time or at the end of a long career. We are stepping into the unknown, trusting each impulse. Picasso was remarkably gifted, but perhaps his greatest gift was his sense of adventure and his confidence in his visions. As we develop our confidence through these experiments, drawing becomes an adventure, even when we move into representation.

Regina Krausse, improvisation drawings, first (left), second (center), and third (right) stages, oil pastel, 18 × 24 in.
We can watch the original drawing grow and develop in new ways, trusting its evolution, using black and white or color.

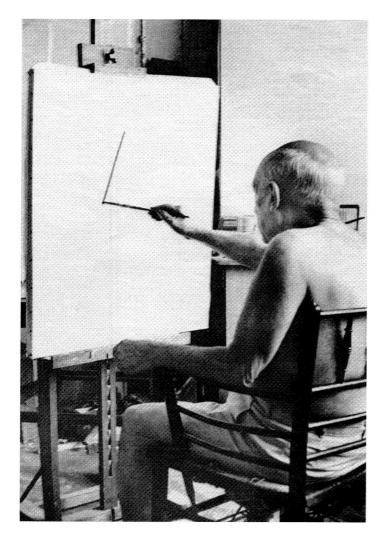

When I have something to express,
I have done it without thinking
of the past or future.
Pablo Picasso

Picasso Beginning a Painting,
photograph, *Time,* 1980
We are all beginners as we make the first mark.

When the drawing process comes to an end, we can look at our drawings and reflect on what happened. The range of responses is especially clear in a group context. Some people feel exhilarated, as if after dancing or walking in a new place. Some may be tearful, experiencing for the first time the act of drawing without judgment. Most are amazed at the variety and vitality of their drawings, which seem to have happened almost by themselves, without intentions or plans. Although some people may be mystified by the results (which are often unexpected), for most the process of drawing with eyes closed has been reassuring. It has deepened the sense of living in the moment, free from expectations and judgments.

This simple process can reveal a multitude of natural forms—like an explosion of wildflowers after a rain. These forms reflect the differences among people. Each person's work shows a kind of elemental signature, a unique quality of touch and distinctive rhythms and shapes. We saw these differences while experimenting with different media. Now they emerge again, even more clearly.

When we take the time to meditate on our drawings, they speak an elemental language. Lines and forms may undulate softly, like grasses in streams, or leap and crackle, like a fire in the wind, or seem to grow from the depths of the earth. These personal distinctions are inseparable from the archetypal patterns of nature—the universal forms we see in rocks, clouds, moving water, and the growth patterns of plants. Especially when the drawings follow one another in a series of two or more, we can see these inner forces in action, evolving in different ways, following natural patterns of growth.

> *One of the characteristics of great drawings is the artist's wholehearted acceptance of his own style and character. It is as if the drawing says for the artist, "here I am."*
>
> Nathan Goldstein
> *The Art of Responsive Drawing*

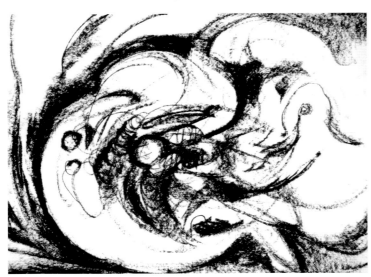

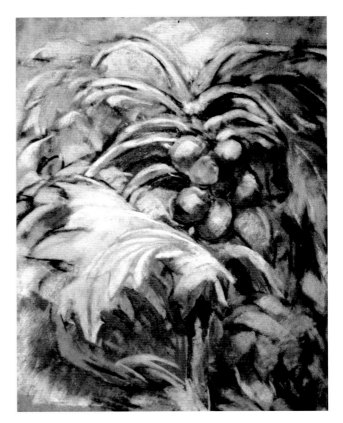

Pat Kriegler, improvisation (above); *Coconut Palm,* **pastel, 17 × 14 in. (right)**
The organic forms that emerged earlier in Pat's experiments with materials (see page 29) have grown even stronger with the sensing experiment—they seem to evoke the generation of life itself (above). These distinctive forms can be seen in her drawing of a coconut palm (right), bringing us into the living center of the tree. Her unique viewpoint can be compared with the drawings of trees on the following pages.

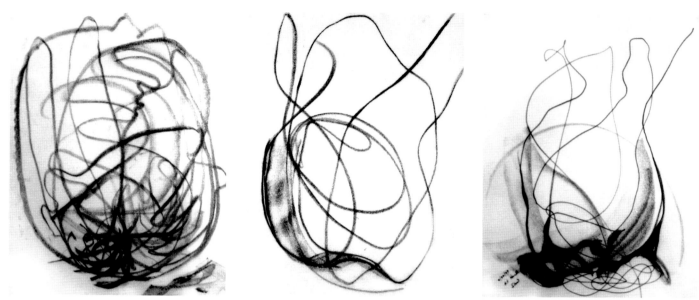

Ariel Kent, first drawing in a series of four (left), 24 × 18 in.; second drawing (center), 24 × 18 in.; third drawing (right), 24 × 18 in.
Living forces evolve from one drawing to the next, from the unlimited possibilities of the first drawing (left), to the distinctive shapes of the fourth drawing (below left).

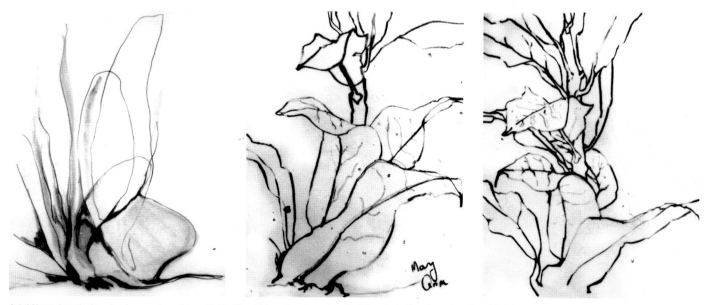

Ariel Kent, fourth drawing in a series of four (left), 24 × 18 in.; drawing of a plant (center); drawing of a plant (right)
The distinctive forms that emerged in the sensing drawings resemble the growth of a plant following its own destiny. Later, they find their match in a real plant.

the source of personal style: four approaches

As we see the drawings from the sensing experiment, it becomes clear that an artist's personal style is inseparable from elemental qualities. We can see these abstract qualities carried into personal style in the representation of trees by the four different artists depicted on this page and the next. The flame-like movements of Patrick's drawings contrast with the earthy solidity of Regina's drawings. The flowing movements in Darroll's and my drawings reflect the elements of air and water. In Chapter Four, "Drawing the World," we will go even more deeply into the source of individual differences—our inner sensations and perceptions of touching, weight, and space.

Regina Krausse, improvisation drawing, 18 × 24 in. (right); *Grasses and Tree, Limantour,* charcoal, 18 × 18 in. (far right)
The sharp clarity of vertical and curving lines in Regina's improvisation drawing are expressed in the drawing of grasses and a tree.

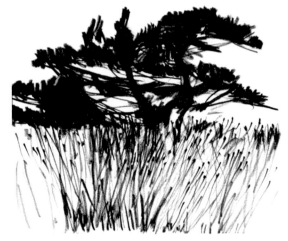

Darrol Shillingburg, first sensing drawing, charcoal, 18 × 24 in. (top right); second sensing drawing, charcoal, 18 × 24 in. (bottom right); *Blossoming Tree,* charcoal, 14 × 17 in. (far right)
The light, flowing movements inherent in waves and clouds find their match in a flowering tree, dissolving into the sky.

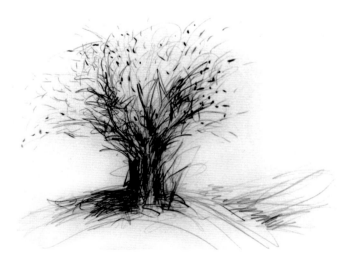

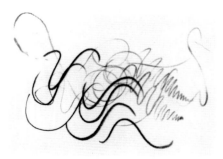

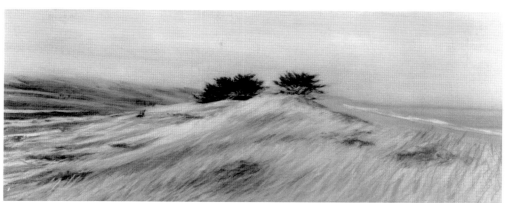

C. S. Siegel, experimenting with oil crayon (above); *Two Trees, Limantour,* oil on board, 12 × 30 in., 1995 (right)

The wavelike movements in the sensing drawing can be seen in the windy grasses in the seascape.

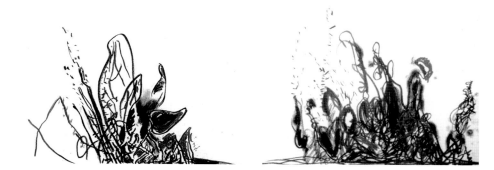

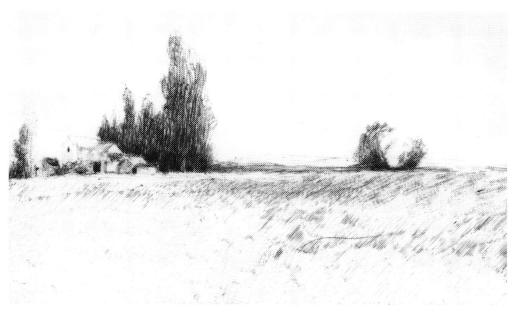

Patrick Maloney, first sensing drawing, oil crayon, 18 × 24 in. (above left); second sensing drawing, oil crayon, 18 × 24 in. (above center); third sensing drawing, oil crayon, 18 × 24 in. (above right); *Tree and Barn,* pen, 14 × 17 in., 1990 (right)

Some drawings seem to express the birth of the universe itself. In this series of improvisations (above), a condensed ball of fiery energy erupts into distinctive shapes, characteristic of fire. Pat's flamelike forms become trees, meeting the sky (right).

expressing the four elements

We have seen how the spontaneous expression of elemental qualities carries expressive power in abstraction and determines how we draw the world. The resemblance of these qualities to natural phenomena is as mysterious and varied as nature itself. But underlying the many variations in our drawings, the characteristic qualities of the four elements recur so often that they form a universal language. This language expresses states of being that we share with all living creatures and all matter—natural cycles of rising, falling, contracting, expanding. This living language is communicated through drawing and color.

EXPERIMENT: Drawing the Elements of Earth, Air, Fire, and Water
To further explore this elemental language, we can consciously choose to draw each element—earth, air, fire, and water—one at a time. Begin first by closing your eyes.

Kristina Muhic Arroyo, *Earth,* oil pastel, 18 × 24 in.

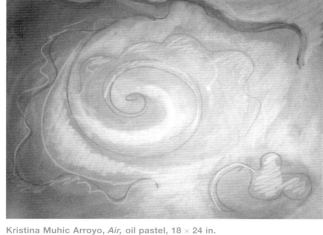

Kristina Muhic Arroyo, *Air,* oil pastel, 18 × 24 in.

Kristina Muhic Arroyo, *Fire,* oil pastel, 18 × 24 in.

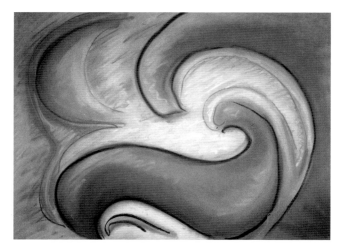

Kristina Muhic Arroyo, *Water,* oil pastel, 18 × 24 in.

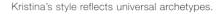

Kristina's style reflects universal archetypes.

Gradually become aware of any inner sensations in this moment. Then name one of these elements to yourself, noticing any inner changes it might bring. Do you sense a quality of movement or distinctive shapes? Let this felt sense guide your drawing, beginning with eyes closed, if this is helpful. Let the crayon move across the paper, letting the force of the element lead the way. Draw the other elements in the same way. Notice any inner changes you might experience as you draw each element, letting the full experience of each one move through you and onto the page.

Expressing the four elements in this way not only demonstrates a universal language we share with others; it can highlight individual differences. It can open a wide range of your expressive powers, often unexpected. These powers are far more fundamental to creative expression than the ability to create a likeness.

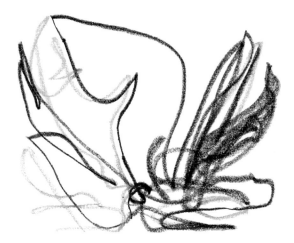

Geneva Gates, the element of fire, oil pastel, 10 × 10 in.

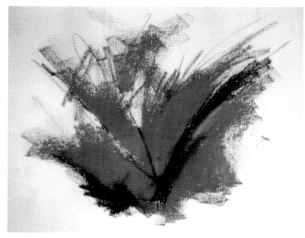

Linda Larsen, the element of fire, oil crayon, 18 × 24 in.

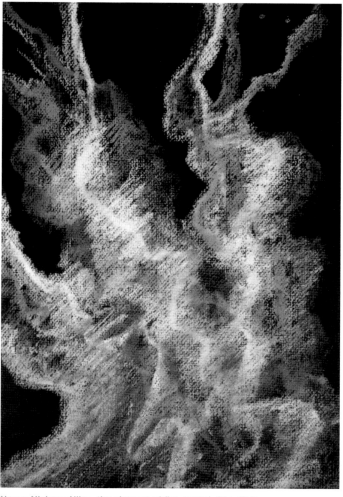

Nancy Niehaus Niles, the element of fire, pastel, 24 × 18 in.

Three other versions of fire reveal the power of individual differences.

drawing as a natural force

The laws of the stars descend and, through the mediating elements of air and water, impress themselves upon the earth.

Theodor Schwenk
Sensitive Chaos

t is awesome to notice the similarity between the natural forms that emerge in our spontaneous drawings and the forms made by the elements in nature. In his book *Sensitive Chaos*, Theodor Schwenk describes and illustrates the special characteristics of water, from the perfection of its original spherical form to the rich diversity of shapes that are created as earthly forces interact with it. As we draw spontaneously, we re-create these interactions, allowing our intimate relationship, not only to the rhythms of water and air, but of earth and fire as well, to be recorded. The hand touching the paper becomes a force of nature—as primal as the river that carves the stones in canyons.

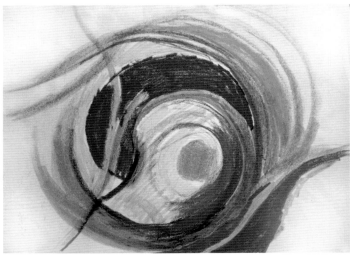

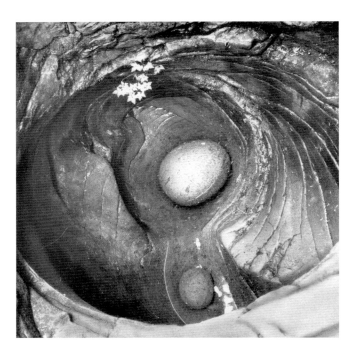

C. S. Siegel, sensing drawing, oil crayon (above); Theodor Schwenk, *The Spiraling Movement of Vortices Seen in the Hard Rock of Glacial Potholes*, photograph (From *Sensitive Chaos*, Rudolph Steiner Press, 1990)
Like the river that carved the glacial pothole in the photograph, the hand touching and moving on the paper is a natural force.

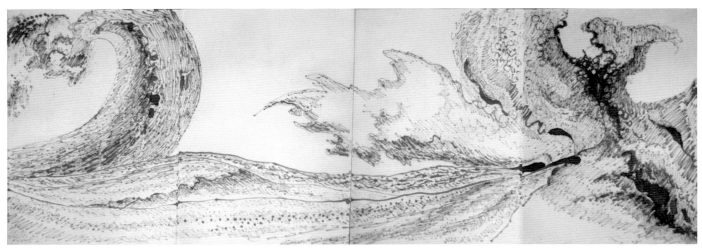

Arthur S. Holman, *Wave* series, pen and ink on folded book, 8 × 24 in., 2003
The element of water, flowing freely, finds its own movement and generates its own shapes in this drawing.

The primal forms in our drawings are present from an early age. We can see them in the drawings of young children, whose scribbles are a natural form of self-communication, an affirmation of body feelings. Even at two or three years old, the visual language is already in place in us: the encompassing circle, the openness of flowing lines, the strength of the vertical, the excitement of diagonals crossing.

These archetypal forces are expressed in many ways. The psychologist Carl Jung was among the first to recognize the importance of the archetypal images of ancient people—the Great Mother, the Hero figure, the Beast. Ancient symbols such as the cross and the circle have their basis in primal forces as well. But the abstract archetypes that emerge in our spontaneous drawings underlie even images and symbols, for they directly reflect the patterns of life itself and the elemental forces that created stars, moons, and galaxies.

In the marks we have made on the paper, which often resemble the unintelligible scribbles we thought we left behind in childhood, an ancient and powerful language begins to emerge. Young or old, famous or unknown, we all interact with the deepest forces in the universe through the simple rhythms and forms we cannot help but make.

The expressive therapy process drawings of the psychologist Carl Rogers depict two basic elemental archetypes: the encompassing circle, spiraling inward, and a wavelike form, expanding without boundaries. These primal patterns of contracting and expanding are echoed in the art forms of all cultures. We can see the encompassing circle in a child's drawing, a prehistoric petroglyph, and the stained-glass window of Chartres Cathedral.

The walls of tombs and the shards of ancient pottery and the finger paintings of today's child each bear the same testimony—that in art all mankind is one.

Rhoda Kellog
The Psychology of Children's Art

ABOVE: **Drawing of petroglyph, Bandelier National Monument (top); Django (age three), crayon drawing (bottom)**
The encompassing circle, spiraling inward, reflects the patterns of elemental forces.

LEFT: **Rose window, Chartres Cathedral, 1220–1230, Chartres, France (Photo: Erich Lessing/Art Resource, New York)**
The unifying spirit of the encompassing circle is celebrated in this rose window.

The primal forms of expansion find full expression in the drawings and paintings of modern masters such as Arshile Gorky, whose passion for nature and the subconscious influenced a generation of artists known as Abstract Expressionists. The paintings of Willem de Kooning, Jackson Pollock, and Joan Mitchell grew from the act of painting itself and the spontaneous forms created by movement and inner reality. Their forms resemble the patterns of waves or clouds, or the hidden movements in matter we can see in microphotographs. Pollock, especially, worked directly with the force of gravity in allowing the fluid paint to create its own forms on the canvas.

Finding meaning in abstract paintings requires a new way of approaching art, in which the viewer must be as aware of his or her own reactions to the painting as of the painting itself. To find meaning in our own abstract forms, we must do the same, giving up preconceptions, becoming aware of sensations of the present moment. As we see our work in the meditative spirit in which it was created, we can enter another level of self-discovery. This exploration will not only open possibilities in art and healing; it will reveal new ways to approach representational drawing.

From the very nature of the inner conditions of creativity, it is clear that they cannot be forced, but must be permitted to emerge.

Carl Rogers
On Becoming a Person

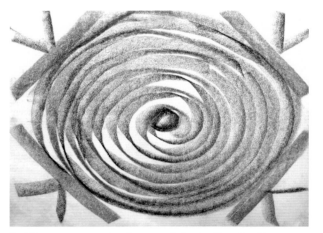
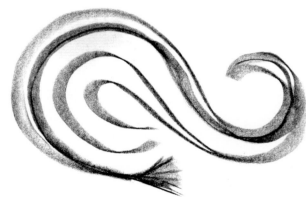

Carl Rogers, process drawings, one following the other (from person-centered expressive therapy workshop)
The boundaries of the encompassing circle give way to flowing lines, expanding outward.

Vibration pattern of sound waves in glycerin, detail of microphotograph (From *Man and His Symbols*, Doubleday and Company, 1964) (right); Mieka Kie Weissbuch (age three), crayon and marker (far right)
The spontaneous movements in the art of young children and modern masters resemble the hidden forms of matter, revealed in microphotographs.

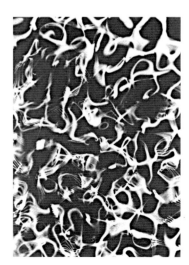
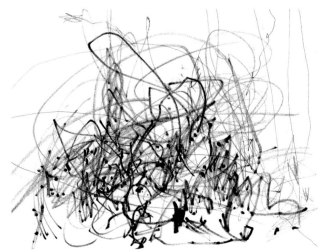

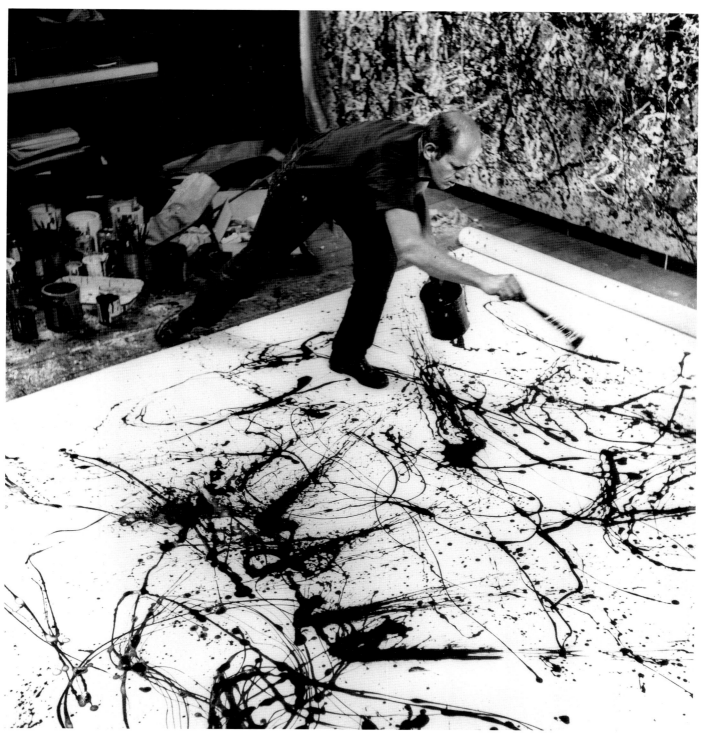

Hans Namuth, *Jackson Pollock,* photograph, 1950 (National Portrait Gallery, Smithsonian Institution, Washington, D.C., gift of the estate of Hans Namuth, © The estate of Hans Namuth)

Pollock combined the immediacy of drawing with the substance of paint, allowing the spontaneous power of his intuition and physical movement to be expressed directly.

seeing as creation

Georgia O'Keeffe understood the importance of abstraction as a form of revealing inner feeling states. Her appreciation for this inner language gave her the insight and courage to pursue her unique vision. This chapter will explore ways of finding meaning in our abstract lines and shapes, going beyond expectations and criticism into a vital interaction with our drawings. This energetic exchange will not only facilitate self-discovery and personal integration, but will be a foundation for finding our natural potential in drawing the world around us.

Carol Griffin, *Abalone Series,* oil pastel on colored paper, 19 × 25 in.

Georgia O'Keeffe, *(Special) Drawing XIII,* charcoal on paper, 24³/₈ × 18¹/₂ in., 1915 (The Metropolitan Museum of Art, New York, Alfred Stieglitz Collection, 1950 [50.236.2]. Image © The Metropolitan Museum of Art)

O'Keeffe's expressive power grew directly from inner sensation.

More than thirty years before the Abstract Expressionists we have just discussed, Georgia O'Keeffe, along with Arthur Dove and Wassily Kandinsky, was exploring the power of colors and shapes. The distinctive beauty of O'Keeffe's drawing and paintings is testimony to the potency of self-communication through art. We can see the origins of her expressive power in a series of early charcoal drawings called "specials," which grew directly from sensation. The forms in the drawings were startling—unmistakably speaking the secrets of her inner life, with very little reference to visual reality.

The forms that emerge from our own spontaneous drawings and the colors we choose are powerful as well, as they too come from direct sensation and reveal a part of our inner lives. Coming from our essential nature, these colors and shapes are "saying things" that couldn't be said any other way. But do we hear the messages they have for us? Because we are used to messages in words, symbols, or images, at first glance the lines on the drawing paper may only look like childhood scribbles—full of energy, but unintelligible. We may like the colors we have chosen, but do they have meaning?

I found I could say things with colors and
shapes that I couldn't say in any other
way—things I had no words for . . .

Georgia O'Keeffe

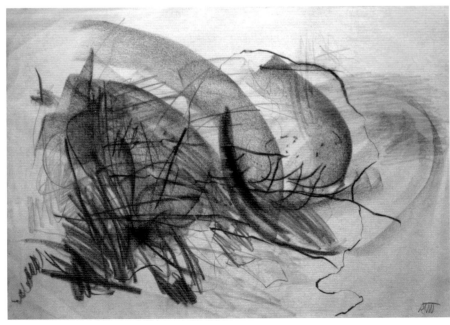

Audrey Wallace Taylor, improvisation with charcoal, 18 × 24 in.

Our sensing drawings are also powerful.

Meaning in the Process

We can find meaning from our creative improvisations in several ways, even before seeing the results. The simple act of drawing or choosing colors in itself can profoundly shift our consciousness, in a way similar to meditation practice. Sensations might become more vivid—colors may seem brighter and forms clearer. Some people experience a sense of freedom—like opening a door in a room that has long been closed or climbing out of a car at the end of a trip. In this expanded reality, realizations that may have been buried or forgotten emerge by themselves, often bringing unexpected insights about our lives.

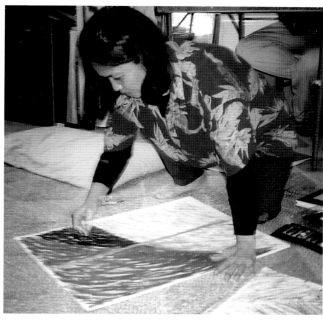

Ayumi Kie Weissbuch, in the process of drawing. By observing the intimate details of working, we become aware of our unique inclinations.

These realizations can often come as you observe and share (if you are with others) how it felt to make the drawings. When consciously observed, the simple activity of drawing and using color can become a microcosm for your whole life. By observing the most intimate details of your way of working, you can become aware of your unique, deeply rooted inclinations. The particular way you touch the paper, move across the surface, or hold the crayon might seem insignificant, but each way can have a profound effect on your creative experience and on the meaning it might have. A change in your breathing or a spontaneous desire to draw with your nondominant hand or with both hands can release tension and initiate a new sense of balance and generosity of spirit that goes far beyond the drawing process.

Meaning in the Work

Insights and new recognitions that occur during the process of working with your eyes closed can continue with eyes open as your experience is revealed in shapes, lines, and colors. Seeing the work can expand the process of self-discovery, as you recognize the distinctive power of your own forms—familiar and yet full of surprises. On the other hand, you might be mystified, confused, or even disappointed in your work, which may seem chaotic or out of control. Conversely, if you were expecting more freedom, your work could feel too timid or constricted. For example, if the experience of drawing felt very expansive, the appearance of a small nest of lines in the center might seem to contradict that feeling. If you believe what you see (and most of us do), you might question the authenticity of your original experience or at least your ability to express it. You may have been happy enough before you opened your eyes, but everything can change with seeing.

In this moment you are faced with two realities: your inner sensations during the drawing process and your reaction to what you see on the page. Which one is true? Are both true? These are large questions, but for now it is enough to realize that the act of seeing often initiates disappointment and moves into judgment. It is in this place of judgment that the creative flow usually falters. To recover the original meaning in our drawings and colors, we need to find a way of seeing our work that corresponds to the spirit that created it. We need to cultivate seeing as a creative activity in its own right.

We have been using our eyes to judge the world since the day we were born. . . . A warrior is aware of that and listens to the world, he listens to the sounds of the world.

Carlos Castaneda
A Separate Reality

Ayumi Kie Weissbuch, seeing the drawing. Seeing the work can expand the process of self-discovery as you recognize your own forms, familiar and yet full of surprises.

Cultivating the perception of seeing as a creative activity can take some conscious effort, because critical habits associated with seeing are deeply embedded and are constantly reinforced by the demands of daily living. After all, we have learned to survive in the world by the acuity of our discerning judgment, by distancing ourselves from what we see. How else could we watch even five minutes of news on television or a contemporary action film, or look at a computer screen for hours? How could we survive driving, constantly dodging cars, watching for lights, stop signs, and police cars? Our eyes have given up their innocence to carry a huge burden for modern survival. They have become so closely linked with conceptual thinking, judging, and comparing that we take this partnership for granted. It is an awesome task to invite another kind of partnership, in which we approach the object we are seeing like a lover, not pulling away or evaluating but moving closer, trusting, completely open to what is there.

In finding this new partnership between seeing and intuition, we can follow Carlos Castaneda's suggestion to "listen to the sounds of the world." As we consciously cultivate our nonvisual senses (hearing, touching, and moving), we can begin to "see" in a different way. I invite you now to approach drawing and color as though you were listening.

EXPERIMENT: Seeing as Creation

When you have completed a spontaneous drawing using either black-and-white or color media, take some time to look at it. Can you be open to the lines and shapes and colors as though they were sounds, letting them enter not only through your eyes but into your whole body? Let them come in through your breathing as well. Instead of trying to analyze the drawing and colors, let them come inside, let them influence and inspire you. When seeing is listening, we allow the rhythm of the lines, the power of the shapes, and the vibration of the colors to be felt inside. Right now, in this moment, can you feel these lines, shapes, and colors just as sensation? You may feel it in your head, back, heart, your fingers or your feet as they meet the floor.

Under the influence of the lines and colors, you may notice different inner qualities. You might feel expansive or compressed, calm or agitated. As you take the time to feel the inner responses that are often too subtle to notice without special attention, your whole body can become like a musical instrument, resonating in different ways with what you are seeing. This conscious interaction with what you see can be a moment of rich communication with your own work, a creative event as vital as the act of drawing itself.

The special attention given to appreciating what we (or others) have created is a form of contemplation. In his book *Practical Mysticism* (Vintage, 2003), Evelyn Underhill describes this process as "profound concentration, a communion between the seer and the seen." In his book, he invites us to enter this state in the simplest way, choosing an ordinary object like a pencil, or natural objects like a flower, stone, or shell. Try using Underhill's invitation as an experiment:

All that is asked is that we shall look for a little time, in a special and undivided manner, at some simple, concrete, and external thing. . . . Look, then, at the thing you have chosen . . . and so concentrate your whole attention on this one act of loving sight that all other objects are excluded from the conscious field. . . . As you, with all your consciousness, lean out toward it, an answering current will meet yours. It seems as if the barrier between its life and your own, between subject and object, had melted away. You are merged with it, in an act of true communion, and you know the secret of its being.

The "loving sight" of contemplation that Underhill describes is essential as you work with the experiments in this book. Seeing ourselves in drawing and color can be a vulnerable experience, requiring a special care and respect for our inner nature. In his book *Birth Without Violence* (Healing Arts Press, 2002), Frederick Leboyer speaks of a parallel need for care and respect at the time of childbirth, suggesting that "we must disappear so that only baby remains—be absorbed into its being—become this new person. . . . For this silent watching and listening . . . we must learn to be here . . . only with the most passionate attention." As we extend this passionate attention to our own work, seeing becomes another act of creation and we can be touched and empowered by our own work, as well as that of others.

EXPERIMENT: Seeing the Work of Others

Take the time to see this pastel of an abalone shell (reproduced larger on pages 46–47). Notice any inner response, any sensation that might wake up with your concentrated attention. As you give up conceptual interpretations, the elemental feeling in your own body will lead you closer to the original impulse behind the painting. You can know the inner meaning of the forms and colors through your own response. We will experiment in this way with seeing other illustrations in this chapter and in the whole book, noticing how they resonate inside you.

Leonardo da Vinci, detail from *An Oak Sprig and Dyer's Greenweed*, red chalk on pink surface, touched with white, 7 1/2 × 6 in., circa 1505–1506 (The Royal Collection © 2007 Her Majesty Queen Elizabeth II. Photo: A. C. Cooper)
This delicate drawing came from meditative seeing.

Do you not see that the eye encompasses the beauty of the whole world?
Leonardo da Vinci

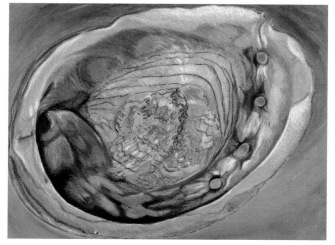

Carol Griffin, *Abalone Series,* oil pastel on colored paper, 19 × 25 in. This drawing was done after meditative seeing. How does it resonate inside you?

the language of movement: bridging worlds

In creating a new alliance between seeing and inner sensation, I use the language of movement. Before analyzing or even speaking of our responses to a drawing, we can "move with it." Because we are alive, we are full of the potential for movement. We move constantly in everyday life and communicate with others through simple gestures—the wave of goodbye, the open arms of welcome, or the strong hand of "stop." These movements are richly expanded as we move to the rhythms of music, improvising or following traditional forms of dancing.

Moving to what we see may seem unfamiliar, but I am convinced it is just as natural as any other daily activity. We can see this natural inclination in children, who not only readily move to music but wave their arms and clap their hands and spin when they see colors and forms that excite them. Adults are not so lucky. We dutifully trudge around galleries and museums, our arms glued to our sides, while the paintings we are seeing are beckoning us to respond to them.

But movement can grow spontaneously and easily out of seeing, even for adults. When people are invited to describe what they are seeing, the verbal descriptions are almost always accompanied by gestures. The words "that hill up there" are invariably accompanied by a gesture that matches the incline or curve of the hill. A group of fragile flowers on the ground can bring a different kind of movement, perhaps with hands and fingers.

Moving to Your Work

The perfectly natural language of gesture and movement can be invaluable as a way to rediscover the original spirit of a painting or drawing.

EXPERIMENT: Experiencing Movement

After completing your spontaneous drawing, stand in front of it, facing it fully, seeing the colors and shapes in a receptive way. After noticing your inner feeling, allow a movement to grow from that sensation. This movement could start anywhere: head, legs, hips, heart, stomach. It can move into your arms and spread throughout your body.

As you allow the shapes and colors to influence you, the drawings can become like scores for movement, each with a different pace and expressive quality. You don't have to produce movement, but simply invite it, giving up restrictions and allowing what is there to express itself. All kinds and qualities of movements are acceptable—from intensely vigorous to quietly languid, from forceful to tentative. You might find yourself moving all over the room; at other times the movements might be hardly perceptible.

As you move in a spontaneous way, archetypal patterns of movement emerge: the serenity of an encompassing circle, the dynamic challenge of two lines crossing, or an exuberant rush of swirls like the foam in a waterfall. Stillness can be yet another movement, powerful when we choose it. We don't need to think of this as dance but

Whether we speak of streaming water or moving air . . . or the movements of the human form . . . or of the regulating movement of the stars, it is all one: the archetypal gesture of the cosmic alphabet, the word of the universe, which uses the element of movement in order to bring forth nature and man.

Theodor Schwenk
Sensitive Chaos

just as a moving dialogue, a spirited response with the whole body that profoundly changes the way we see and speak.

Understanding Through Movement

Especially when one of your own drawings is hard to understand or fails to meet your expectations, movement can bring it alive. Movement can validate the original impulse of the drawing or even amplify it, often bringing a more appreciative, accepting view of the work. Movement can shift the way you see and feel. As you move with "constricted" lines, you can rediscover their original expansiveness. Forms that seemed too heavy can be experienced inwardly as strength, perhaps in the legs. Lines that seemed timid can wake up delicate inner responses, perhaps in breathing.

Responses in movement are unpredictable, but they eventually fall into elemental archetypes. We can see these in the three stages of movement illustrated here, in which Regina is moving with a series of drawings shown earlier. The first drawing led Regina to hang down, as if called to earth. The second drawing brought her back to standing and initiated a slow swaying movement, evocative of water, in her arms and shoulders. The third drawing inspired the most vigorous movement—the confident, assertive quality of fire. Seeing in a receptive way and letting it move us can take us from the realm of judgment to the tangible sensations of being alive. These sensations are not always comfortable, but they are always real.

Not everyone is comfortable with movement, and the readiness to move with artwork can vary widely. It might be difficult to give up conceptual interpretation for an unpredictable interaction with our mysterious inner forces. But the deeper levels of understanding make it worth the effort. No longer standing at a distance, we're actively engaged with what we see.

The first drawing (top) led Regina to hang down, as if called to earth. The second drawing (center) initiated a swaying movement, evocative of water. The third drawing (bottom) led to a vigorous movement, with the confident, assertive quality of fire.

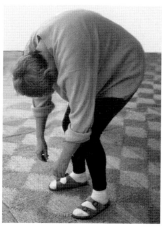

Regina Krausse, first drawing (left), moving to first drawing (right)

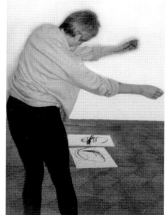

Regina Krausse, second drawing (left), moving to second drawing (right)

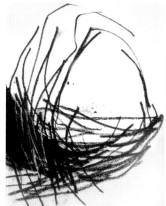
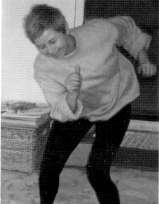

Regina Krausse, third drawing (left), moving to third drawing (right)

moving to and drawing from another's work

Seeing in a receptive way not only gives you appreciation for your own work but for others' as well. In deeply seeing and experiencing another person's work we become as vulnerable as the artist and closer to her original impulse.

EXPERIMENT: Looking at Regina Krausse's *Loving Your Most Differently-abled Child*

To experience this kind of closeness, take the time now to look at Regina's drawing. Look at it as if for the first time, giving up evaluations, either positive or negative. Right now, simply feel the lines and shapes in your own body. Any response is valid. Notice if you feel a quality of movement anywhere inside, and then try actually moving, beginning anywhere, and trusting any impulse. If you draw immediately after moving, your drawing can become a vivid record of your energetic exchange—something new, which has a life of its own. When your drawing is finished, compare it with the drawings on the next page, noticing any similarities and/or the uniqueness of your interpretation.

Regina Krausse, *Loving Your Most Differently-abled Child,* charcoal, 30 × 20 in. As Regina heard from the people who had worked from her drawing, she was touched by the relevance of their experiences to her own.

Art is a language of the body with no rules, but convinced passion.
George Segal

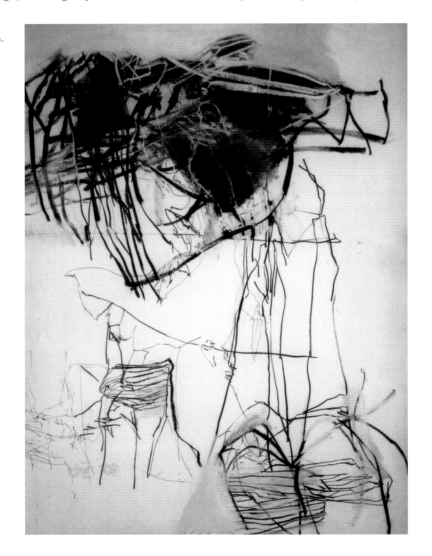

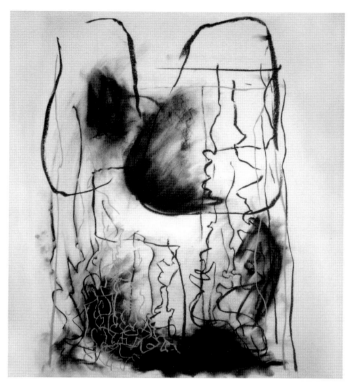

Jan Gross, charcoal drawing, after Regina's drawing, 24 × 18 in.
Jan's "breathing in her shoulders" moved down her spine, supporting her pelvis.

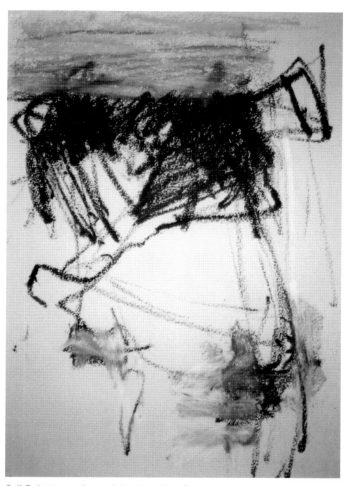

Gail Robertson, charcoal drawing, after Regina's drawing
Gail felt a stabilized weight in her head and shoulders and a lightness in her pelvis and feet.

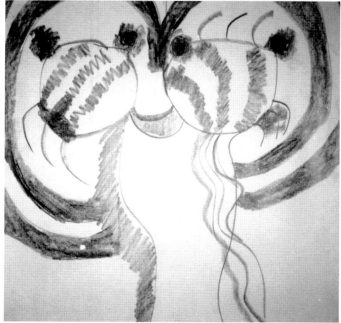

Barbara Stamm Dosé, charcoal drawing, after Regina's drawing
Barbara felt radiating electrical waves making contact through her eyes.

drawing as healing: balancing elements

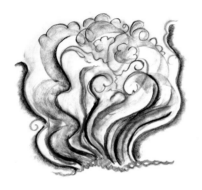

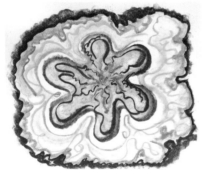

Penny Nickels Smith, *Healing Series*, drawing I (top), drawing II (center), drawing III (bottom), oil pastel, 17 × 20 in. With movement, the angular lines of Penny's anger opened into vibrant circles, which evolved into the confident unity of a looping flower form. Each drawing inevitably followed the next, like the changing seasons—winter, spring, and summer. Witnessing this spontaneous generation of natural forms has convinced me, over and over, of the creative potential inherent in everyone, artist or not.

A series of at least three drawings allows our elemental nature to be expressed more fully and can reveal a balancing process as awesome and inevitable as the changing times of day and different seasons.

EXPERIMENT: Creating a Healing Series

A series can begin with no intention, or you may focus on a disturbing feeling or difficult situation in your life. Drawing from these feelings may be uncomfortable, but you might be surprised at the rich diversity it can bring forth. Especially if you move with each drawing, the transformative action can be remarkable.

We can see here the elemental fire of Penny's anger followed by the fluid movements of water and air, which evolved into the full confidence of an emerging flower. We can also see the dense mass of Pat's frustration became lighter and disappear into air.

Observing your own nature through creative expression can take the same courage and dedicated curiosity as that of a naturalist like John James Audubon, who waited for days in the grasses to watch the behavior of birds. He was there not to change or improve them but simply to observe, accepting whatever happened. Through this acceptance you can discover your own nature in all its aspects and the instinct for wholeness inherent in all of us.

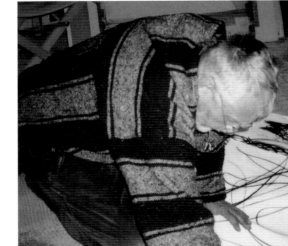

Patrick Maloney in the process of drawing. After moving and drawing, Pat's dense mass of frustration became lighter.

We have seen how receptive seeing and moving with your own or others' drawings can lead to a transformative process of art and healing, not only expressing your emotional states but balancing them as well. In the three drawings below we can see yet another example of this spontaneous balancing process. An overwhelming sense of anger is expressed in dramatic complements in the first drawing. In the second drawing, the emotion is still strong but lighter, more linear. Circular lines contrast with clear vertical and diagonal lines. In the final drawing, the circular movements and luminous warm and cool colors take over. Anger has moved into self-acceptance and a sense of calm. Every step in this transformative process generates a rich vocabulary of elemental forms, from fire to earth to air to water. Finding this rich visual vocabulary through our experiments with drawing and self-communication can widen our expressive range. It can also bring us into a deeper connection with what we are feeling and seeing in the world around us.

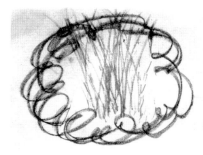

Child (age four), drawing; translated by Lynn Scott, oil crayon, 18 × 24 in.
In this child's drawing the vertical lines of anger spontaneously generate the encircling forms related to water.

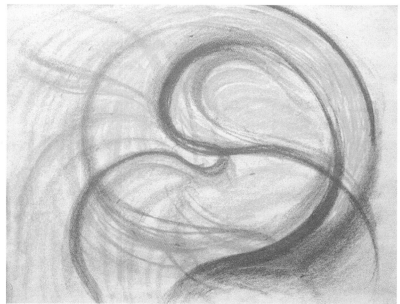

C. S. Siegel, healing series, oil pastel, 18 × 24 in.
In this sequence, the fire of rage is expressed (top left), becomes contained (bottom left), and disperses into rambling loops of air and water (above).

from abstraction to representation

Detail, *Christ of the Pentecost,* St. Madeleine Cathedral, Vézelay, France, stone, 36 in. high, 1125–1150 (Photo courtesy of Jane Vadnal)
The life force of the Christ figure is expressed directly by dynamic movements of diagonals and circles, unhindered by standards of Renaissance realism. This work, along with children's art and African sculpture, inspired modern masters such as Matisse and Picasso.

It could be just a step away to move with and draw what you are seeing, not as a task to perform but as a spirited dialogue, in which we can be expanded by what we draw. In the next chapter we will bring our explorations in self-communication into remarkable meetings with trees, hills, and everything else in your world. We do not need to replicate these subjects accurately but rather see them as new aspects of ourselves, waiting to be discovered. As we draw, our inner world becomes richer, and our unique viewpoints evolve into personal style.

As we find our inner forms and movements reflected in the world, we will discover that the elemental forces so visible in our abstract work are the foundation of representational work, as well. We can see these forces in the lively Romanesque sculpture at Vézelay and in the working drawings of Renaissance masters such as Raphael and Leonardo da Vinci. Under the refined detail, the predominantly circular movements carry the real message—unifying the figures and giving them life. Circular movements are clearly expressive in Matisse's figure drawing, playing against the powerful diagonal lines in the background. These expressive lines resemble the archetypal fire and water energy expressed in the healing process on the previous page. In the next chapter, "Drawing the World," we will explore the dynamic meeting between the elemental forces we have explored and what we see in the world. In finding our unique powers in drawing we will be guided by our inner sensations of movement, touching, weight, and space.

Beatrice Darwin, trees and hill, charcoal, 18 × 24 in.
Dynamic vertical movements create a spirited dialogue with trees.

Henri Matisse, *Standing Nude,* brush and ink on paper, 10³/₈ × 8 in., 1901–1903 (Museum of Modern Art, New York, gift of Edward Steichen [11.1952], © Succession H. Matisse, Paris/ARS, New York. Digital Image © The Museum of Modern Art; licensed by SCALA/Art Resource, New York)

The circular and diagonal movements of Matisse's drawing are echoed in the elemental healing series on page 57.

drawing the world: the inner sense of movement

Abstract forms can reveal our inner life, but images can touch us deeply as well. From the earliest paintings found in the caves in Lascaux, images have enchanted us with their magical potential to capture the life force. We don't know if the lifelike forms grew from observation and passion or from specialized training, but I would argue for passion. Drawing is a language of the body innate in everyone. Claiming this language is only a matter of discovering your passion—your personal viewpoint—and letting it speak as you draw the world.

Honoré-Victorin Daumier, detail of *Council of War*, lithograph, 11 ³/₈ × 9 ³/₁₆ in., 1872 (The Metropolitan Museum of Art, New York, Purchase, Jacob H. Schiff bequest, 1922 [22.63.7]. Image © The Metropolitan Museum of Art)

revealing different viewpoints

Our personal viewpoints can emerge naturally if we simply draw what we see in the environment. Drawing an everyday object, such as a plant, for even seven or ten minutes can reveal important differences in the way we see the world. These differences are especially apparent when several people draw the same object. Although seeing the drawings together can invite critical comparisons, it can be a rare opportunity to witness the miracle of unique perceptual viewpoints. Some people draw the plant as if it were very close, each leaf distinct from the other. Others draw the plant, the stool underneath, and even the space behind. Each perception is unique and valuable. The tendency to judge some drawings "better" than others can limit this power and the diversity and richness of form that grows from our different perspectives. The recognition of these individual differences is the real source of creative power.

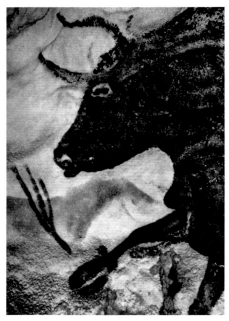

Black Bull, detail of a cave painting, circa 15,000–10,000 B.C., Lascaux, France (Photo: Hans Hinz) (above); Rembrandt van Rijn, *Young Woman at Her Toilet,* pen and wash, 9³/₈ × 7¹/₄ in. 1632–1634 (© Albertina Museum, Vienna) (right)

Movement, touch, weight, and space communicate the life force in both the cave painting and Rembrandt's drawing.

When we see these drawings as communication, something else becomes clear—whether or not it is visually accurate or aesthetically pleasing, the image on the page more than likely resembles a plant, not a chair or a dog, even for people who have never drawn. This resemblance is something of a perceptual miracle. It would be very difficult to ask for a plant in a shop in Mexico or Japan without first learning the language, but even the simplest drawing can communicate important distinctions between objects. In this context, drawing can be seen as a natural, perceptual language. We get better with practice, but we don't need to learn something new.

You can see the individual differences in your drawing either as quirks that you need to correct or as stemming from personal power—unmistakable evidence of a valuable, unique way of being. To discover more about this power, we will explore different modes of sensing, one at a time. Each of these modes—movement, touching, weight, and space—will reveal a different viewpoint, a distinctive way of relating to the world. Each of these perceptual modes can lead to a different style in drawing or painting.

Movement

The inner sense of movement, or basic impulse, communicates the life force that unifies a composition. A more specific use of movement, called gesture, is an important tool in achieving visually correct proportion and perspective in our drawings and paintings.

Touching

The tactile sense reveals your personal touch, the distinctive quality of your marks and shapes. It is the basis of the unique styles of modern masters such as Pablo Picasso, Henri Matisse, and Georgia O'Keeffe. The sense of touch also contains the secret of the convincing detail we see in master drawings, from Leonardo da Vinci to Andrew Wyeth.

Weight

When combined with touching, the sense of weight is the basis of the three-dimensional modeling we see in Michelangelo and the muralist Diego Rivera. When expressed in light and dark shapes, the sense of weight and gravity is a major unifying force in composition.

TOP: **Lynn Hassan,** *Spring Willow,* charcoal
The essential gesture of a spring willow tree fills the page, reflecting the passion and vitality of our own movements.

BOTTOM: **Carol Griffin, study of stone, charcoal**
The sense of touch is combined with weight.

C. S. Siegel, *Tideflats,* acrylic,
48 × 48 in., 1988
The sense of space unifies the landscape.

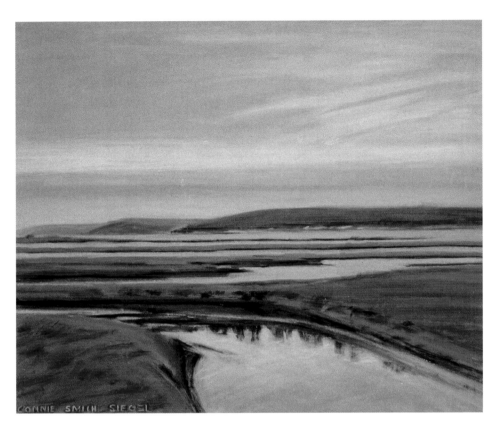

Space

The sense of space can bring out our instinct for order and balance. It is especially evident in the compositions of Chinese and Japanese brush paintings. It is important in attaining correct proportions and accurate perspective when depicting objects in their environments.

Seeing

Seeing is an integral part of all the experiments, but this perception has expressive possibilities in its own right: the subtle range of shading and detail, the world of light and shadow, and the expressive possibilities of color.

These modes of sensing are parallel to Kimon Nicolaides' exercises in *The Natural Way to Draw,* but we will work with them in terms of experiments instead of exercises. An exercise has a particular goal for improvement, but there is no need to "be good" in an experiment. The point is to discover yourself. As you draw from the different perceptual approaches, you can be expanded and energized by each. But there will be one that will feel more natural. By trusting your sense of attraction, you will come home to your unique viewpoint, your own way of being alive in the world. To track your preferences, date the drawings and note how they felt to you.

Although the vital principle of movement has been fundamental to making and understanding our abstract improvisations, it can take on new possibilities when drawing what we see in the world. To experience these possibilities, it can be helpful to begin with the preliminary experiments on the next page.

Regina Krausse, first ten-minute drawing (above left); third drawing, drawn after moving with the plant (above)
The first drawing (above left) was visually accurate but unsatisfying. The movement of the sensing drawing (left) freed Regina from restrictive details. After moving with this drawing and then the plant, her movement found its own details in the third drawing (above).

Regina Krausse, sensing drawing, eyes closed
Movement, just for its own sake, follows its own path.

EXPERIMENT: Ten-minute Drawing of a Plant

Your personal viewpoint can be intensified with this sequence of experiments. Find a plant or other object and draw it for seven or ten minutes. Draw it large or small, and with any medium. After the previous experiments with abstraction, notice how it feels to draw an object you are seeing. You may experience a joyful connection as you watch an image grow on the page. On the other hand, you might feel frustrated or critical of the results, perhaps feeling that this is a test of your drawing skills, an evaluation of what needs to be improved. If this experiment feels like an evaluation, how do you see your drawing?

EXPERIMENT: Sensing Drawing with Eyes Closed

After completing and seeing your ten-minute drawing of a plant, close your eyes and become aware of sensations in the present moment. Then bring your hands to a new sheet of paper, noticing its presence. When you feel ready, touch the paper with a crayon, moving any way it leads you. When you see the drawing, notice its intrinsic movement, and allow your own movement in response. Let this movement be expressed in a second drawing.

Lynda Jasper-Vogel, fichus plant, ten-minute drawing, charcoal, 24 × 18 in. (below left); movement sensing drawing, eyes closed, following ten-minute drawing (below right)
The dutiful detail in the ten-minute drawing (below left) gives way to free-form, vigorous movement (below right).

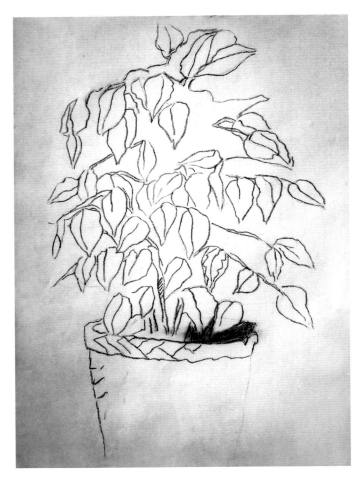
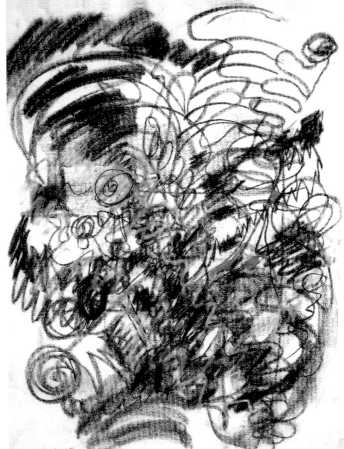

After you see and move with this second sensing drawing, come back to the plant you drew earlier. Take some time to see it again, not as something you need to capture or draw correctly but as something that could influence you. Feel the quality of its life force, noticing any place in you that wakes up. Allow a movement to begin there, trusting its direction. After a time of seeing and moving with the plant, close your eyes and continue moving, noticing that the movement has a life of its own. Then find a crayon, bring it to the paper, and draw with eyes closed. When you have finished, notice the forms that have emerged in the drawing, influenced by the plant.

EXPERIMENT: Moving and Drawing with Eyes Open

After drawing with closed eyes, look at the plant, move with it once again and draw it with your eyes open. Can you still be with your own sense of movement? If you find yourself losing this sense, close your eyes and move again, just to be reminded that it is only movement. There is no need to make a likeness of the plant. Let your drawing be a new creation. Like a child who has qualities of both parents, the influence of the plant you see, combined with your own life force, will create a drawing with individual characteristics all its own.

Lynda Jasper-Vogel, first plant drawn after movement, eyes open (below left); second plant drawn after movement, eyes open (below right)

Vigorous movement brings life force into the plant, animating the leaves, including the grounded pot (below left). In the fourth drawing (below right), the whole space is vibrating with movement, bringing a new sense of order.

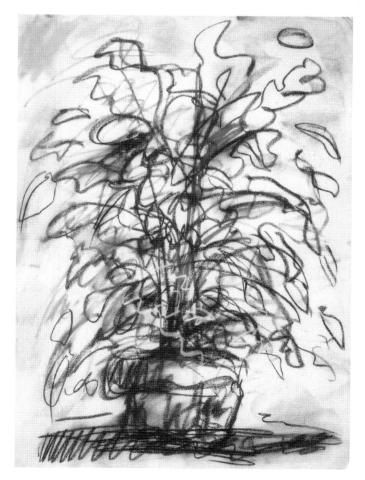

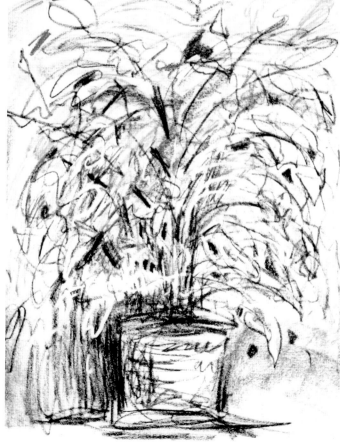

kokoromochi: the living force

One of the most important principles in . . . Japanese painting is that called living movement, or kokoromochi, *the transfusion into the work of the felt nature of the thing to be painted. . . .*

Henry P. Bowie
On the Laws of Japanese Painting

Our sense of movement is pervasive, important to our existence, and yet it is hard to describe in its fullness. The word is usually defined as "a change in position," but its larger meaning includes all of life—from the action of stars and earthquakes to a falling leaf or a spider slowly descending on a thread. How do we put into words the difference between a falling leaf and the tiniest spider? Like the leaf, the spider responds to gravity as it lowers itself on a thread, but it can pull itself up again, moving on its own will. There is a Japanese word that comes close to describing this miracle of life: *kokoromochi,* the true spirit and living force that moves through all things. In Japanese brush painting the artist's goal is not to replicate what he or she is seeing but to transfer this living force into what he or she is painting, whether a tree, a rock, or a person. Expressing this living force in the Japanese tradition can take long practice, but we can experience a similar possibility through awareness and movement.

RIGHT: **Leila Joslyn, fichus plant, ten-minute drawing (top); fichus plant, eyes closed after moving (bottom)** The archetypal movements in the Baiitsu painting are echoed in the student's drawings. The upward movement in Liela's branches was distilled and intensified after moving with the plant.

FAR RIGHT: **Yamamoto Baiitsu (Japanese, 1783–1856, Edo period),** *White Prunus,* **hanging scroll, ink on silk, 68 × 31 in., 1834 (© The Cleveland Museum of Art, Mr. and Mrs. William H. Marlatt Fund [1975.93])** Coming from a deep inner source, Baiitsu balances archetypal rising movements with earth and rock.

諸國瀧廻り下野黒髪山きりふりの瀧

Hokusai, *Kirifuri Waterfall on Mount Kurokami,* woodblock print, 15^3/$_8$ × 10^3/$_8$ in., 1833 (Private collection)

As you see this woodblock print of the Japanese master Hokusai, notice your inner response. Hokusai has given visual form to the living force of water in response to the irresistible pull of gravity. Played against the overwhelming downward movement, notice the upward movements meeting this force—the people standing upright at the base and the small trees and people climbing up the hill.

discovering yourself in the world

In the following experiment you can find your own subjects to draw, either in your work area or outside. To remain centered as you meet the wide range of forms in the world, take the time to experience your state of being before you begin, exploring the drawing paper with your hands.

EXPERIMENT: Finding Your Subject

Draw your subject with crayon or charcoal, trusting the path the crayon is making on the paper. When the drawing process feels complete, move with your drawing, noticing where you experience it inside.

After this preliminary sensing drawing, take some time to simply see what is around. Do you notice anything that attracts your attention? If you are outside, it could be a clump of grass under your feet, a nearby rock or a tree, or a distant hill. Does anything call you in the world? When something comes to your attention, take the time to feel it inside. After moving with your subject, draw it with eyes closed, directly from this inner feeling. Then move again with what you have chosen and draw your subject with eyes open. Can you still let your sense of movement guide the drawing?

As you look at your drawings after this experiment, you may find a similarity between the elemental quality of movement in your first sensing drawing and the forms you drew in your environment. We can see this inner connection in Linda's work. Coming from a sense of breathing, her airy strokes led her to tree limbs meeting the sky. In contrast, Beatrice's sense of weight led her to the earthy solidity of a rock. When approached as self-discovery, drawing what you feel and see in the world can become an inner adventure—a joyful reunion with your own life force.

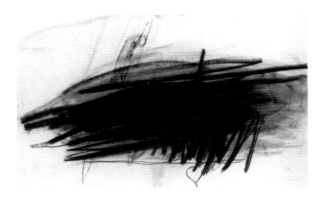

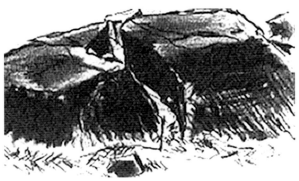

Beatrice Darwin, sensing drawing, eyes closed, charcoal, 18 × 24 in. (top); *Granite Rock, Sierra Nevada*, charcoal, 17 × 24 in. (bottom)
The feeling of weight expressed in the sensing drawing leads the artist to draw a granite rock and, later, a tree.

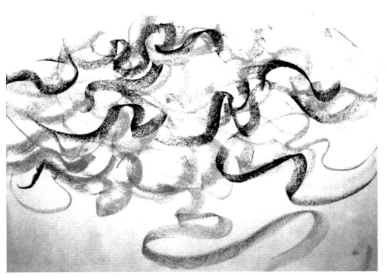

Linda Fries, sensing drawing, eyes closed, charcoal

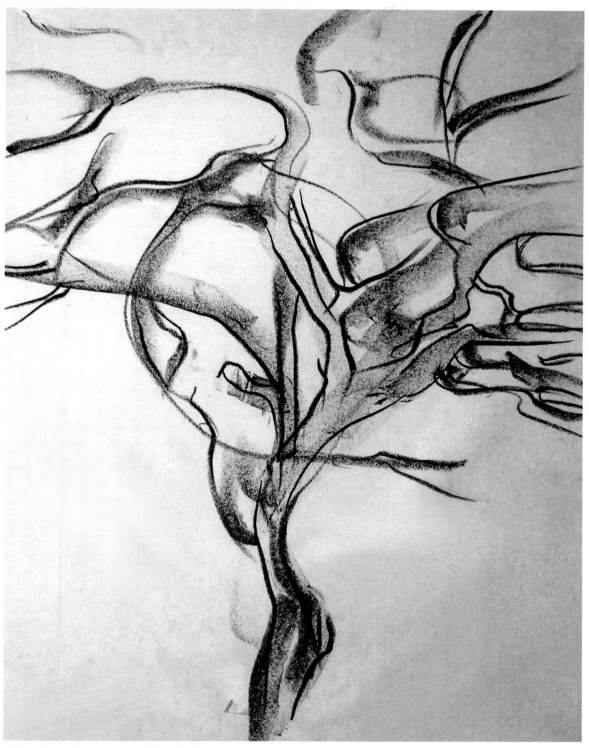

Linda Fries, *Winter Tree,* charcoal, 24 × 18 in.
The sensation of breathing (opposite bottom) leads the artist to draw the spacious limbs of a tree.

movement: a source of personal style

*I love the act of [drawing]
spontaneously. Starting with
something and not knowing where
it is going to end up.*

Lynnelle

Our inner forces not only determine how we see and draw the world around us;
they provide the foundation of personal style and expressive power. This
expression of life forces in a work creates a tangible *presence* that can elicit an almost
involuntary gasp of appreciation from people. The painter Emil Nolde speaks of this
quality in a picture as "the successful audacity of its form." We can see this presence
in Lynnelle's drawings, as she moves between abstraction and representation, always
influenced by the vitality of her own movement.

Lynnelle, movement sensing drawing, charcoal, 18 × 24 in.

Lynnelle, *Bull,* charcoal, 18 × 24 in.

The distinctive rhythms in Lynnelle's sensing drawing
(above) are reflected in the dynamic forms of a bull (top
right) and later in the portrait study (right).

*I'm enjoying exploring what
charcoal can do: what happens with
the mark on the paper, with an
eraser, with rhythms, the placement
of light and dark.*

Lynnelle

Lynnelle, *Kevin Cooper,* charcoal, 18 × 18 in.

ndividual viewpoints can be expressed even before drawing. As people in a group stand together in the garden behind my studio, some see the rocks and small plants below, while others see the trees on the distant hills. As people describe their choices, in a sense they are already drawing, as they instinctively use their hands as well as words to describe what they are seeing. I point this out so that the request to consciously move with what we are seeing will not seem so unusual. Moving with what we see can reinforce an overwhelming truth—we are not separate from what we are seeing. Drawing is not a matter of capturing something but of being captured. It is not a photographic replication but a mutual communication.

EXPERIMENT: Exploring Individual Viewpoints

To explore these individual viewpoints, find a friend, or several, and meet in a place out of doors. Look around for a while, and then share what you are seeing with others. Even without drawing, this simple sharing can point out profound differences in perception. The uniqueness of each different point of view becomes clearer if you move and then all draw from each other's choices. Working with the same subject is something like dancing to the same piece of music. You can experience aspects of nature you might not have noticed, unfamiliar parts of yourself waiting to be expressed.

Pat Kriegler, rock formation, charcoal, 24 × 18 in. (left); sensing drawing, pastel, 14 × 17 in. (above)
The center core of weight expands into a rock formation.

C. S. Siegel, sensing
drawings, eyes closed,
24 × 18 in. (right); wisteria
and trellis, 24 × 18 in.
(far right)
The original swirls are
clarified after movement
and lead to a wisteria plant
winding around a trellis.

Beatrice Darwin, movement
study of oak tree, charcoal,
10 × 24 in. (top right):
distant oak tree, charcoal,
10 × 24 in. (bottom right)
Beatrice's sense of abstract
form revealed in her first
sensing drawing led her to
a powerful oak tree on a
distant hill.

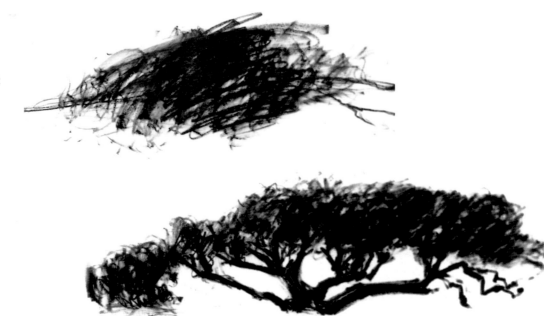

Even though we think we are looking at something outside of us, in choosing our subjects we choose our own nature. The first moment of seeing is very kinesthetic—there is no difference between inner and outer. In the drawings here we can see elemental qualities of earth, air, fire, and water occurring naturally: the inner core of weight that underlies Pat's rock formation, the fluid movements coming from hips and back in my drawing, the sense of weight moving forward in Beatrice's drawing, and a flamelike movement rising from the ground in Kristi's work. The inner conditions expressed clearly in the sensing drawings profoundly influence what we see and draw.

Monet held that the first real look at a subject is likely to be the truest one. By moving with what you see and drawing directly after, you honor your natural impulse before getting caught up with details that often obscure the original vision. It is best to move with the whole body, but when this isn't possible, moving with your hands on the page before drawing, or even just closing your eyes before or during drawing, can bring you back to the source, your inner nature.

How will the Tao reveal its presence without movement?
George Rowley
The Principles of Chinese Painting

Kristina Muhic Arroyo, sensing drawing, charcoal, 18 × 24 in. (top left); lily, movement drawing, charcoal, 24 × 18 in. (bottom left); lily, second drawing, eyes open, charcoal, 24 × 18 in. (above)
The original movement of the sensing drawing can be seen in the movement drawing of the lily and continues in the final drawing.

recovering the original vision

Movement cannot only sustain our first vision but can bring it back if we lose it. We can see this recovery in David's drawings, illustrated here. His first sensing drawing was geometric and centered, but he was frustrated when this abstract simplicity was lost in the details of rocks and small plants. When he closed his eyes and drew from a sense of movement, his personal forms returned, confident and inventive. The last drawing included the rocks and plants, but on his own terms, simplified and more abstract.

Movement not only sustains our connection with the life force through abstraction, but it can support realism as well. As David later drew familiar trees and bushes in the redwood forest located near his home, his personal rhythms and forms not only led him to the scene but unified the specific details. Movement can be helpful if we want our drawings to match the generosity of what we are seeing—to find the proportion and perspective we want to convey. It is a matter of giving more time for feeling and of paying special attention to the space of the paper and seeing movement.

David Newell, first sensing drawing, charcoal, 24 × 18 in. (top left); rocks and plants, drawn directly after the sensing drawing, charcoal, 14 × 17 in. (top right); rocks and plants, closed eyes, restoring movement, charcoal, 18 × 24 in. (bottom left); rocks and plants, improvisation, charcoal, 14 × 17 in. (bottom right) David's original simplicity (top left) was lost in details (top right) but restored through movement, which led to abstract improvisations (bottom left and right).

EXPERIMENT: The Sense of the Whole

Begin by getting in touch with your inner movement, eyes closed. When you have chosen an object to draw, give time to simply see it. Focus on the whole object, from top to bottom, side to side. As you are seeing your object, move with it. As you are moving, look at the paper, sensing how the object could fit on it. Wait until there is a sense of where the object needs to go, and with a light stroke let the movement of it find its way to the paper. You can make adjustments as you draw or start again if the proportions don't feel right. If you are drawing a figure, follow your first perception of the person, without getting caught up in the details. This is a simple but powerful process, a kind of dance between what you are seeing and the space of the paper. Keep the intention of drawing the whole object. When the entire form has been expressed, details can be included, or volume can be developed. But for now, focus on the whole—not so much as a way of getting it right but to deepen your connection with what you see. Movement can be at the service of what we see, both the essential gesture of a single object and the essence of a whole scene.

David Newell, *Bushes in Redwood Forest, Occidental,* charcoal, 17 × 14 in., 2000
Abstract forms of circles played against verticals underlie the details in this forest scene, unifying the composition and echoing the abstract elements in David's first sensing drawing.

Be guided by feeling alone. . . . Before a site and any object, abandon yourself to your first impression. If you have really been touched, you will convey to others the sincerity of your emotion.
Jean-Baptiste-Camille Corot

the essential gesture in master drawings

Maintaining a sense of the whole, or the essential gesture, is especially important when drawing the figure. In this we can be inspired by master drawings of the Western tradition of painting. Although we associate this tradition with visual accuracy, these drawings are more often carried by a sense of movement and life force than by a dedication to detail. As you revive the spirit of these drawings through the previous movement experiment, try a parallel experiment as well: the gesture drawing exercise in Nicolaides' book, *The Natural Way to Draw*. This exercise can be especially useful in the quick (three- to five-minute) poses of life drawing.

EXPERIMENT: Gesture Drawing

Begin by establishing a form of scribble that feels natural, just in itself. Then, after seeing the entire figure, begin drawing with this scribble, keeping the whole form going at once, from head to foot, without using an outline. It is especially important to feel the pose in your own body, even taking the position yourself to feel it from the inside. Try this with anything else you see in the world. This is movement in the service of seeing, following the whole form, making corrections as needed, or trying again if the proportions don't feel quite right.

BELOW: Anonymous (Spanish or Italian), *Angel*, red chalk on cream paper, 6 3/4 × 5 5/16 in., early sixteenth century (The Metropolitan Museum of Art, New York, gift of Cornelius Vanderbilt, 1880 [80.3.72]. Image © The Metropolitan Museum of Art) When doing a gesture drawing, keep the whole form going at once.

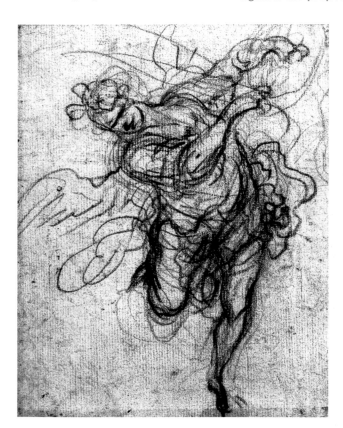

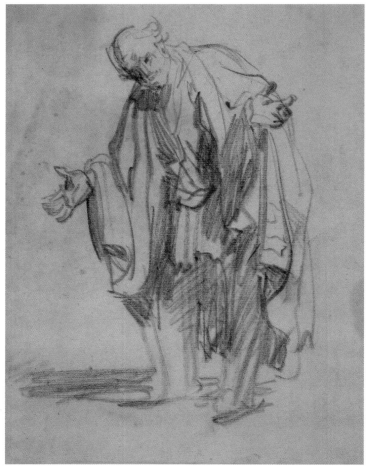

RIGHT: Rembrandt van Rijn, *Study of St. Peter*, chalk, 10 × 7 1/2 in., 1629 (Staatliche Kunstsammlungen, Dresden, Germany) From his feet meeting the ground to his outstretched hands, the gentle humanity of St. Peter is fully revealed through movement.

After a while you will notice that your single figures or objects are part of a total environment. As you draw this environment, you will encounter the creative challenge of perspective. Although some knowledge of linear perspective can be useful, the most effective approach is to draw the gesture of the whole space.

EXPERIMENT: Drawing the Gesture of the Whole Space

Before you start working, first become aware of the horizontal and vertical edges of your paper. Then line up what you are seeing with these edges as you draw, working quickly to keep the unity. Although matching the visual, you are still working with abstraction, finding the movements and rhythms that unify the whole space. Each movement has an archetypal power that you can feel inside, which can resonate in your own body.

I woke up this morning with "unity of movement" in a picture strong in my mind. I believe van Gogh had that idea. . . . Now I see there is only one movement. . . sweeping out into space but always keeping going— rocks, sea, sky, one continuous movement.

Emily Carr

Honoré-Victorin Daumier, *Council of War,* lithograph, 11³/₈ × 9³/₁₆ in., 1872 (The Metropolitan Museum of Art, New York, Purchase, Jacob H. Schiff bequest, 1922 [22.63.7]. Image © The Metropolitan Museum of Art)
The individual figures are caught up in one passionate diagonal movement, played against the vertical door.

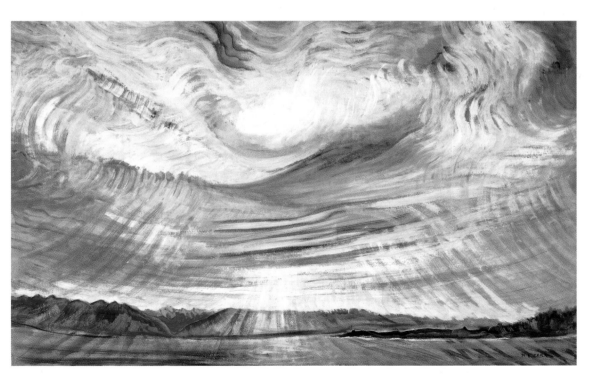

Emily Carr, *Sky,* oil on wove paper, 23¹/₈ × 35³/₄ in., 1935–1936 (Photo © National Gallery of Canada, Ottawa)
In this spacious seascape, Emily Carr draws with thinned oil paint on large sheets of manila paper, carrying her inner movement into painting media. Notice the stability of the horizontal lines against the upward swirling clouds.

archetypal movements: water, fire, and air

We have seen the use of movement in master drawings, depicting the essential gestures and proportions of figures and places. These drawings have an archetypal power that can be felt inside, a vital presence that goes beyond the subject. Under the refined detail of Leonardo's portrait study (see opposite page), circular movements reveal a cosmic world. The curving gesture of Leda's head and the spirited patterns of her braided coiffure resemble the natural rhythms he so avidly observed in nature, from the crossing of currents in streams and oceans to the fibers he discovered in the human heart.

In Leonardo's explosive drawing of a volcano (interpreted here by Regina Krausse), we can see another archetype—the element of fire rising from the depths of the earth. This universal movement resembles the exuberant growth of a blossoming tree and a spirited drawing by Penny Nickels Smith from a healing process (see page 56). These patterns and archetypal movements are reflected in myriad art forms all over the world—a universal language echoing life.

Regina Krausse, translation of a 3- × 3-inch drawing of a volcano by Leonardo da Vinci, location unknown
An archetypal fire, rising from the depths of the earth.

C. S. Siegel, *Stream in Winter*, Caran d'Ache Neocolor and acrylic wash on green mat board, 13 × 32 in., 1992
As the continuous flow of water meets obstacles, it turns back on itself in endless variations.

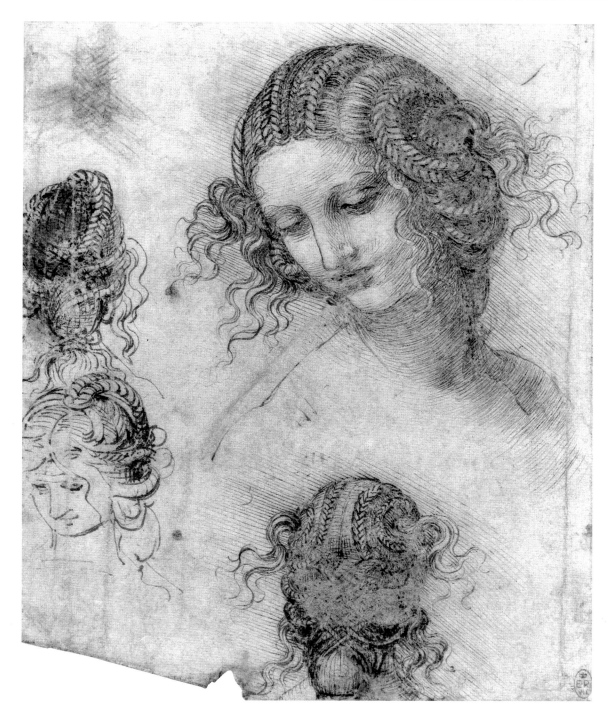

Leonardo da Vinci, detail of *Studies for the Head of Leda,* pen and ink over black chalk, 7 $\frac{7}{8}$ × 6 $\frac{3}{8}$ in., circa 1505–1506 (The Royal Collection © 2007 Her Majesty Queen Elizabeth II. Photo: EZN)

Leda's face reflects a quiet refinement, but the curving gesture of her head and the spirited patterns of her braided hair resemble the primal patterns of flowing water. These patterns are echoed in symbolic art all over the world, from Africa to Ireland.

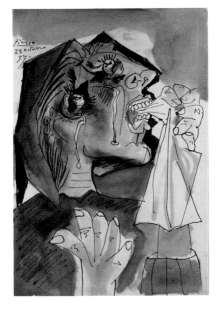

Archetypal Movements: Coming to Earth

Movement can come from the deep geometry of earth, and it is an important source of emotional power in master drawings. The sharp angular movements in Picasso's crying women are cataclysmic, as unforgiving as shattered cliffs on high mountain peaks. Although the lines that describe Rembrandt's prodigal son flow downward, almost uncontrolled, they are balanced by the stable vertical lines of the father's robe. The solid geometry of the dark spaces behind the figures holds the emotional lines of the dramatic encounter in balance. These forms and movements in the drawings of Picasso and Rembrandt carry the essential meaning, even without the images.

It is this elemental essence, carried by movement and shape rather than realistic accuracy, that gives the work of master artists a sense of immediacy and presence. You can see for yourself as you draw the different elements—we all share this archetypal language, artists or not. We have access to the tremendous power of the elemental world, simply by virtue of being alive.

Pablo Picasso, *Study for Weeping Woman,* oil washes and black ink on off-white wove paper, 15³/₄ × 10¹/₄ in., 1937 (Fogg Museum, Cambridge, MA, © Picasso Estate/ARS. Photo: Imaging Department © President and Fellows of Harvard College) Sharp, angular movements express unspeakable anguish.

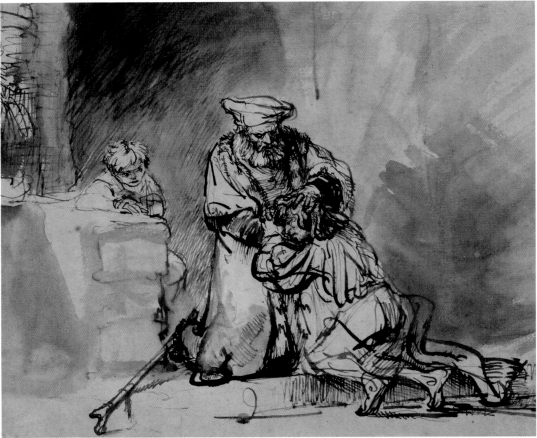

Rembrandt van Rijn, *The Return of the Prodigal Son,* pen and wash in bistre, 7¹/₂ × 9 in., 1642 (Teylers Museum, Haarlem, The Netherlands)
The emotional lines of the figures are played against a more geometric background.

Archetypal Movements Carried into Painting

The powerful forces of fire, water, air, and earth come together in van Gogh's painting *The Starry Night*. The upward thrust of the flame-like tree is played against the wavelike rhythms in the night sky, all supported by the horizontal hills and sleeping village. This painting contains the paradox of everyday life—the safe shelter of a specific place surrounded by archetypal, untamed cosmic energies.

These different forces are integrated in the painting largely because of the power of van Gogh's drawing—his distinctive rhythms and characteristic forms, passionate yet deeply connected to the earth. These connections are even more evident in van Gogh's earlier drawings, which have a tactile power more associated with sculpture than painting. Although we associate van Gogh with the extravagant rhythms of his later works, their movements are rooted in the powerful nonvisual sensations of touch and weight. In the next section we will explore these sensations.

Our exploration of movement has opened a new relationship with the subjects we draw—from one of dutiful replication to an energetic exchange in which a convincing sense of proportion and perspective come naturally. In the same way, the energetic exchange with our subjects through touching and weight can bring a natural sense of realistic detail and three dimensions to our drawings.

Emilio Lanier, *The Element of Fire*, oil crayon, 18 × 24 in.
This student work echoes van Gogh's *Cypresses*.

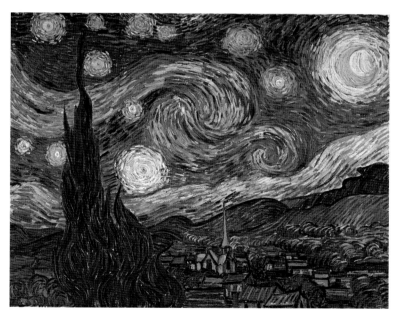

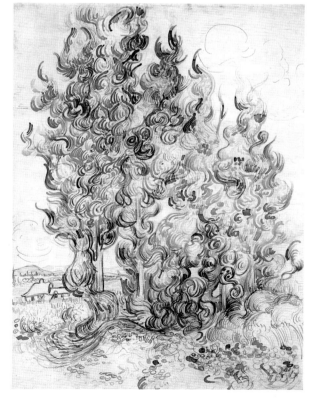

Vincent van Gogh, *The Starry Night,* oil on canvas, 29 × 36¼ in., 1889 (The Museum of Modern Art, New York, acquired through the Lillie P. Bliss bequest [472.1941]. Digital Image © The Museum of Modern Art/Licensed by SCALA/Art Resource, New York) (above); *Cypresses*, pen and brown inks, with graphite, on buff wove paper, laid down on card, 24¹¹/₁₆ × 18⁵/₁₆ in., 1889 (The Art Institute of Chicago, gift of Robert Allerton [1927.543]. Photo © The Art Institute of Chicago) (right)
The archetypal movements in van Gogh's drawing are carried into his painting and integrated with the whirling sky and solid earth.

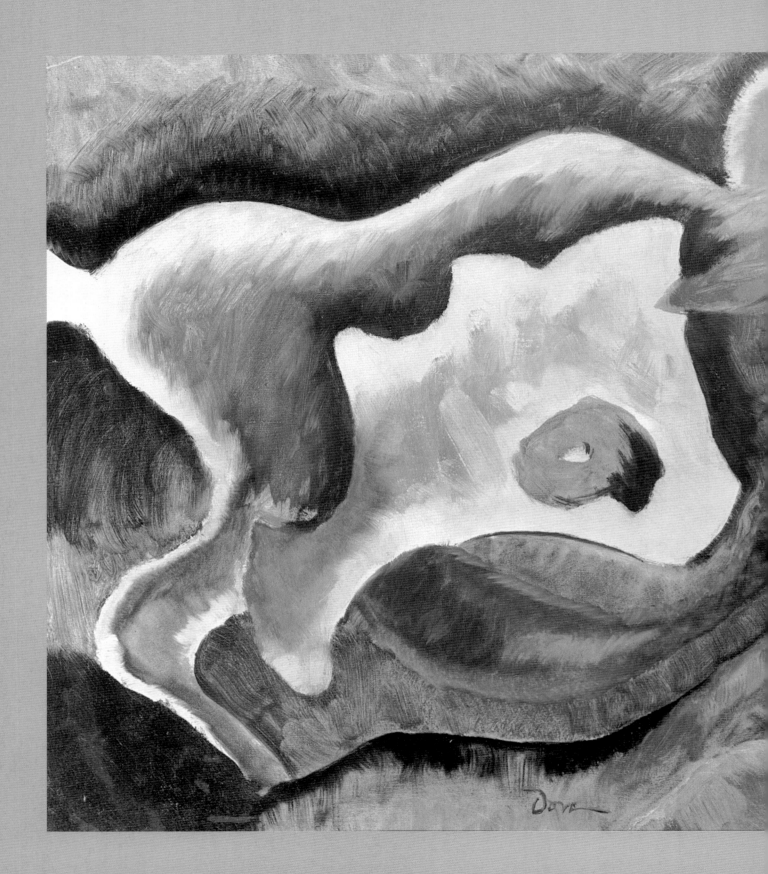

the sense of touch

Movement can bring vitality and unity to your work, but you may be wondering about the intricacy of detail. To experience the perceptual source of detail, move close enough to touch what you are seeing. This tactile connection to surfaces and edges accounts for the astonishing sense of visual reality we see in master drawings. But the sense of touch can also carry us into unexpected places, generating forms and shapes we can never have seen, and yet which are unmistakably real. American masters such as Georgia O'Keeffe and Arthur Dove explored this nonvisual world, discovering the living forms of nature, drawn from the inside out.

Arthur Dove, *Goat,* oil on canvas, 23 × 31 in., 1935 (The Metropolitan Museum of Art, New York, Alfred Stieglitz Collection, 1949 [49.70.37]. Image © The Metropolitan Museum of Art)

drawing through touch

Jean Woodard, earth fragment, charcoal,
17 × 14 in.
Influenced by touching, a small fragment
of earth becomes a whole world.

The sense of touch brings us to a tangible, sensuous contact with a world that is not dependent on seeing. I was reminded of this world during a visit to a mountain hot spring. Sinking into the engulfing warmth of a hot pool at night, I was surprised to find sand under my feet. This unexpected sensation brought a wordless pleasure, a reminder of the joy of being alive. Time slowed down, and something deep inside woke up, like a sea anemone opening to the incoming tide. Walking back on a dark road without a flashlight, I experienced another aspect of touch. As my feet contacted the road, touching became my trusted guide—one foot after the other—slow but sure. This is a sense we can depend on, one that has been with us from our first sensing experiments and our tactile contact with the paper.

In the next experiments we will explore this powerful sensation and its influence on drawing.

EXPERIMENT: Experiencing the Sensation of Touch

Close your eyes now and notice the ways in which you are being touched. Feel the touch of the chair . . . the floor under your feet . . . the touch of your clothing . . . and the air surrounding you. Notice the place where the air enters you in breathing, touching you from the inside, and then, in its own time, moving out. As you feel the

Vincent van Gogh,
*Young Man with
Sickle,* chalk and
watercolor, 18 × 24 in.,
1881 (Collection
Kröller-Müller
Museum, Otterlo,
The Netherlands)
The sense of touch
reveals the solid
character of this
person.

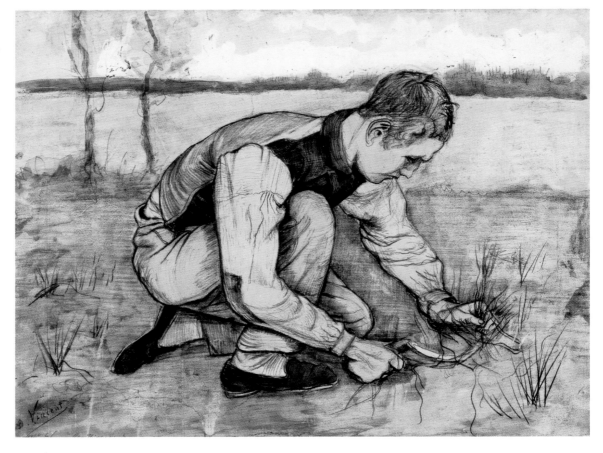

touch of your breathing, notice what your hands are touching. Let your hands come up in the air, and in time let them come to the paper. Let the paper touch you as you explore the surface and edges, noticing any effect this contact has on your breathing. After a time of exploration, find a medium that you want to touch the paper with, and with the curiosity that comes with tasting a new dish, let the crayon or charcoal meet the paper. With your eyes closed, let the contact guide you, noticing the particular quality of the crayon against the paper. Can you still feel the touch of breathing?

EXPERIMENT: Exploring an Object Through Touch

When the previous drawing feels complete, prepare another sheet of paper and a crayon beside it. Choose an object to hold in your hands. With your eyes closed, take some time to explore it through touching. Just be present with this object, for no other reason than to get to know it better. How does it affect you inside? Then, continuing to touch the object, find your crayon and explore the paper again, letting the experience of the object influence your drawing. As you draw with closed eyes, there is no need to reproduce the object, but let your path on the paper be influenced by it.

EXPERIMENT: Drawing with Eyes Open, Influenced by Touch

When this exploration has come to an end, open your eyes, and notice what happened in your drawing, seeing it simply as a record of a journey. Then take some time to see the object, and draw it with your eyes open. Let yourself be influenced by the experience of touching in any way it happens, noticing what seeing brings. Seeing might expand your experience, or you may miss the intimate contact you had with your eyes closed and the freedom from judgments and restrictions. If this happens, touch your object again. Try this experiment with other objects, noticing your inner response to each. Explore with your eyes closed and then open, finding out what works best for you. Although a sense of the real can appear in your drawings, there is no need to produce a likeness.

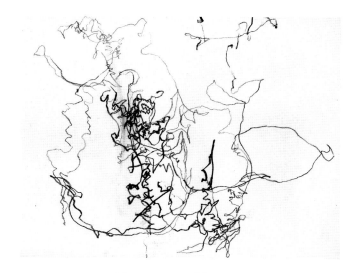

Patrick Maloney, sensing drawing, eyes closed, 6B pencil, 18 × 18 in. (top right); anise plant, after touching, eyes open, 6B pencil, 24 × 10 in. (right)
The distinctive quality of touch revealed in the sensing drawing continues in Patrick's tactile drawing of a plant.

touch: the source of individual style

ndividual distinctions can be seen very clearly when several people draw from a similar object. After the first experiment with touching the paper, I asked people in a group to close their eyes, and then I put yucca pods into their outstretched hands. Without seeing, their tactile experience of the pod was directly expressed as they made a drawing. They then made a third drawing with eyes open. We can see the individual styles of touch, from Susan's large circular movements, to Pat's three-dimensional modeling, to Beverly's angular boldness, to Barbara's exuberance, to Liana's sensitive concentration. Notice the different points of view, from a focus on the whole branch to the closer views that fill the page.

Susan Brayton, sensing drawing, eyes closed, Conté crayon, 24 × 18 in. (left); yucca pod, eyes closed, Conté crayon, 24 × 18 in. (center); yucca pod, eyes open, Conté crayon, 24 × 18 in. (right) The large circular movements in Susan's sensing drawing continue in the closed-eyes drawing of the yucca pod. She keeps this circular form with eyes open.

RIGHT: **Pat Kriegler, yucca pod, eyes open after touching, charcoal, 24 × 18 in.** A sense of three-dimensional modeling.

FAR RIGHT: **Beverly Davis, yucca pod, eyes open, charcoal, 24 × 18 in.** A distinctive sense of weight and direction is evident in this drawing.

Barbara Hazard, yucca branch, eyes closed, charcoal, 24 × 18 in. (far left); yucca branch, eyes open, charcoal, 24 × 18 in. (left) Barbara's delight in touching is expanded with eyes open and is expressed in a sense of life force, tactile and exuberant.

Liana Kornfield, yucca pod, eyes closed, charcoal, 17 × 14 in. (far left); yucca pod, eyes open, charcoal, 17 × 14 in. (left) (© Liana Kornfield) The tactile sense in Liana's first yucca pod is enriched by seeing.

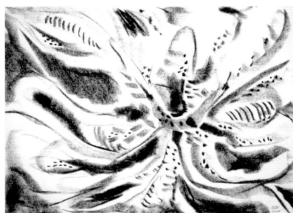

Carol Griffin, yucca pod, eyes open, charcoal, 18 × 24 in. (top); yucca pod, looking inside, charcoal, 18 × 24 in. (bottom)

Although Carol's first drawing was visually accurate, moving closer into the pod revealed a rich world of shapes and spaces.

The flower is small. . . . I'll paint it big and then they will be surprised into taking time to look at it.

Georgia O'Keeffe

O ur uniqueness is expressed not only in personal touch but in our whole point of view—how close or far away we want to be from our subject. For those more connected with the sense of touching, the closer the better, as we can see with Carol, whose drawings flourish with closer contact. This viewpoint echoes the paintings of Georgia O'Keeffe, who found a whole world in the center of flowers.

EXPERIMENT: Drawing a Fragment

You can experiment with this progression yourself. Go back to the object you were drawing, or find a natural object, such as bark, that has a sense of texture. Move the object close until it fills your field of vision, and then use a small cardboard frame or slide mount to isolate a fragment as small as one or two inches. Now draw, enlarging this fragment so that it fills the total space of the paper. The abstract shapes found in a fragment parallel the archetypal forms that we found through movement. But instead of laying out the entire form, we are drawing as if from the inside out, one part at a time.

The masters of Chinese and Japanese painting successfully combined the tactile intimacy of touch with the immensity of space. Their audacious compositions, often based on fragments, were carried into Japanese prints. These compositions in turn inspired Post-Impressionist artists such as Paul Gauguin and Vincent van Gogh.

Bernie Larkin (Art Fundamentals 133), *Fragment of Bark,* 6B pencil on charcoal paper, 18 × 24 in.

In this drawing, a fragment of bark, four inches long, resembles a map of a country.

陪月間川杖履逢　半帆時節更相近
吟哦躑影躚良宵　為問梅花笑如知
　梧石杜堇　[印]

Du Jin (Chinese, Ming dynasty, active circa 1465–1505), *The Poet Lin Bu Wandering in the Moonlight,* hanging scroll, ink and color on paper, 61 ½ × 28 ½ in., late fifteenth century (© The Cleveland Museum of Art, John L. Severance Fund [1954.582])

The fragments of land, rock, and tree, painted with an intricate sense of touch, create a series of overlapping planes that suggest an infinity of space. The poet himself becomes part of the space—a definite presence—yet not disturbing the abstract unity.

from the inside out

Diedre Dubroski, two drawings of partner, charcoal, 17 × 14 in. (top);
Danielle Shelley, drawing of partner, charcoal, 18 × 24 in. (bottom)
Two people draw each other, influenced by touch—intensely
observed and unflinchingly honest.

The sense of touch can be immensely helpful in drawing portraits. It can cut through the fear of making mistakes and bring us to the inner core, the living reality of a person.

EXPERIMENT: Drawing Yourself and Others

Close your eyes and sense your own head and face from the inside. What is your inner experience of what we call features? Then explore your eyes, nose, mouth, and cheekbones with your hands, as if for the first time, as if your face were a landscape with hills and valleys. Keeping your eyes closed, let your drawing follow this exploration. After this sensing drawing, either sit down in front of a mirror or find a partner and sit opposite him or her. After you have taken some time to see yourself or your partner, touch the crayon to the paper and let the experience of touching your own face influence the way you draw. Keep your attention on your model, letting the drawing go its own way.

When you see your drawing later, it will probably be apparent that touching expresses a strong sense of the real, but on its own terms. Unlike the gesture, which captures the whole, the sensation of touching can move from one part to the other, following your interest. The stronger your interest in a particular part, the larger it can get, often leading to proportions that are wildly inaccurate in visual terms. These proportions are not always flattering, but the life force is there—the line has come from a deep, direct experience.

Patsy Maloney, closed-eye drawings after exploring face, charcoal (above); self-
portrait after touching, eyes open, charcoal, 12 × 12 in. (right)
The polarities of feeling expressed with closed eyes give life and depth to the
final drawing.

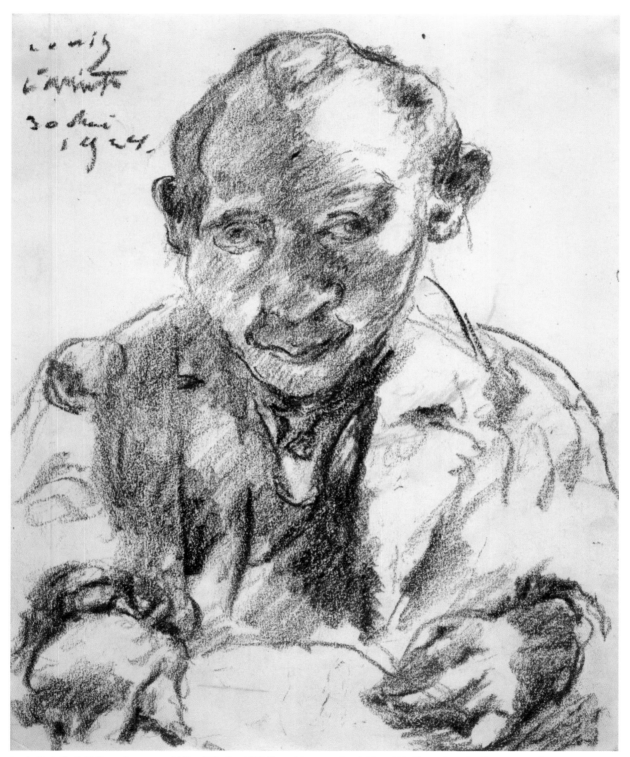

Lovis Corinth, *Self-Portrait*, crayon, 12¹/₂ × 9¹³/₁₆ in., 1924 (Fogg Museum, Cambridge, MA. Photo: Imaging Department © President and Fellows of Harvard College)

Human presence is carried by touch.

Susan Doyle, *Portrait of Carlos,* charcoal, 24 × 18 in., 1985
An economy of line from touching resembles the work of Matisse.

Like a trip without a plan, there is a sense of adventure with the sense of touch, as we let each moment lead to the next. These trips can be uncomfortable, sometimes even frightening, as you find yourself stranded on an island without accommodations or out of gas in the middle of the desert. But the spontaneous excitement of adventure can be irresistible.

Drawings that result from unplanned explorations guided by the sense of touch can resemble the work of Matisse or Picasso. An audacity of form comes from the intimacy and confidence of touching. This is the basis for work we call Expressionism, in which inner sensations and tactile experience overshadow the need for visual accuracy.

Expressionists can be at home with touching in much the same way as can a blind person, whose world is largely constructed from the sense of touch. As people blind from birth gain their sight, they must painstakingly learn to be at home in a new world, in the searching way of an infant. In the same way, we need to be patient as we claim our sense of touching, not judging our work by visual standards but appreciating its power. The sense of touch contains much that is magical in drawing—not only a compelling immediacy, outrageously truthful, but a convincing sense of detail that we have come to associate with master drawings.

Helen Redman, *Self-portrait,* pen and ink, 14 × 11 in., 1965 (above); *Singing the Bones,* self-portrait, acrylic on canvas, 48 × 30, in. 1993 (right)
The early self-portrait is confident and direct. Thirty years later, Redman's tactile line penetrates the fear and truth of aging.

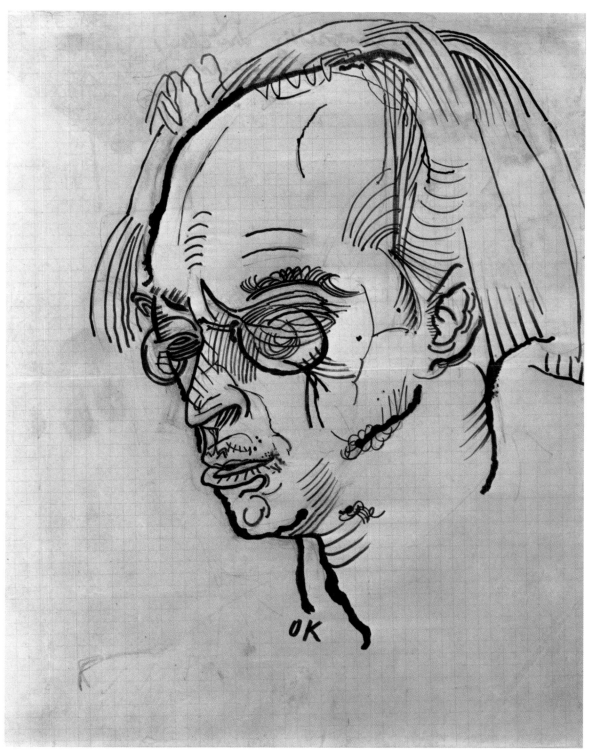

Oskar Kokoschka, *Portrait of the Poet Herwarth Walden,* black ink over graphite on off-white wove paper, 11 3/16 × 8 11/16 in., 1910
(Fogg Museum, Cambridge, MA © Kokoschka Estate/ARS. Photo: Imaging Department © President and Fellows of Harvard College)
Passionate observation created this portrait.

the intimacy of detail: exploring devil's gulch

Every summer for years my students and I have met to draw in a place called Devil's Gulch, a deep forested valley with a stream running through it, surrounded by hills. Through drawing, we have explored the many aspects of this special place, from the dried grasses to the wild growth of bushes and trees to the ancient redwoods that tower above. Our sense of touch delights in the endless variety. As we draw from the sense of touch, we enter a timeless world in which a rock covered with lichen can be as exciting as a whole mountain range, a small stalk of grass is as interesting as an entire hillside, and the hollow of a redwood reveals hidden wonders.

EXPERIMENT: Exploring a Natural Place

Choose a small section of a natural place to explore through touching. Let this exploration lead you into drawing, leaving your eyes closed. Then allow this sense of contact to continue as you draw with eyes open. Let this drawing be a journey with no time limit, finding a pace that feels natural to you. Draw as if you are hiking in the wilderness, where every step, every turn, reveals something new.

Regina Krausse, grass study, from eyes closed (top) to open (bottom), pencil, 17 × 14 in.
A deep connection with the paper creates the tactile power of this small stalk of grass.

Max Schardt, rock and lichen, eyes open, after touching, soft pencil, 18 × 24 in.
The sense of touch opens a world in which a lichen-covered rock can be as interesting as an entire mountain range.

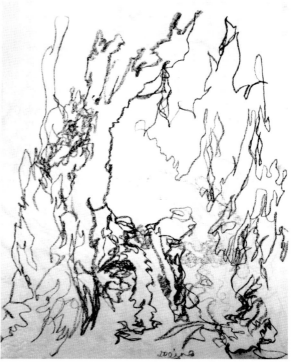

ABOVE: **Lynn Scott, pencil study**
In this drawing from inside the dark hollow of a redwood tree, the passionate sense of touch is naturally coordinated with seeing.

LEFT: **Regina Krausse,** *Devil's Gulch,* **charcoal, 18 × 12 in.**
Spending almost an entire day in one place, Regina explored a wild tangle of trees and branches.

There can be a profound satisfaction in extending the tactile connection over time, beginning in one place and trusting the intensity of your sense of touch to find the way, without knowing where it will end. The extended drawing can be a form of meditation—a sustained, loving, attention—in which you enter the spirit of what you are drawing and are led by it for as long as it takes.

EXPERIMENT: "Blind Contour" Exercise
The previous experiment is parallel to the "blind contour" exercise in Nicolaides' *The Natural Way to Draw,* which is intended to coordinate the sense of touching with seeing.

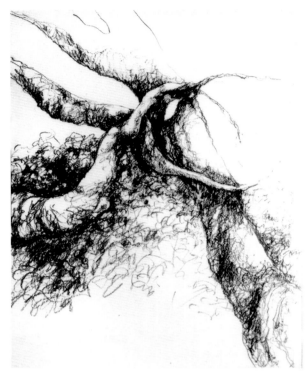

Nicolaides asks the reader to "place the pencil point on the paper, fix your eye on the model, wait until you are convinced that the pencil is touching the model before you draw. . . . Then move your eye slowly along the contour of the model and move the pencil slowly along the paper . . . glancing at the paper only to locate a new starting point (when an edge comes to an end)." Try this exercise for yourself, using any subject.

This is a powerful exercise, especially for longer studies, but it might not match your personal way of touching. As a university teacher I thought the contour exercise was good for everyone, but when I found the wealth of individual variations emerging from the direct sensation of touch, I used the exercise less often. In developing your individual style it is important to let your unique sense of touch be revealed in its natural state before coordinating it so closely with seeing. We don't need powerful exercises. Those who feel at home with touching need only a small reminder; just touching the paper can awaken your sense of tactile contact. After drawing with closed eyes for the first time, one student found the hollow of a redwood tree and spent the rest of a bright summer day happily drawing in the dark, led by the sense of touch.

Jean Woodard, trees in Devil's Gulch, charcoal, 17 × 14 in.
Enter the spirit of what you are drawing and let yourself be led by it, sustaining your attention over time.

Barbara Hazard, *View from the Fire Road*, pencil on printmaking paper, 8 × 11 in., 1981
The same confidence and delight in touching we saw in the earlier yucca pod (see page 89) is carried into space, exploring trees, distant hills, and sky.

tasting, smelling, and other sensations

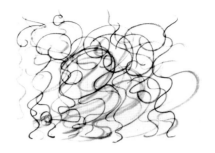

Once we are in the touching mode we can move into other nonvisual sensations, such as taste, smell, and sound. We can experiment in the same way as with touch, drawing from these sensations.

EXPERIMENT: Nonvisual Sensations

After preparing paper and drawing medium, hold a pretzel with your eyes closed. Then eat it slowly, allowing the taste, texture, and even the sound of eating to influence how you touch the paper with a crayon or charcoal. How is a pretzel different from a raspberry? The sense of smell can influence your drawing as well. As you smell something aromatic and then draw with your eyes closed, notice any feelings that come. For many, this sense can wake up memories from the past.

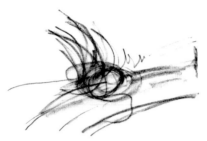

The vitality in Dove's *Goat* (shown on pages 84–85) reflects a powerful cycle of nature—the impulse to generate new life, continuing the species in a cycle of birth and death. This generative impulse elicits a response from Charles Brooks, as shown in the quote below.

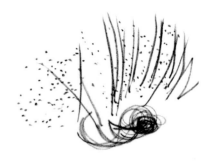

My eye plunged down the thigh and leg and came upon a chasm,
above which a great, curving, brownish shape grew, filling the picture.
I caught my breath as I saw it was the goat's erection, or rather the
whole goat becoming erection, growing and swelling toward a vast cleft,
warm and deep as the night or as the earth itself.

Charles Brooks
Sensory Awareness

Kristin Garneau, *The Smell of a Banana*, charcoal, 18 × 24 in. (top); *The Smell of Turpentine*, charcoal, 18 × 24 in. (center); *The Smell of Perfume*, charcoal, 18 × 24 in. (bottom)
From pickles to turpentine, smells can bring back strong memories in people. Perfume especially can remind us of loved ones.

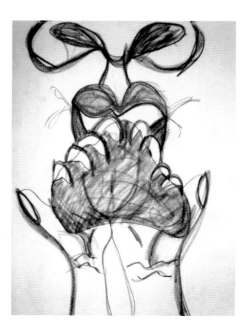

Patsy Maloney, eating a pretzel, charcoal, 14 × 14 in. (above); Lynn Scott, drawing while eating, charcoal, 17 × 14 in. (right)
Eating involves not only taste but smell and sound and touch.

When you are really enthralled,
really stimulated, by a force other
than the visual, strange-looking
things are apt to occur, but you will
not judge your work by formula or
conventional standards.

Kimon Nicolaides
The Natural Way to Draw

The Power of Sounds

Making and hearing sounds can be a powerful inspiration, not only the sound of your crayon but sounds surrounding you—other voices, or the sounds of nature. The sound of a stream, birds, insects, and the rustle of leaves in the wind can inspire your drawing. Drawing to music can intensify emotional states. We can be inspired by our own voice. Try making vocal sounds while drawing: They can accompany and support the movement on the paper, initiating new forms and sustaining a vital connection to your inner life.

ABOVE: C. S. Siegel, *The Sound of Our Own Voices,* oil crayon, 18 × 24 in., 1973
Vocal sounds accompanied this drawing.

RIGHT: Charles Burchfield, *The Insect Chorus,* opaque and transparent watercolor with ink and crayon on wove paper, 20 × 15⁷/₈ in., 1917 (Munson-Williams-Proctor Arts Institute, Museum of Art, Utica, New York [57.99])
Sounds can initiate unexpected forms.

Rediscovering Your Media

Touching, tasting, smelling, and hearing can inspire new ways to use your media. Each drawing medium has a distinctive touch and moves on the paper in a particular way. Each kind of paper will influence your experience, as well. Take some time to experiment with the wider range of drawing materials described in the Appendix, noticing the qualities of the different media, just in themselves. Then play with how they support each of the perceptions we are exploring. A graphite stick can lead us into more fluid movement.

For years I used the definite line of a C-6 lettering pen to linger on details of rock formations and tide pools. Acrylic wash on gray paper with white crayon was suited for the more fluid movements of running water and the changing patterns of clouds. Lately, I draw with pastel on colored paper to capture the excitement of color and light. As you experiment extensively with these and other materials you can find the most satisfying match for what you are feeling and seeing.

The quality of aboluteness, the note of authority, that the artist seeks depends upon a more complete understanding than the eyes alone can give.

Kimon Nicolaides
The Natural Way to Draw

Patrick Maloney, *Patsy in the Garden*, pen and ink, 11 × 22 in.

Mourning family losses, Patsy found solace in her garden, touching the ground, and experiencing the miracle of new life. As Patrick drew his wife and garden, the detail emerged naturally as part of an intimate exploration, each plant precious. The many parts, lovingly felt, came together as he drew. The power of touch can open us all to the healing abundance of the natural world. It can wake up all our other senses as well.

CHAPTER SIX

the sensation of weight

From food to music to the pleasure of a caress, the sensations of touch, taste, smell, and sound define and enrich our experience of the world. They are the raw materials of the poet's language. But what poet rhapsodizes about weight? Even though it influences our every move, the expressive aspect of weight seems to be silent. But silent or not, the awareness of gravity is the foundation of many meditation practices, from Buddhist sitting practice to the martial arts. The sense of weight underlies visual expression as well, and our exploration will reveal a new depth of expression in drawing, from three-dimensional realism to effective abstract composition.

Linda Larsen, *Standing with the Oak*, oil pastel, 18 x 24 in., 2005

the influence of weight

The awareness of weight and gravity is at the core of the practice of Sensory Awareness. Charlotte Selver, my teacher in this practice, recalls an early teacher, Heinrich Jacoby, asserting that "we are only a part of the mass of the earth." When she objected, "But I am an individual!" Jacoby replied, "To your father you are his daughter, to the postmaster you are his customer, to the earth you are a part of the mass of the earth."

This powerful reality that underlies meditation practice is also at the foundation of the visual arts, not only architecture and sculpture, but drawing and painting as

Vincent van Gogh, *Peasant Woman Digging,* black chalk on paper, 22 × 16 in., 1885 (Van Gogh Museum, Amsterdam [Vincent van Gogh Foundation])
Van Gogh's early figures seem to grow from the earth.

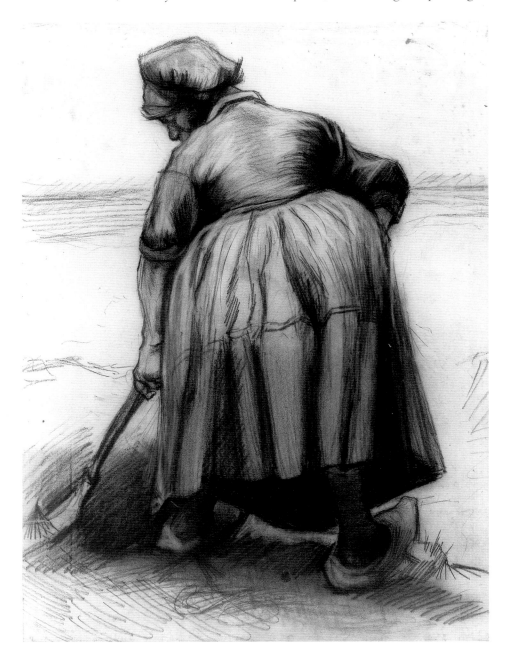

well. The force of gravity gives substance to our movement and touching and bridges these perceptions into painting.

Before we explore these possibilities, you can experience for yourself what influence it might have on both your state of being and on your drawing. The experiments with weight are simple, but they can be challenging. Although the pull of gravity influences everything we do, the actual experience of this force in our own bodies may not be so obvious. We are uncomfortably aware of gravity under the burden of too much weight. We can be thrilled when gravity is challenged as we ride on roller coasters or watch the dramatic leaps of ice-skating and gymnastics. The actual sensation of weight just in itself can be far more subtle, but just as dramatic in its effects.

EXPERIMENT: Experiencing Your Weight

Whether you are sitting or standing, close your eyes, and notice where you are touching the chair or the floor. Under the floor is the earth. Can you give your weight to being supported by the earth, not only where you are touching it, but in your back, shoulders, and even in your head? If you are holding yourself away from the floor, give this up and let yourself be supported. As you yield to the downward pull of the earth, follow it gradually until you are lying on the floor. Take your time, noticing all the steps in between. When the floor is fully supporting you, can you be awake to the downward pull throughout your body?

When you are ready, come up to standing again. Feel this new relationship to the earth, from your legs up through your back to your head. After a while, slowly shift your weight from one foot to the other, noticing the point where it becomes equally distributed and then moves to the other side. We shift our weight in this way many times a day, as we walk. Now we are giving this interaction with the earth our full attention.

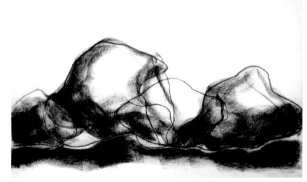

EXPERIMENT: Drawing with Your Weight

Prepare a piece of paper, with your media beside it. Continuing to stand, place your hands on the paper and gradually let your weight come on to it with eyes closed. Feel the difference between pressing and giving your weight freely, from your feet clear to your head. As you let more weight on, and then take it off, you can have a dialogue with the mass of the earth through the medium of the paper. Then find the crayon or charcoal, sensing its weight. As you meet the paper with your crayon, let your weight come through as directly as possible. Then play with the shift of weight with the crayon, letting it go wherever it wants to go.

Linda Fries, sensing weight, eyes closed, charcoal, 18 × 24 in. (top); sensing a stone, eyes closed, charcoal, 18 × 24 in. (center); influenced by weight, eyes open, charcoal, 18 × 24 in. (bottom) The sense of movement and touching in these drawings was influenced by the weight of the stone.

EXPERIMENT: Including a Stone

Prepare another piece of paper, with your media ready beside you. Find a medium-sized stone, set it beside your paper, and close your eyes again. When you feel ready, find the stone and lift it. As you hold it in your hand, notice any influence of the stone inside of you. After a while follow the pull of the stone down to the table, gradually letting the table carry its weight. When you feel ready, pick up the stone again.

Find a drawing medium that feels right for this new exploration, and touch it to the paper with your eyes closed. Let your drawing be influenced by your experience of the stone, trusting what happens. When the drawing has come to an end, open your eyes and take the time to see your stone. Draw again with your eyes open, letting your experience with closed eyes influence the way you touch and move on the paper. Your sense of weight can still be active, even with eyes open. If you lose this sense, pick up the stone again.

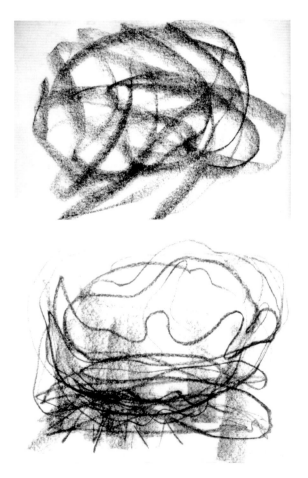

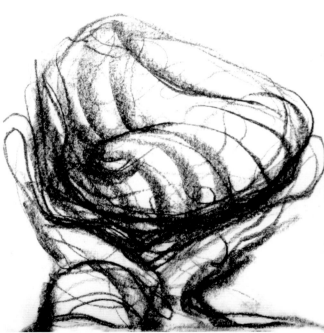

Liana Kornfield, weight on the paper, eyes closed, charcoal, 18 × 24 in. (top left); sensing a stone, eyes closed, charcoal, 18 × 24 in. (bottom left); influenced by the stone, eyes open, charcoal, 24 × 18 in. (above), (© Liana Kornfield)

From the first experience of weight on the paper to sensing the stone to adding the sense of seeing, the sense of weight seems to have a life of its own.

After the first two experiments with weight, a group of people were asked to close their eyes and were given a stone to hold in their hands. The drawings that followed not only show the influence of the stones but the many individual ways of responding to them, from Beverly's bold curves and sense of mass to Pat's chiseled lines to Lynne's full-bodied rocks and tree.

EXPERIMENT: After Sensing the Stone

After the experiment with the stone, look around your environment. Influenced by the sensation of weight, what are you attracted to? As you draw, use any of the media or ways of working that emerged as you drew the stone earlier, continuing to feel the sense of weight and volume. If you lose this sense, close your eyes and re-experience your mass, your weight on the earth, even picking up the stone again.

Beverly Davis, weight on the paper, eyes closed, charcoal, 18 × 24 in. (top left); sensing a stone, eyes closed, charcoal, 18 × 24 in. (top right); still life, charcoal, 18 × 24 in. (left) The curved forms in the weight drawing are distilled in the stone and repeated in the still life.

Pat Kriegler, sensing a stone, eyes closed, charcoal,
18 × 24 in. (top left); stone, eyes open, charcoal, 18 × 24 in.
(top right); large rock formation, influenced by the stone,
charcoal, 24 × 18 in. (right)

The powerful influence of weight is reflected in the stone
and the rock formation.

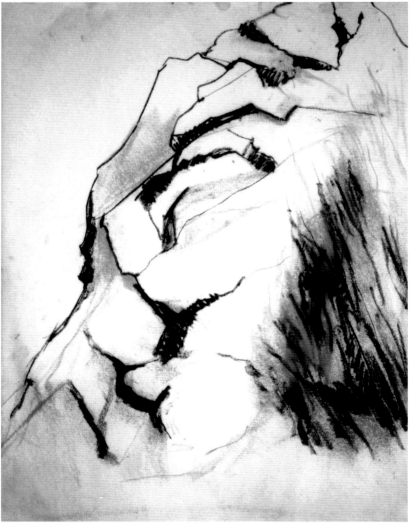

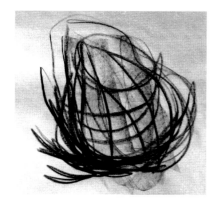

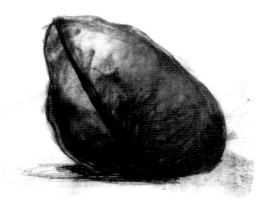

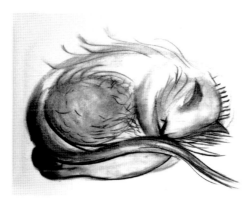

Lynn Hassan, sensing a stone, eyes closed, charcoal (top left); influenced by weight, eyes open, charcoal, 18 × 24 in. (top right); hills, influenced by the stone, charcoal, 18 × 24 in. (bottom left); sleeping cat, charcoal, 14 × 17 in. (bottom right)

The massive weight in Lynne's rock finds its match in the surrounding hills and becomes softened in the sleeping cat.

Lynn Hassan, *Spring Willow,* charcoal, 18 × 24 in.

three-dimensional modeling

As we can see from the previous experiments, the experience of weight can naturally increase your sense of three-dimensional modeling. We can intensify this sense by combining weight with the sense of touch, as we do in the following experiment.

EXPERIMENT: Drawing a Face

The combination of weight and the sense of touch can be especially useful in making a portrait. Begin by exploring your own face through touching, as in the "Drawing Yourself and Others" experiment on page 92, this time aware of the volume and mass. After drawing this exploration with your eyes closed, draw yourself in the mirror or someone sitting in front of you. Let your sense of weight and touching support your observations, whether you are drawing a portrait, the whole figure (as with Michelangelo) or hills and trees.

Linda Larsen, self-portrait from touching, eyes closed, Conté crayon, 18 × 24 in. (top); self-portrait, eyes open, Conté crayon, 18 × 24 in. (bottom)
This powerful self-portrait was created from the inside out, influenced by the closed-eyes exploration.

Jean Woodard, *Study of Tree,* charcoal pencil, 12 × 9 in., 2004
The sense of three-dimensional modeling has grown naturally from a meditative sense of touching and weight—each stroke building on the next.

Although this sense of three dimensions can happen naturally through this experiment, if you want to sustain this sense in longer drawings, the modeled drawing exercise of Nicolaides presented in *The Natural Way to Draw* can be helpful.

EXPERIMENT: Modeled Drawing Exercise

Begin by establishing a solid tone at the center of whatever you are drawing, as if you were building a clay sculpture. As you build up the figure or object, working with the side of a soft Conté crayon will help you let go of any outline or detail. When you have the proportions of the general mass, go back and forth over the surface as if you were touching the object, gradually pushing the tone darker as the form recedes, letting it become lighter as it comes forward. As you work, realize that you could make this drawing in the dark, just from the sense of touch and weight. This sense will sustain your connection with your subject.

BELOW LEFT: Michaelangelo, *Study for the Figure of Adam,* **red chalk, 7 ¹/₂ × 10 ¹/₈ in., 1510 (© The British Museum, London)** Every muscle is modeled in this masterful drawing.

BELOW RIGHT: Bobbie Allen (Art Fundamentals 133), drape study, Conté crayon on gray paper, 24 × 18 in. The drape study has been drawn like a contour map: the valleys darkest, the slopes gray, and the peaks light.

C. S. Siegel, *San Geronimo Valley Late Afternoon,* pastel, 13 × 30 in., 2001 In this landscape, modeling has been combined with light to create a sense of three dimensions.

The Nicolaides modeled drawing exercise on the previous page is powerful, but requires a concentrated focus. I was ready to present it to a group of people one afternoon in a summer workshop but hesitated when I saw their exhaustion from a day in the wind and sun. I suggested instead another kind of experiment, involving touching and weight, but less demanding, more open-ended.

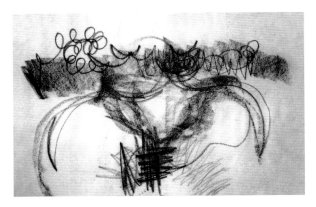

EXPERIMENT: Working in Partners

Find a partner, and then sit before a drawing pad with your partner standing behind you. When you put the crayon on the paper, your partner will put his or her hands on your shoulders. Close your eyes. When you both have the sense of resting on the earth, your partner will explore your shoulders and back. As you draw, let the influence of this touch guide you on the paper. After a time, let the drawing come to an end, trade places, and repeat the process. When this second exploration ends, step away from each other, and notice any echoes of this experience still happening inside you. Then open your eyes and notice what you are attracted to in your environment. What wakes up inside with this new influence? Draw what you are seeing, letting your sense of contact guide your drawing.

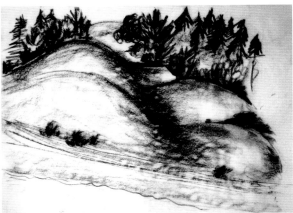

This exploration not only revived the energy of people in the group but spontaneously initiated a sense of the modeled drawing for many. The feeling of volume increased, and forms were modeled from touching. This power comes from a heightened sense of connection with what we see and draw.

Although this experiment can increase the sense of three-dimensional modeling, a very different effect can emerge as well: a rich abstraction of textures, shapes, and spaces, expressive in their own right. Although these forms may resemble visual reality, they have an expressive power and life of their own.

Leila Joslyn, eyes closed, influenced by partner's touch, charcoal, 18 × 24 in. (top); drawing of hills, eyes open, influenced by touch, charcoal, 18 × 24 in. (bottom)
The forms of the first drawing are clearly echoed in the hills drawn afterward.

Holly Hammond, eyes closed, influenced by partner's touch, charcoal (right); eyes open, the sensing forms led to trees, charcoal, 24 × 18 in. (far right)
Vertical strokes from touch and weight are echoed in the solid shapes of trees.

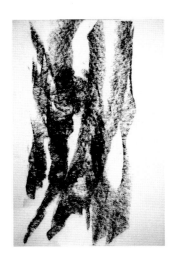
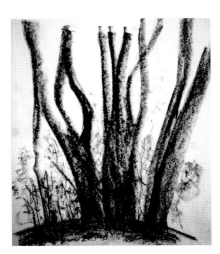

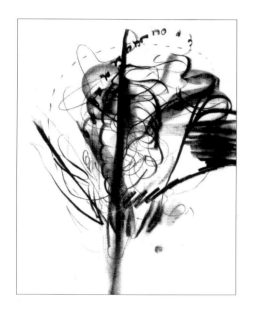

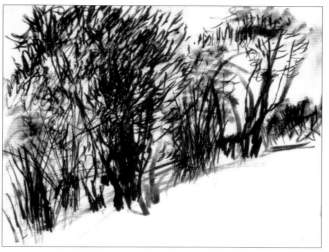

Beatrice Darwin, influenced by partner's touch, eyes closed, charcoal, 24 × 18 in. (far left); trees, influenced by touch, eyes open, charcoal, 18 × 24 in. (left) Beatrice's increased sense of contact initiated a spirited dialogue with trees, rich with texture and movement.

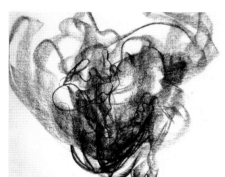

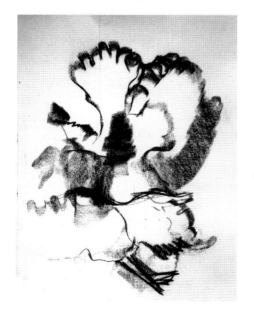

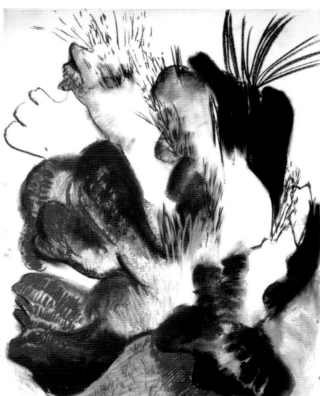

Lynn Hassan, eyes closed, influenced by partner's touch, charcoal, 18 × 24 in. (top far left); rock and lichen, eyes closed, from touching, charcoal, 24 × 18 in. (bottom far left); rock and lichen, eyes open, charcoal, 24 × 18 in. (left) The deep sense of touch and weight continued with eyes open, creating new forms with nature, moving toward abstraction.

moving into abstraction

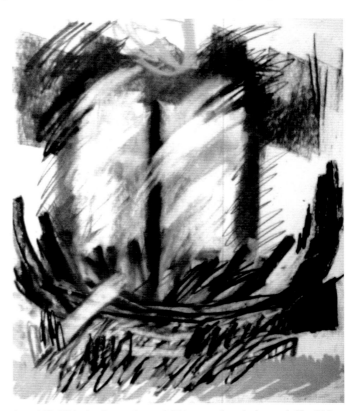

Although the sense of weight moves naturally into three-dimensional modeling, it can move in the opposite way as well—into the two-dimensional patterning associated with the Eastern tradition, indigenous art, and the abstraction of modern masters.

Sometimes the original tonal mass has a life of its own and creates its own shapes. We can see this clearly in Ayumi's drawings. Growing by stages and finally reaching its maximum density with the stone, the dark mass opened up in the center and spontaneously broke into light and dark shapes. These shapes are interacting with each other in a kind of dialogue with gravity, echoing the shapes and spaces of Hokusai's waterfall.

This dynamic balancing of shapes is the source of an expressive mode called *notan,* a Japanese word that describes the harmonic distribution and balancing of light and dark on a page. Unhindered by the need to create a likeness, the creative voice of weight emerges. Coming from the center of the earth, it brings us to the deepest source of composition and abstract form—the force of gravity.

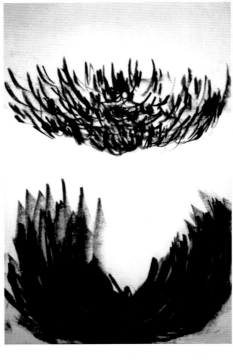

Ayumi Kie Weissbuch, sensing weight I, eyes closed, charcoal, 18 × 24 in. (top left}; sensing weight II, eyes closed, charcoal, 18 × 24 in. (center left); stone, eyes open, charcoal, 18 × 24 in. (bottom left); improvisation in light and dark, charcoal, 24 × 18 in. (above)

We can see the evolution of composition from the experience of weight to the first sensing drawings to the influence of the stone to the rich play of light and dark in the final drawing.

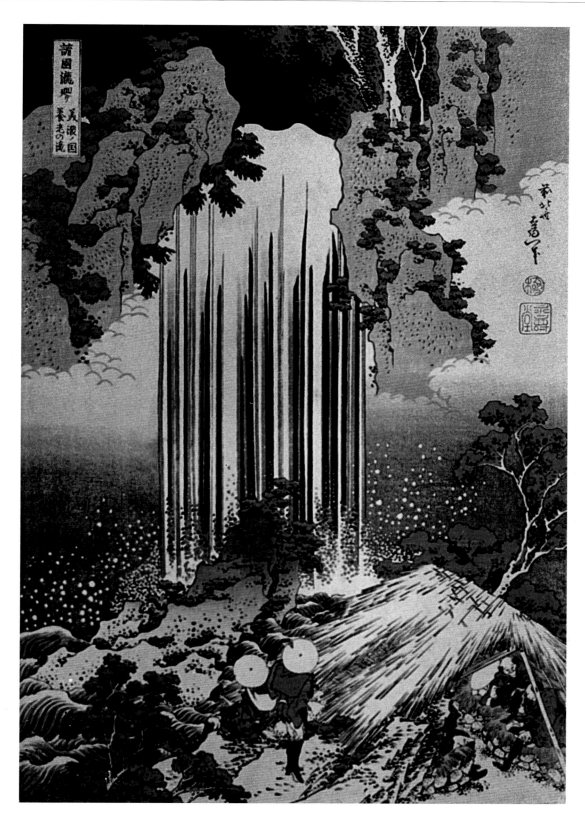

Hokusai, *Yoro Waterfall in Mino Province,* colored woodblock print, 14 × 10 1/4 in., 1934–1835 (Private collection) We see the same dynamic force of weight as we saw in Ayumi's drawings in the Hokusai waterfall, creating powerful shapes and spaces.

Pieter Bruegel, *The Return of the Hunters,* oil on panel, 46 × 63¾ in., 1565 (Kunsthistorisches Museum, Vienna) Figures, trees, and distant hills are simplified by clear shapes.

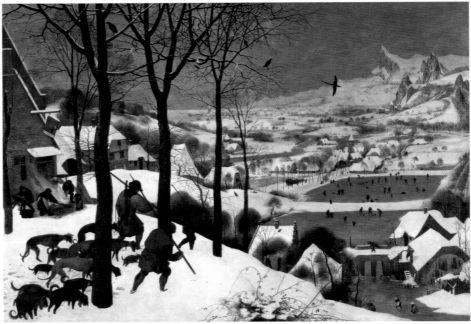

Lynn Hassan, notan study of hills, charcoal, 14 × 17 in.
White, gray, and black create a hillside.

Debby Boman-Lawrence, notan study, charcoal
Black, white, and gray create a balance.

Although light and dark composition underlies the details of master artists in the Western tradition of painting, abstract shapes and spaces are more clearly visible in the Eastern tradition. Japanese prints, especially, influenced Post-Impressionist painters such as Van Gogh and Gauguin, bringing a new level of abstraction into their work.

EXPERIMENT: Abstract Notan Study

To explore this direction, return to the first experiments with weight and do them again, experiencing your own weight on the paper and drawing with eyes closed. As you see the lines and tones that emerge from this drawing, convert them into flat patterns, filling the spaces with black, white, and gray. Freed from realism, these shapes will begin to interact with one another and can even generate new forms.

EXPERIMENT: Notan Landscape Study

After you have explored making abstract shapes in black, white, and gray, use these three tones to draw your environment. Instead of focusing on the three-dimensional aspect of the world, convert it into flat shapes. These shapes are the most enduring, primal means of expression, from cave painting to the modern masters. Abstract shapes are especially evident in the Eastern tradition of painting, but we can find these flat planes of dark and light unifying the Western masters as well. To go further into the powerful expression of notan, we will explore the regenerative aspect of weight and its evolution into what seems to be the opposite: the sense of rising and, finally, the perception of space.

As well as composition, weight can generate energy. As you experiment with weight, you may experience a remarkable phenomenon—when the pull toward earth is fully experienced, it can wake up the opposite force. The deeper the pull, the more forceful and exuberant is the urge to rise. Out of the dense earth, the dark womb, comes the regenerative impulse to life. There is no need to produce this effect or even expect it. It will happen by itself, as you give yourself permission to follow the influence of gravity wherever it leads.

The conscious alignment with gravity is at the heart of creativity and the process of healing as well. Always conscious of gravity in her teaching, Charlotte Selver maintained that it corrected the collapsing of her spine that occurred in her nineties. Still teaching a full schedule at 101, her continued stamina was a testimony to this claim.

Knowing down, we know up.
Knowing up, we freely stand.
Charles V. W. Brooks
Sensory Awareness

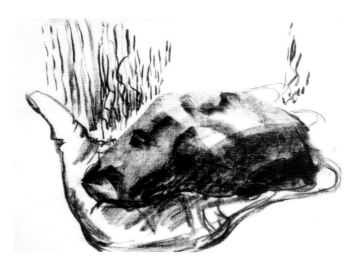

Lynda Jasper-Vogel, sensing a stone, eyes closed, charcoal, 17 × 14 in. (far left); influenced by the stone, eyes open, charcoal, 18 × 24 in. (left)

A deep sense of earth can generate a spontaneous upward rising.

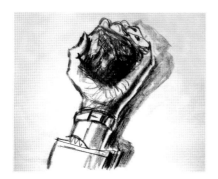

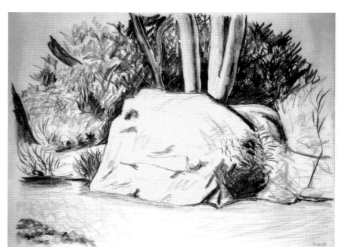

David M. Miller, stone, eyes closed, graphite, 15 × 17 in. (far left top); stone, eyes open, charcoal, 16 × 16 in. (far left bottom); large rock and tree, influenced by stone, charcoal, 15 × 17 in. (left)

The solid stone and the hand rising find their match in a large rock with trees rising from it.

Barbara Lawrence, sensing a stone, eyes closed, charcoal, 14 × 17 in. (right); trees, influenced by the stone, charcoal, 18 × 24 in. (far right)
The stone led Barbara to the vigorous growth of trees.

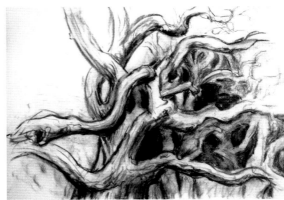

Adrienne Terrass, sensing a stone, eyes closed, charcoal, 24 × 18 in. (above); tree, influenced by the stone, charcoal, 24 × 18 in. (right)
Like a seed, the weight of the stone generates movements of growth. These movements are expressed later in a strongly rooted tree, rising upward. The sense of weight gives a strength and depth to the drawing.

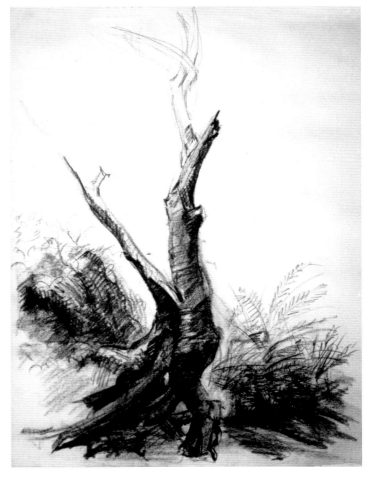

Life is in the soil. Touch it with air and light and it bursts forth like a struck match . . . even to the spirit's leaving there is life, boundless life, resistless and marvelous, fresh and clean. God.

Emily Carr

What we must yield to, when we are borne upward involuntarily against the pull of the earth, is the spontaneous generation of energy in our own organism.

Charles V. W. Brooks
Sensory Awareness

Emily Carr, *Edge of the Forest,* oil on paper, 34¹/₈ × 23 in., circa 1935 (McMichael Canadian Art Collection, Kleinburg, Ontario, gift of Doris and Dr. J. Murray Speirs, Pickering [1969.20])
An exuberant tree rises from the dense earth.

the shamanic journey with gravity

As the solid mass of weight gives way to space, it can bring the insights and transformative power associated with shamanic practice. The weight of a stone led Jan into the hollow of a large redwood tree and a long series of drawings in which the dense mass of the tree finally dissolved into floating pieces of hill and sky. This communion with the tree deeply affected her life and renewed her commitment to creative expression.

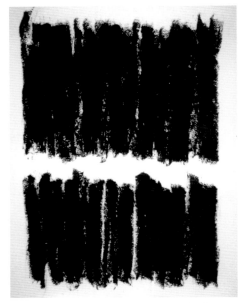

Jan Gross, *Under the Earth* (sensing weight), charcoal, 24 × 18 in.

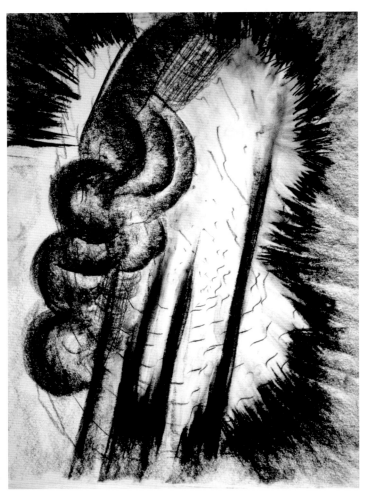

Jan Gross, *The Hum of Pith,* charcoal, 24 × 18 in.

Jan first drew the massive volume of the tree (left), its life force (above), its wholeness (opposite top left), its regeneration and transformation into space (opposite top right), and then the hills surrounding (opposite bottom).

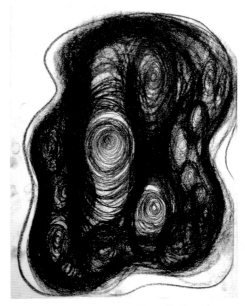

Jan Gross, *The Tree's Heart Rises, Redwood* series, charcoal, 24 × 18 in.

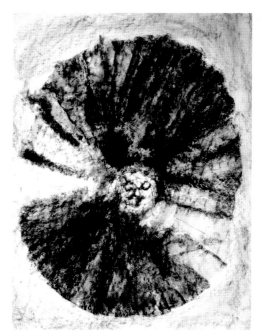

Jan Gross, *I'll Build You a Shield,* charcoal, 24 × 18 in.

Jan Gross, *Spiral Protection,* charcoal, 24 × 18 in.

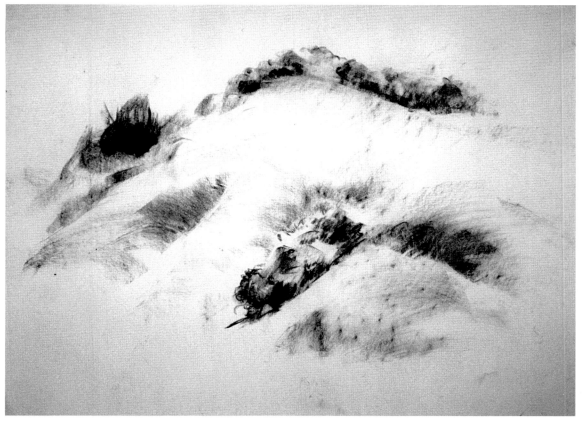

Jan Gross, *Becoming Light,* charcoal, 18 × 24 in.

After experiencing and drawing a stone, Ingrid was shaken by her experience of gravity and the archetypal form it created. The startling transformation of this massive form into the infinite space of her second drawing confirms the depth of her experience. The archetypal simplicity of Ingrid's first drawing echoes the brooding figure in Goya's *Witches' Sabbath.* Her second drawing matches the infinite space in Goya's *Giant,* which combines the archetypal form of weight with the openness of space. The massive figure poised on the edge of the world contains the power, the vulnerability, and the mystery of the human condition. Although the subject may be unsettling, the integration of light and dark forces in Goya's piece carries a strong message of unity. In balancing the elements of light and dark, space and weight, artists, like shamans, affirm the basic order of the natural world.

ABOVE: Ingrid Nudelman, sensing drawing influenced by weight of stone, charcoal, 18 × 24 in. (left); space after weight drawing, charcoal, 18 × 24 in. (right).
RIGHT: Francisco Goya, detail of *The Witches' Sabbath,* 55 1/8 × 172 1/2 in, 1819–1823 (Museo del Prado, Madrid, Spain. Photo Credit: Scala/Art Resource, New York.)

Ingrid's first drawing of weight (above left) echoes the shape of Goya's horned goat figure (right), a primal force growing from the depths of the earth. As with the bat-like monsters in his earlier print, this archetypal form epitomizes the force of darkness—a negative symbol evoking fear and revulsion. But when this symbol is experienced as the element of earth, it can be transformative—a life-affirming connection with gravity that can give us strength and renewal. A sense of infinite space (above right) followed Ingrid's powerful weight drawing.

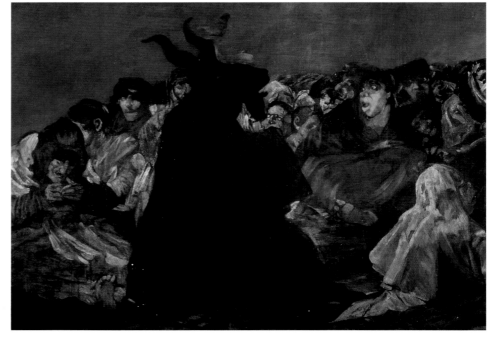

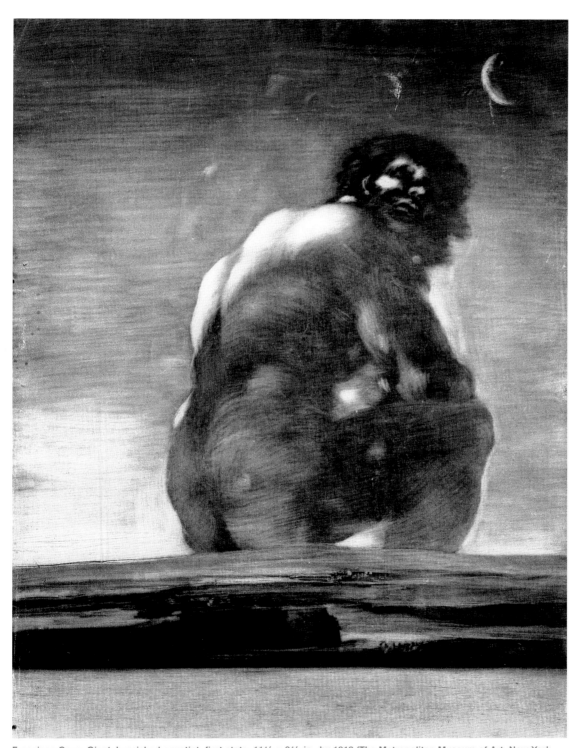

Francisco Goya, *Giant,* burnished aquatint, first state, 11 ¹/₄ × 8 ¹/₄ in., by 1818 (The Metropolitan Museum of Art, New York, Harris Brisbane Dick Fund, 1935 [35.42]. Image © The Metropolitan Museum of Art)

Although the subject of this mysterious print may be unsettling, the underlying composition of Goya's *Giant* integrates weight and space, a sense of unity and balance in this cosmic uncertainty.

the perception of space: invisible power

After the tangible experience of weight, the perception of space can seem elusive. And yet its influence on our state of being and our creative expression can be profound. For centuries Eastern artists have embodied the spiritual dimension of space—an expression of an all-embracing universe. The powerful expression of space in Cézanne's work opened a world of expression and freedom to contemporary artists. In this chapter we will explore the many dimensions of space, tapping into a deep source of inner balance and integration.

Paul Cézanne, *Large Pine, Study,* graphite and watercolor, 12 × 18 1/8 in., 1890–1895 (The Metropolitan Museum of Art, New York, bequest of Theodore Rousseau, 1973; jointly owned with the Fogg Museum, Harvard University, Cambridge, MA [1974.289.1]. Image © The Metropolitan Museum of Art)

exploring space

Before working with the perception of space, I often ask people to write down their first response to the word itself. Although the responses vary widely, many are related to how *Webster's Dictionary* defines space: "a boundless three-dimensional extent in which objects and events occur and have relative position and direction." The boundless aspect of space reminds me of a late afternoon when I was leaving the beach, just as the sun was casting its last golden glow on ocean, dunes, and sky. A small boy just arriving, on seeing this shining expanse, ran down the beach, arms waving in delight, exclaiming, "So much of it!"

Lynnelle, *Self-portrait,* charcoal, 24 × 18 in., 1984
Lynnelle's sense of intimate space comes from the sense of touching.

EXPERIMENT: Exploring Personal Space

There are many other definitions of space. Reflect on your own and write down anything that comes to you. Then take some time to see the space around you, feeling its extent. Notice your relationship to the objects or people in the space and how this changes as you move closer to them, one step at a time. As you move closer to other people, you may feel the unmistakable limits of your personal space and the discomfort when these limits are pushed by even a few inches. After this close encounter, notice your inner response as you back away, one step at a time, creating distance between yourself and the others.

Preferences for near or far can become clear in this experiment. Those more at home with touching and weight are generally more comfortable at close range, and those more at home with movement and space may prefer a greater distance. These spatial shifts and their different feeling qualities have been studied by the anthropologist Edward Hall in his book *The Hidden Dimension* (Anchor, 1990). Hall's distinctions describe a language of space that is parallel to our sensory modalities. They are intimate (touching), personal (mass/weight), social (movement/seeing the whole), and public (movement/space).

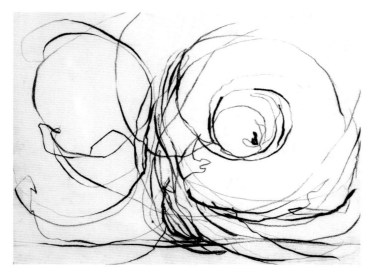

Lynnelle, drawing of inner space, eyes closed, charcoal, 18 × 24 in.
Distinctive forms emerge from a sense of inner space.

EXPERIMENT: Exploring Inner Space

Even before relating to others, you can explore your own inner space. Close your eyes and notice any sensation of space inside. From where you touch the floor to the top of your head, what do you experience of your inner space? Is there a sensation of space in your back, in your shoulder blades or pelvis? Notice the space inside your head, between your ears, behind your eyes, and inside your mouth.

Without interrupting these sensations, bring your hands to the space of the paper and explore both the surface and the edges with your eyes closed. When you are ready, find your medium and draw on the paper, still with eyes closed. When the drawing feels complete, notice your inner response as you see it.

Wang Hui, *Clearing after Rain over Streams and Mountains,* hanging scroll, ink on paper, 44⁷/₈ × 17⁷/₈ in., 1662 (The Metropolitan Museum of Art, New York, bequest of John M. Crawford Jr., 1988 [1989.363.141]. Image © The Metropolitan Museum of Art)

From the mysteries of faraway space, to the intimate space of touching, the language of space influences our work and our state of being.

Horizontal, vertical, and tilted paper formats. Each format has its own quality, and can influence your state of being.

EXPERIMENT: Seeing the Space of the Paper

Exploring the space of the paper with eyes open can bring a whole new range of expression. Take the time now to see the empty space of the paper, lining up with it as a swimmer might before diving into a pool. We can be affected by this empty space even before we put down a line. This influence becomes clear if you change the position of the paper to its opposite; if your paper was horizontal, what happens in your sense of inner space if it becomes vertical? What happens if a vertical becomes horizontal? Then try the paper in a diagonal position, noticing the effect of these changes in your whole body.

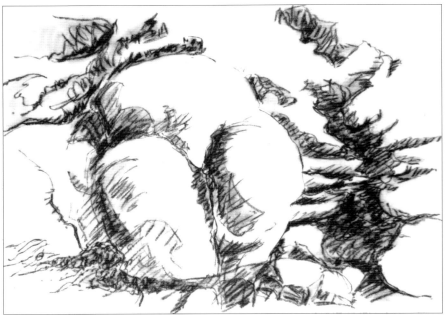

Lynnelle, lines in horizontal space, eyes open, charcoal, 9 × 18 in. (top left); lines in vertical space, eyes open, charcoal, 18 × 9 in. (bottom left); *Rock Goddess,* charcoal, 22 × 30 in., 1987 (above)
Lynnelle's forms of inner space are strengthened by exploring the space of the paper and emerge in the drawing of the rock goddess.

C. S. Siegel, space of the paper (far left); drawing in the space I, oil pastel, 18 × 24 in. (center); drawing in the space II, oil pastel, 18 × 24 in. (left) Influenced by the format, a sense of order appears and can carry over into representation.

EXPERIMENT: Drawing in the Space

After you choose its position, see the whole space of the paper again. Take the time to feel the effect of each of the four edges in your own body: top, bottom, right side, and left side. This empty space enclosed by four lines has a presence, just in itself. It may not need anything, but as you experience the space, you may feel it wants something. If you have an impulse, put down a line or mark anywhere in the space. Notice how this mark affects the original space. Follow it up with another line or mark, trusting your instinct. As you work, remember to back away from the drawing and reconnect again with the whole space every time you make a mark. You can stop anytime—doing nothing can be a choice in its own right. Or your sense of curiosity or even discomfort may impel you to continue working. When you feel complete, look at your drawing from a distance, noticing any influence on your state of being.

After finding ourselves in the space of the paper, discovering our distinctive forms in the visual world can be like coming home. These spatial relationships are the foundation of composition, providing unity and a universal meaning beyond time and place.

When what you do just comes out of nothingness, you have quite a new feeling.
Suzuki Roshi
Zen Mind, Beginner's Mind

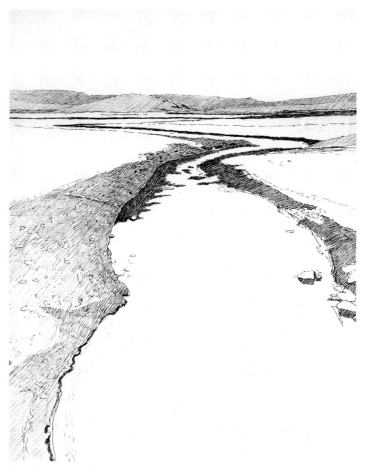

C. S. Siegel, *Nicasio Reservoir,* pen and ink, 14 × 11 in.
Finding our distinctive forms in the world can be like coming home. Whether it is a reservoir, tide flats, or a river flowing down a canyon, I am impelled to draw when I see the archetypal form of an arch. This reservoir drawing was an inspiration for larger works.

As you meditate on the space of the paper, it can become a metaphor for the space of your own body. The horizontal and vertical edges echo the lines of gravity and guide your choices, in the same way that we find balance when standing or walking. We call this space and its boundaries the picture plane. Each mark we make in the space of the paper is balancing two basic polarities—the irrepressible, spontaneous life force and the implacable force of gravity. As we integrate these two forces in the picture plane, we reaffirm the basic order of the universe. This instinct for order and balance goes beyond individual expression. We see the universal power of the balancing impulse when a group makes lines in the same space, each taking turns.

Group drawing in three stages, oil pastel, 24 × 18 in.
Like tightrope walkers responding to gravity, six people balance the space of the paper, each taking turns.

 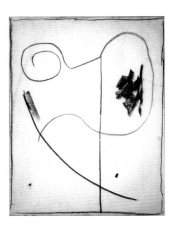

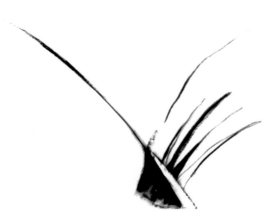

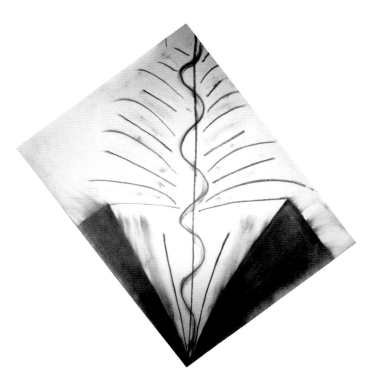

Lynn Hassan, space of the paper, charcoal, 18 × 24 in. (above); Stella Aysha Washburn, space of the paper, charcoal, 24 × 18 in. (right)
The stability of the horizontal format inspires the active diagonals in Lynn's drawing, in contrast to the unstable format of Stella's drawing, which calls for a stabilizing vertical line.

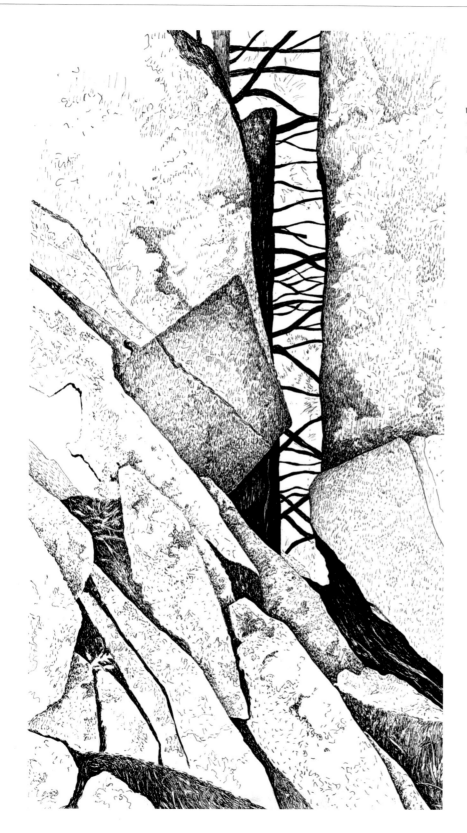

Mbuti bark cloth, Democratic Republic of the Congo, pounded bark and plant dyes, 15 × 23 in., twentieth century (Courtesy Andres Moraga Textile Art)
A patterned language reflects forms of the African forest, unique to each tribe and yet universal.

The bearer of the universal forces of the cosmos meets its counterpart— the centric forces of the earth.
Theodor Schwenk
Sensitive Chaos

C. S. Siegel, *Rock Crevice, Colorado*, pen and ink, 1970.
Vertical lines balance the steep diagonal rock formations in a sandstone canyon. The triangular shapes echo the patterns in the tribal bark cloth.

relating to the world through space

When we are fully aware of the space of the paper, our sense of balance is impeccable. Yet we can lose this unerring sense when distracted by the challenges of realism. As we struggle to depict a hill or a tree, the need for unity in the space of the paper can be forgotten. Whether these images come from imagination or from direct observation, the need for exactitude in proportion and detail can totally engage our attention, leaving our primal instinct for balance out of the process. Maintaining a sense of order often requires conscious intention.

When the people of ancient times composed a large picture, they used three or four great divisions; thus they achieved a design of the whole although it contained many small details.

Chinese master Tung Ch'i-ch'ang

EXPERIMENT: Drawing Your Environment

After your first drawing in the space of the paper, prepare another piece. When you have become aware of the empty space of the second paper, look around your environment. Let yourself be drawn to lines or forms that want to be in the space of the paper. Notice the impact of the first line and wait until another wants to follow. As you draw, remember you are only filling the space of the paper, being influenced by the richness of the world but not duplicating it.

At the beginning it can be helpful to determine your composition with three main lines. If the first three lines don't feel right on the page, it is best to start again. The Chinese master Tung Ch'i-ch'ang advises artists: "After the outline of the mountain has been decided upon, only then put in the wrinkles." As in all the experiments, try this out for yourself.

EXPERIMENT: The Power of Boundaries

To become more aware of the format, begin making boundaries for different kinds of proportions—long horizontal ones, tall thin ones, a square, even a circle or triangle. Each different format influences how we see the same subject, or even leads to different subjects. The format can be a formidable ally if we satisfy its requirements for unity. It gives boundaries to our experience and reminds us of our power of choice.

David M. Miller, four different formats from the same location Each format influences how we see and leads us to different views.

Ma Yuan (Chinese, active 1190–1225), *Viewing Plum Blossoms by Moonlight,* ink and color on silk, 9⁷/₈ × 10¹/₂ in. (The Metropolitan Museum of Art, New York, gift of John M. Crawford, Jr., in honor of Alfreda Murck, 1986 [1986.493.2]. Image © The Metropolitan Museum of Art)

A powerful sense of touching and weight is combined with space in this drawing.

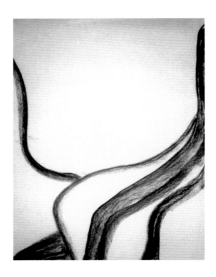
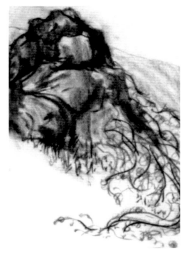

Lukia Pertz, space of the paper, charcoal, 24 × 18 in. (left); rock and bush I, charcoal, 24 × 18 in. (center); rock and bush II, charcoal, 24 × 15 in. (right)
In this series, the space in the first drawing was lost in the second, weighty drawing. Space and weight are balanced in the last drawing.

EXPERIMENT: Adding the Notan Tones of Black, White, and Gray
Review the experiment with notan that we explored through weight, converting what you see into tones of black, white, and one gray. This process makes our choices visible, reminding us that we are balancing light and dark, not creating a likeness. Our sense of balance attains a commanding presence, not to be ignored.

Holly Hammond, space of the paper, charcoal (right); bridge, influenced by space, pastel on toned paper (far right)
Holly's original lines led her to a curving bridge. The shapes in the drawing become powerful with light and dark contrast.

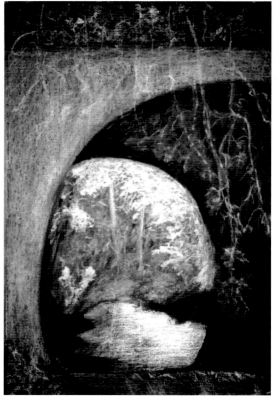

Attention to the space of the paper can keep us connected to ourselves as we draw in the world. And the space we see in the world can lead to an inner sense of unity as well. Even when drawing from a very specific place, such as Papermill Creek, the sense of space can lead to universal principles of abstraction, the source of personal style.

EXPERIMENT: Seeing Space

After you have prepared your paper, stand or sit comfortably. Close your eyes and become aware of inner space. Can you sense the space in your head where your eyes are? Let them rest in this space. Then open your eyes and simply see the space around you. Can you feel this space anywhere in your own body? For at least five or ten minutes, simply be present to the space you are seeing, without the need to accomplish anything. Then choose a medium and draw, trusting any impulse, allowing any development. There is no need to replicate the space you have seen. Just let it influence how you feel inside and how you touch the page.

If one is able to realize how the ancients applied their minds to the absence of brush and ink, one is not far from realizing the divine quality in painting.

Ch'ing master

J. M. White, *Papermill Creek,* seeing space, charcoal and ink wash
Inner space is reflected in the world.

Darrol Shillingburg, *Papermill Creek,* space in the willows
Finding the unifying power of the hidden spaces.

When seeing is fully experienced as a sensation, it can lead us back to a "pure" way of seeing. Objects can lose their distinct identity and can be perceived in terms of shapes and colors. Although this way of seeing can be disorienting in everyday life, the pure sensation of seeing is an essential creative basis in drawing and painting. Finding our original vision can be an important aspect of meditation and shamanic practice, as well.

EXPERIMENT: The Power of Space

In his book *Journey to Ixtlan* (Simon and Schuster, 1972) Carlos Castaneda describes a lesson given by his teacher, Don Juan. You can try this as well, experiencing and then drawing from his instruction.

> *[Don Juan] pointed to a large bush and told me to fix my attention not on the leaves but on the shadows of the leaves. He repeated over and over . . . that to not do what I knew how to do was the key to power. In the case of looking at a tree what I knew how to do was to focus immediately on the foliage. The shadows of the leaves or the spaces in between were never my concern. . . .*

Susan Sasso, space of the paper, later modeled, graphite, 18 × 24 in. (above); *Papermill Creek,* seeing space, graphite, 18 × 24 in. (right)
The forms in Susan's space drawing carry over to her rocks and trees. Notice the difference between Susan's circular forms and the chiseled weight of Virginia's drawing (opposite top) or the tactile clarity of Danielle's (opposite bottom), all drawn from the same view — looking across Papermill Creek.

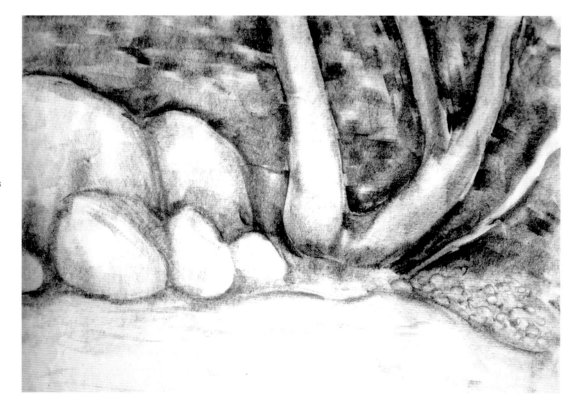

I became so immersed in the shadows of the leaves that by the time Don Juan stood up I could almost group the dark masses of shadows as effectively as I normally grouped the foliage. The total effect was startling. I told Don Juan that I would like to stay longer. He laughed. "I told you," he said, "the body likes things like this."

If the empty spaces are right, the whole body is alive, and the more such places there are, the less boring the whole thing becomes.

Ch'ing master

EXPERIMENT: Negative Space Exercise

You may feel a similar sense of wholeness and well-being as you perceive a part of the world that is habitually ignored. This sense can be initiated by the drawing process itself. After you take the time to see the spaces in between objects, draw these spaces with a clear outline, as if they were solid. Start the first line on the edge of the paper so that the space you are drawing is connected to the format, not floating in the middle. By giving a clear definition to the space from the beginning, this exercise directly challenges the dualistic way of seeing the object as more important than the background.

Try out all these experiments, finding which feels best to you. Whichever way you enter, this exploration can lead to a new expressive freedom and an expansion of your individual style.

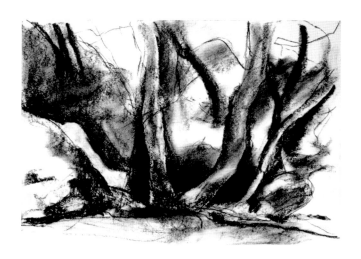

ABOVE: Virginia Fauvre, *Papermill Creek,* seeing space, charcoal, 18 × 24 in.

LEFT: Danielle Shelley, *Papermill Creek,* drawing negative space, charcoal, 18 × 24 in.

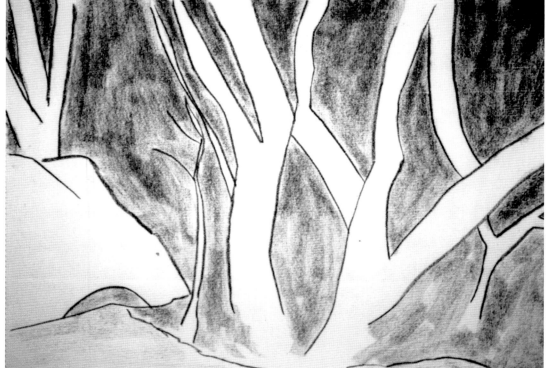

innovations in space:
the modern masters

Paul Cézanne, *Large Pine, Study,* graphite and watercolor,
12 × 18 1/8 in., 1890–1895 (The Metropolitan Museum of Art, New
York, bequest of Theodore Rousseau, 1973; jointly owned with
the Fogg Museum, Harvard University [1974.289.1]. Image © The
Metropolitan Museum of Art)

Our explorations in space can parallel the development of such
modern masters as Cézanne, whose real "genius" was a trust in
the invisible power of space.

EXPERIMENT: Seeing Cézanne's *Mont Sainte-Victoire*
Contemplate this reproduction of Cézanne's *Mont Sainte-Victoire*
below. As you take the time to see it (seven or ten minutes), allow
the forms and colors to be felt inside of you, as if you were hearing.
Close your eyes, noticing your responses. Then draw, at first with
your eyes closed, and then with eyes open, allowing any influence
to emerge. After drawing, look around the room, or go outside, and
notice any changes in your seeing. If you draw what you see, let
this be another experiment that might lead you into new, or unex-
pected, forms. The small Cézanne painting of bathers that Matisse
purchased continually inspired his explorations in form and color.

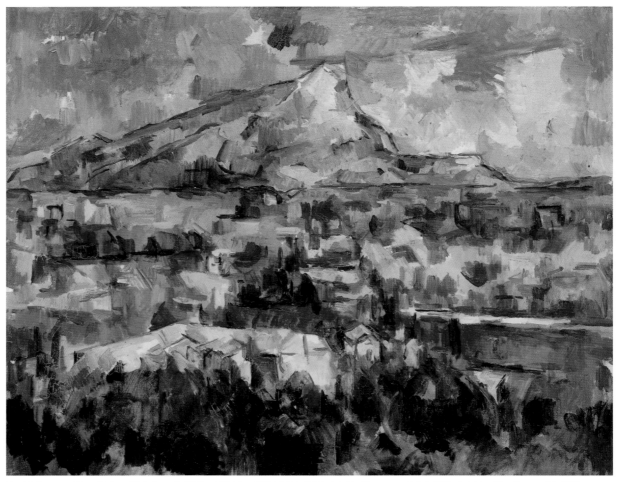

Paul Cézanne, *Mont Sainte-Victoire,* oil, 27 1/2 × 35 1/4 in., 1902–1904. (Philadelphia Museum of Art, Philadelphia, The George W. Elkins
Collection, 1936)

Cézanne's experience of space in nature created a new visual language—his paintings not only depict distant space but create it. Freed from conventional realism, the vitality of his forms inspired a generation of artists, from the cubist experiments and collages of Braque and Picasso, to the audacious color explorations of Matisse. Matisse's sense of composition was further expanded as he worked on his larger commissions. Try working larger yourself, using a roll of butcher paper or canvas. Try working with collage as well—a tangible way to explore the interaction of positive and negative space.

Composition, the aim of which is expression, alters itself according to the surface to be covered.
Henri Matisse

Henri Matisse, *La Danse, Paris Version of the Barnes Mural,* approx. 500 in. wide, 1931–1932 (Photothèque des Musées de la Ville de Paris, © Succession H. Matisse, Paris/ARS, New York) (above); Matisse drawing a dance panel, photograph, 1931 (Photo credit: Archives, Matisse, Paris. Musée d'Art Moderne de la Ville de Paris) (left)
Conscious of the influence of each space, Matisse did not plan his compositions or work from small studies. He drew his lines directly, whatever the size or format.

Expression, to my way of thinking, does not consist of the passion mirrored upon a human face or betrayed by a violent gesture. The whole arrangement of my picture is expressive. The place occupied by figures or objects, the empty spaces around them, the proportions— everything plays a part.
Henri Matisse

Hokusai, *The Amida Waterfall on the Kiso Road,* 38³/₄ × 26 in., 1834–1835 (Private collection)
Hokusai's audacious composition combines touching, weight, and space.

Although the Post-Impressionist painter Cézanne inspired the abstract innovations of many other modern masters, such as Matisse, he was always connected to his immediate sensations as he painted on location. But even as he painted in the mountains and forests, Cézanne was aware of carrying forward a lineage of space. This lineage is exemplified by Nicolas Poussin, the eighteenth-century master who aspired to the classical balance of forces found in the Greek Parthenon (see Poussin's *Holy Family of the Stairs* on page 14). Cézanne spoke of "wanting to do Poussin over from nature" to continue the ideals of structure and harmony outside. The Italian painter Giorgio Morandi carries forward these ideals in a different way, through the intimacy of his drawings and prints, in which tradition has given way to an intimate interaction with space itself.

Artists in the Eastern traditions have been conscious of the inner, spiritual dimension of space. The landscapes of Chinese artists became metaphors for an all-embracing universe. The daring compositions of the Japanese painters and printmakers came from this spiritual understanding and, in turn, they influenced a generation of Post-Impressionists. The American educator Arthur Dow introduced the Japanese principles of space and notan into public education, thus influencing the developing painter Georgia O'Keeffe.

Through the careful balance of shapes and spaces in their compositions, artists and craftspeople of all traditions have affirmed the natural order of the universe. To be reminded of this cosmic order, one need make only a small shift of consciousness into "not doing." Like Alice stepping through the looking glass, you can find this cosmic world, waiting to be explored, in the hidden dimension of empty space.

Rembrandt van Rijn, *Winter Landscape,* brown ink and brown wash on cream antique laid paper, 2⁵/₈ × 6⁵/₁₆ in., circa 1648–1650 (Fogg Museum, Cambridge, MA, bequest of Charles A. Loeser [1932.368]. Photo: Imaging Department © President and Fellows of Harvard College)
Rembrandt's few strokes create depth and infinite space, echoing the simplicity of the Eastern tradition.

Georgia O'Keeffe, *Road Past the View*, oil, 24 1/2 × 30 1/8 in., 1964 (Private collection. Courtesy of the Eiteljorg Museum of American Indians and Western Art, Indianapolis/ARS)

The intimacy of touching leads us into boundless space.

This man [Dow] had one dominating idea—to fill space in a beautiful way.

Georgia O'Keeffe

EXPERIMENT: Seeing Morandi's *Still Life*

To experience this interaction with space, take the time to contemplate this small still-life drawing. Before seeing the drawing, close your eyes and experience any sense you might have of inner space. When you are ready to see the drawing, allow it to touch you, as a sound might, noticing the delicate movement between figure and ground and the shift you might experience inside or in your seeing after. Then try drawing, eyes open or closed, noticing any influence.

Giorgio Morandi, *Still Life,* etching, 16 1/2 × 24 in., 1927 (Morat Institute for Art and Art History, Freiburg, Germany)
Morandi brings the space in the still life into the world (right).

Giorgio Morandi, *House in Grizzana,* etching, 10 1/4 × 8 in., 1927 (Morat Institute for Art and Art History, Freiburg, Germany)

the healing power of space

The evocation of space has long been the basis of healing and spiritual integration, from the ancient tradition of Navajo sand painting to the refinements of eighteenth-century Japanese prints. Like the sand painting, which includes all the elements in a patient's body, the long Japanese wood block print we see here creates a sacred space—a metaphoric space in which all the senses are integrated.

EXPERIMENT: Looking at a Japanese Print

Before reading the caption on the Japanese print, take the time to see it. After closing and resting your eyes, let them come to the picture, simply seeing it for ten minutes. Notice any response, any sensation that wakes up. After seeing, close your eyes and notice any influence inside. Then take the time to write any words that come—inner sensations, free-form poetry, or any narrative.

This print, along with others from the Ukiyo-e "floating world" tradition, was intended to invite the viewer to experience life more fully, and to convey a sense of inner peace. The integration of all the senses with seeing creates a sense of unity that allows the viewer to enter the work and to feel it more deeply. It is this depth of feeling distinguishes all master works, no matter what the tradition.

ABOVE: Charles W. Herbert, Navajo sand painting, detail of photograph (From *The World of the American Indian,* National Geographic Society, 1974)
This Navajo sand painting creates a space in which all the elements in a patient's body and surrounding environment can be reordered.

RIGHT: Unidentified Edo artist, *Jo and Uba Pray to the Rising Sun on New Year's Day,* color woodcut print, 7 1/2 × 20 in., circa 1790–1800 (Fine Arts Museums of San Francisco [1964.141.966]. From *The Male Journey in Japanese Prints* by Roger Keyes, University of California Press, Berkeley, 1989)
All the senses working together create a unified whole in this Japanese print. The faraway space on the left is balanced by the solid weight of the tree trunk on the lower right. The tactile detail of the overhanging tree is met by the gentle movement of the water. These elemental sensations echo the contemplation of the old couple, Jo and Uba, symbols of married happiness.

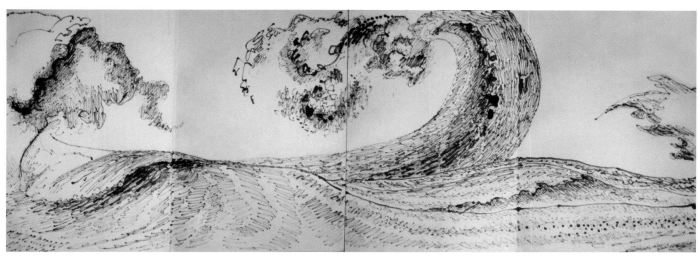

Arthur S. Holman, *Wave,* **pen and ink in folded book, 8 × 24 in., 2004 (Private collection)**

In the Japanese print, all the elements are brought into balance by the space. In this pen-and-ink drawing, Holman allows the untamed force of water to find its own spatial unity, each movement spontaneously leading to others, unpredictable and vital.

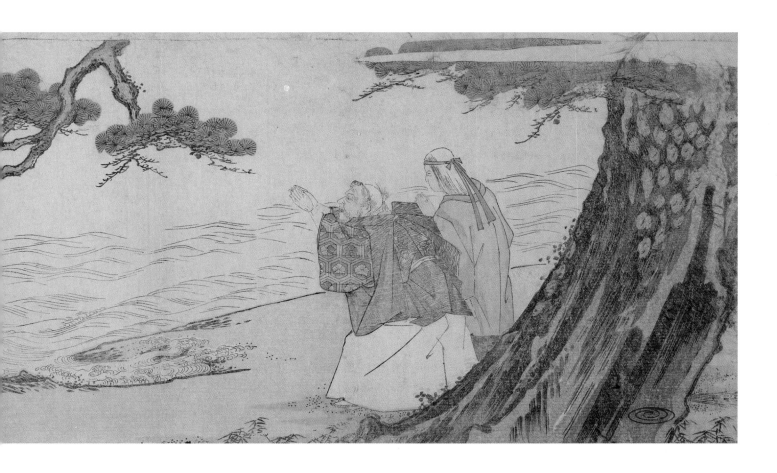

the magic of seeing

Because the perception of seeing can seem to dominate drawing, we have often worked with closed eyes to discover the expressive power of our nonvisual sensations—from the urgent flow of movement to the intimacy and surprise of touching to the enduring presence of weight. But seeing, just in itself, brings important gifts as well—rich nuances of detail and light, reflecting the world and human emotion. With the perception of light comes perhaps the greatest gift: the immensity and richness of the world of color.

Jean Woodard, *Branches and Marsh*, graphite, 5¹/₂ × 7 in.

seeing as meditation

Jean Woodard, *Bird Studies*, pen and ink,
10 × 8 in., 2003
Jean has drawn the bird with devoted
attention, guided by a delicate sense of
touch.

Although spatial composition has its origins in the nonvisual sensations of weight and balance, the full expressive potential of space comes with our eyes open. In this way our exploration of space has brought us back to the magic of seeing. But when we open our eyes, the critic awakes, bringing with it expectations of accuracy and the tendency to judge. When seeing is in partnership with thinking it can overwhelm the other sensations, leaving us out of touch with our body. We reclaim our full sense of being alive only by inviting the sense of seeing into an equal partnership with movement, touching, weight, and space.

In turn, when seeing becomes pure sensation, it can wake us up in unexpected ways. We have explored meditative seeing earlier in the book as a means of coming closer to the original spirit of our drawings. Seeing can bring us closer to ourselves and each other as well. I was struck by this powerful connection in a psychic healing workshop led by the psychologist Lawrence LeShan, who chose seeing as a way to enter the healing process.

The first seeing meditation he offered was designed to bring our sense of seeing into harmony with our whole body, closer to the simplicity of our life functions. Our eyes are used to doing many things at once as they navigate in our fast-moving world of constantly changing images. But our heart, lungs, and stomach do only one thing at a time. To lead our vision back to this simplicity Lawrence gave us each a small cardboard match to look at, explaining that this ordinary, even boring, object could allow us to focus on seeing, just in itself.

EXPERIMENT: Seeing a Simple Object

Begin by closing your eyes and allow them to rest in the space of your head. When you feel ready, look at a match or other simple object for five or ten minutes, letting your whole attention be on the object. If you find your attention wandering, let it go for a while, and then invite it back. Over and over, gently invite yourself back to seeing the object. If your eyes feel tired, allow them to rest, opening them again when you feel ready.

EXPERIMENT: Looking at da Vinci's *An Oak Sprig and Dyer's Greenweed*

After the experiment with seeing a simple object, take the time to contemplate Leonardo's study of oak leaves and acorns. It demonstrates his legendary passion for observation and his genius for discovering the essential forms of nature. Do you notice any of the perceptual qualities we have explored? I first noticed the sense of touch and sculptural modeling on the leaves and acorns but then discovered the modeling was even stronger in the spaces around the subject. Leonardo has created a whole world in this small drawing, unified and vitalized by the presence of the space. Using the full range of all the perceptions we have explored, he has not only recorded details previously missed by others but has expressed the inner movement and the sense of life and growth within the plant. Notice your own observations as you see the drawing and, if you are curious, draw with eyes closed or open, allowing any influence.

Leonardo da Vinci, detail from *An Oak Sprig and Dyer's Greenweed,* red chalk on pink surface, touched with white, 7 1/2 × 6 in., circa 1505–1506 (The Royal Collection © 2007 Her Majesty Queen Elizabeth II. Photo: A.C. Cooper) This drawing of a passionately observed oak sprig contains a whole world, using touching, weight, and space to convey a sense of inner movement and vitality.

seeing and drawing the world

In the next experiment, we move from focusing on a single object to seeing objects in relationship with each other and the space around.

C. S. Siegel, *Gregory Canyon*, pen and ink, 23 × 13 in.
Drawing in deep communion with nature.

EXPERIMENT: Seeing and Drawing Your Environment

After the first seeing meditation, find something in your environment—a group of objects, a corner of a room, or something in nature—and see it in a meditative way for five, ten, even twenty minutes. Let the subject you are seeing come into you as much as the air you breathe. Then draw under the influence of what you are seeing, allowing any development. There is no need to produce a likeness unless it comes by itself. When you see the drawing after, remember this is an experiment in seeing, and not a test.

Even though expectations and comparisons can come up with seeing, our sense of sight can bring surprising discoveries. As we come back to seeing in its pure state, the infinite beauty of textures, edges, shapes, and spaces can be perceived as if for the first time. Influenced by what we see, our experimental drawings can be as rich and unpredictable as our work in touching, weight, and space.

As we give up preconceptions and really see, we become deeply bonded with our subject. Just as we use seeing to heal each other, we can become whole through our dedicated attention to our subject. Seeing the natural world in the process of drawing has long been a regenerating practice for me. As I draw in one place for hours, or even days, in a deep communion with nature, each detail can bring me closer to the subject and my own inner nature.

> *Seeing and drawing can become one, can become seeing / drawing. . . .*
> *No longer do I "look" at a leaf, but enter into direct contact with*
> *its life process, with Life itself, with what I, too, really am.*
>
> Frederick Frank
> *The Zen of Seeing*

C. S. Siegel, *Forest Reflections,* pastel, 13 × 31 in., 2003
These reflections were painted by a quiet stream, observing the nuances of light and flickering leaves. Notice the strong value composition underlying these subtle nuances and unifying the many details. By contrast, the value composition of the drawing of Gregory Canyon evolved one stroke at a time through the layering of tactile detail.

seeing as loving

Before working extensively outside, I drew with my university friends, evolving a close-knit community as we drew each other. I was reminded of these drawing sessions when the first ten-minute meditation offered in the healing workshop of Lawrence LeShan moved to a time of seeing each other. We all saw the person to be healed (a member of the group) for thirty minutes. After this meditation, we were invited to move into a state of oneness, a healing unity with this person. The meditative seeing heightened all of our senses, bringing a renewed connection and deep appreciation for each person. Before the workshop there had been some tension in the group, but in the process of really seeing each other we forgot our differences and were reminded of our common humanity.

To really see anything is to love it—from ordinary objects to our natural surroundings to the people we encounter. I was especially reminded of this transformative potential when a colleague of mine, Jackie Kirk, began painting a series of portraits of people with AIDS. Her painting sessions became transformative experiences for both her and her subjects.

Jackie Kirk, leaf drawing, pencil, 14 × 10 in.

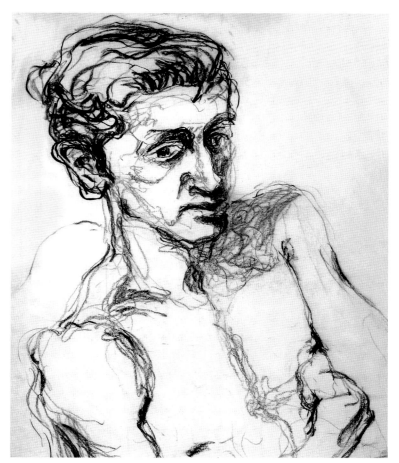

C. S. Siegel, *Figure Study,* charcoal, 27 × 22 in., 1966
Guided by the sense of touch and weight, the unique essence of a person is revealed through drawing.

Jackie Kirk, *Donna,* acrylic on watercolor paper, 30 × 22 in., 1988
Jackie describes a painting session with Donna, a victim of AIDS: "During our time together, something magical happened for Donna. I think it's because I looked. No one ever looked at Donna." In the same loving way, Jackie draws small things in nature (top)—each flower or leaf revealing its unique beauty as she gives it her attention.

light: reflecting the world

Although light illuminates everything we see, observing it more closely in all its different aspects can become a visual meditation in itself, revealing a wealth of form and color.

EXPERIMENT: Seeing and Drawing Light on an Object

To observe light more clearly, find a matte white object, such as an egg or a small white box. Look at this object, and then notice how it changes if you move it into different light conditions. Choose one of these conditions and see where it leads in drawing, experimenting with different materials, as well. The materials you use to draw from the perception of light may be different from those used in modeling from the sense of weight, which depends on a steady tactile connection. As you follow the changing patterns created by light and shadow, you may find it helpful to use soft vine charcoal, which can be easily erased. Using a white crayon on neutral gray-toned paper can allow you to draw the light shapes as clearly as the dark. In the process you may find yourself wanting to use color as well.

EXPERIMENT: Seeing and Drawing the Light Around You

Take the time now to notice the changing quality of light in the space around you, from the clarity of sidelighting to the mysteries of backlighting to the subtleties of reflected light. Before drawing, it is helpful to identify your light source. If it isn't clear, experiment with spotlights if you are inside, or change your position if you are outside. You might try a different time of day as well—the morning or late afternoon sun creates highlights and shadows that are not visible in the middle of the day. Shadows also change with each season. Follow your exploration of light wherever it leads, trusting your response in drawing.

Barbara Stamm Dosé, white box in sunlight

Lynn Hassan, *Gourds and Bowl, Late Afternoon,* Conté crayon, 18 × 24 in.

C. S. Siegel, *Afternoon Light at Spirit Rock,* pastel, 22 × 30 in., 2003

From the comfort of quiet rooms (below) and simple objects (opposite) to a fleeting moment in a sunlit valley (left), the shapes of light and shadow create magic, space, and unity.

Edward Hopper, *Rooms by the Sea,* oil on canvas, 29¼ × 40 in., 1951 (Yale University Art Gallery, bequest of Stephen Carlton Clark, B.A. 1903)

light: reflecting emotion

ight can carry a wide range of human emotion, not only reflected on figures and faces but on their surroundings. The light in still life and landscapes can become a metaphor for deep feeling states. Seventeenth-century painters such as Rembrandt and Caravaggio expanded the more sculptural modeled system of the early Renaissance with the dramatic effects of light and dark called chiaroscuro. Carrying a range of human emotion, these effects became as expressive as the figures themselves.

Sita Mulligan, *One Tree,* pastel, 22 × 29 in., 2004
Sita Mulligan's landscape is another kind of self-portrait. Faced with a life-threatening illness, she found a metaphor for her human condition in a single tree—alone, and yet with support from the earth and "a sky full of hope"—the transformative presence of light in a dark time.

The Earth full of promise,
the Sky endless hope.
Sita Mulligan
A Legacy in Pastel Paintings

Kathe Kollwitz, *Self-Portrait,* etching, 6³/₄ × 5 in., 1894 (Private collection)
The stark clarity of a kerosene lamp in the Kollwitz early self-portrait evolved into a softer, more universal reflection of the human condition in her later work.

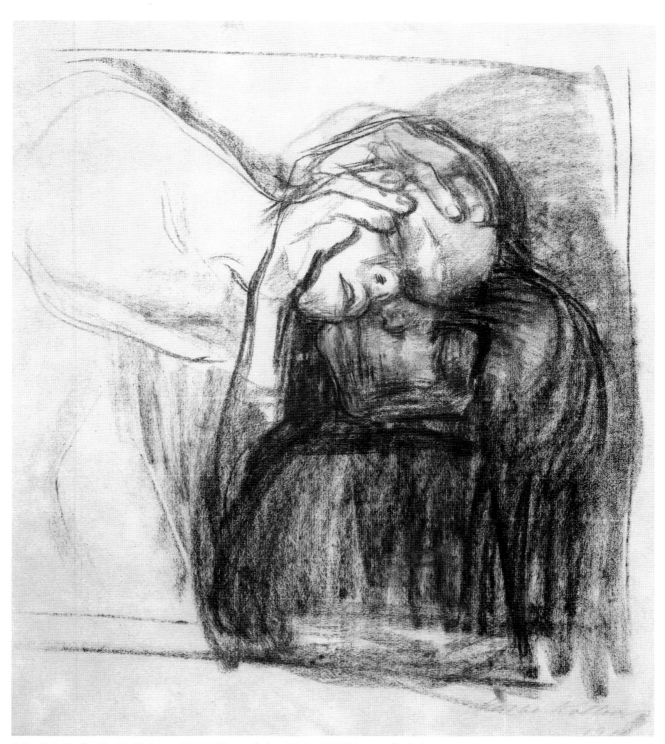

Kathe Kollwitz, *Death with Mother and Child,* **lithograph, 9 × 8¹/₂ in., 1910 (Private collection)**
In this later work, space and light have become one—the constant dialogue between light and dark, life and death. The sense of weight underlies the deep emotion.

Rembrandt van Rijn, *Christ Crucified Between the Two Thieves: The Three Crosses,* print, drypoint, third state of five, 15⁵/₁₆ × 17¹⁵/₁₆ in., circa 1653 (The Metropolitan Museum of Art, New York, gift of Felix M. Warburg and his family, 1941 [41.1.32]. Image © The Metropolitan Museum of Art)

Rembrandt's etching, third state, reflects the emotional power of light on a tragic occasion. Depicting the crucifixion and a whole cast of people, this etching illuminates the figures and space with dramatic clarity. We can see the visual vocabulary of the other perceptions we have explored as well, from the expressive movement of the figures to the details made tangible by the sense of touch. The powerful sense of weight and modeling on the figures and land often moves into abstract shapes.

Rembrandt van Rijn, *Christ Crucified Between the Two Thieves: The Three Crosses,* print; drypoint, engraving, and scraping; fourth state of five, 15⁵/₁₆ × 17¹⁵/₁₆ in., circa 1660 (The Metropolitan Museum of Art, New York, gift of Felix M. Warburg and his family, 1941 [41.1.33]. Image © The Metropolitan Museum of Art)

In the fourth and final stage of the etching, light, united with space, has become dominant, pouring over the figures, obscuring details—transforming a sentient world into a transcendental oneness. Most of the figures have given way to the dynamic balancing of the forces of light and dark, embodying the meaning of Christ's death, a metaphor for "a darkness all over the earth" (Luke 23). And yet this darkness reflects another world of light beyond the temporal, evoking a deeper sense of unity. Rembrandt's orchestration of space for its own sake is an innovation far beyond his time, presaging Cézanne, the Cubist experiments, and even Abstract Expressionists like Willem de Kooning. These artists continued Rembrandt's spirited dialogue with gravity, further releasing space and light from its traditional limits.

light and color

The experience of light can bring yet another liberation. I have been amazed to witness the spontaneous emergence of color as students explore the perceptions of space and seeing, especially if we are working outside. This emergence parallels the early discoveries of artists such as Frederich Church, who made small painting studies instead of drawings as he followed the light in wilderness places.

C. S. Siegel, *Zion at Twilight,* acrylic, oil on canvas, 36 × 96 in., 1994
This large painting came from drawing studies over many years, in the same location in Zion National Park.

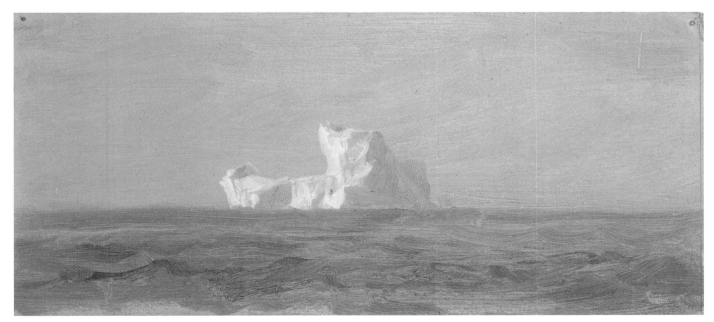

Frederic Edwin Church (American, 1826–1900), *Off Iceberg, New Foundland,* brush and oil with traces of graphite on paperboard, 4 7/8 × 11 1/8 in., 1859 (Cooper-Hewitt, National Design Museum, Smithsonian Institution, New York, gift of Louis P. Church [1917-4-714-b]. Photo: Matt Flynn)
Church made sketches like this one on his travels, then later created monumental paintings in his studio.

The luminous drawings and paintings of the nineteenth-century artist J. M. W. Turner inspired Monet and his passionate observations of light in nature. Painting directly on location, Monet transformed light into vibrating color—a creative miracle. The Impressionist discoveries liberated artists such as van Gogh and Cézanne from the limited palette of traditional realism. In turn, their work inspired modern masters such as Matisse.

The contemporary painter Art Holman continues in this colorist tradition, combining his observations in nature with an inner sense of light. His paintings embody the elemental essence of water, fire, and air, from the blue-green shimmer of breaking waves to the radiance of early spring, celebrating the return of life after darkness.

And yet, there is only one great thing,
The only thing.
To live to see the great day that dawns,
And the light that fills the world.

Inuit song

Arthur S. Holman, *Spring Has Sprung,* oil on canvas, 60 × 50 in., 1994
The light of spring is combined with a sense of inner light.

Arthur S. Holman, *Luminous Wave,* oil on canvas, 42 × 96 in., 1985
The spirited stroke associated with drawing is combined with the shimmer of color, creating a field of light.

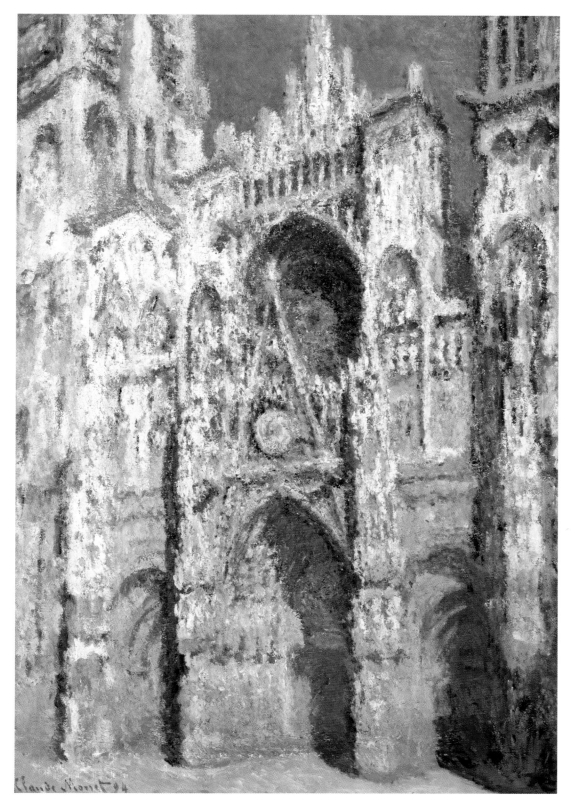

Claude Monet, *Cathedral of Rouen,* oil on canvas, 42 × 28 3/4 in., 1894 (Musée d'Orsay, Paris. Photo: Hervé Lewandowski. Photo credit: Réunion des Musées Nationaux/Art Resource, New York)

Following his passion for light, Monet painted the glittering facade of Rouen Cathedral in a series of works reflecting the changes in light over the course of a day. Through the vigor of his painted stroke, Monet integrates painting and drawing.

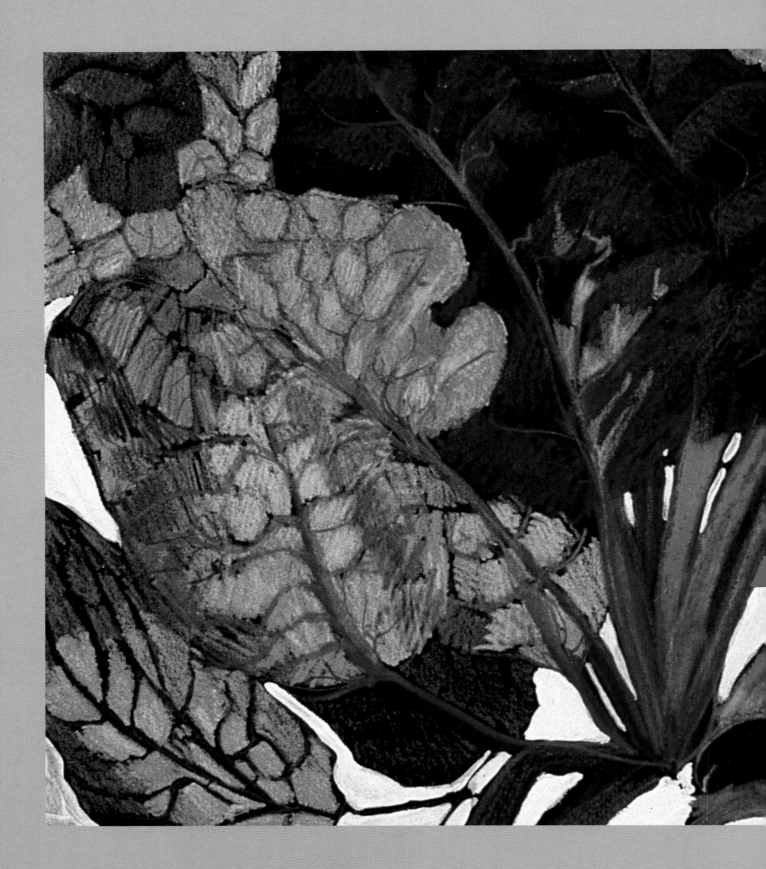

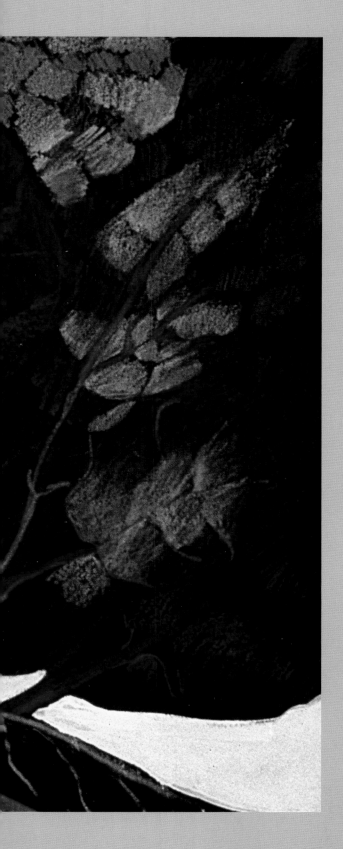

reviewing your perceptual source and moving into color

It can be illuminating to review your drawings so far, noticing perceptual tendencies and primal forms that have emerged by themselves. These tendencies are the source of personal style, supporting your uniqueness in color and painting media. Although light and dark studies can reveal your personal viewpoint, color can be a powerful expressive source as well, and in itself can influence your style of drawing. As your personal approach to drawing evolves, working with others from the same subject or place can further highlight your own particular gifts.

Jackie Kirk, *Red Kale*, colored pencil, 11 × 15 in.

the evolution of personal style

Shall I ever reach the goal so eagerly sought and so long pursued? I hope so, but as long as it has not been attained a vague feeling of discomfort persists which will not disappear until I have gained the harbor.

Paul Cézanne

On the last session of a drawing workshop I often ask people to focus on each of the different perceptions we have explored—touching, weight, space—noticing how these perceptions influence their movement and seeing. The drawings from this final experiment often highlight the individual preferences that have emerged earlier in the workshop. We not only see different perceptions chosen over others, but we can observe their corresponding elemental qualities—the earthy connection of touching and weight or the more spacious movements of water and air. In this way our intuitive choices can parallel the evolution of species. Just as birds find their home in the space of the sky, fish in the water, or gophers in earth, each of us finds an elemental home in the process of drawing. We can see Regina's earthy sense of touching and weight evolve into drawings of rocks and trees. In contrast, I am often drawn to the rising movements echoed in Poussin's ascending figures, which can evolve into soaring aspens in afternoon light. From simple beginnings, the primal forms of our elemental nature evolve into personal style as we draw in the world.

EXPERIMENT: Seeing Your Work as a Whole

It can be helpful to gather the work you have done so far and see it as a whole. Put your drawings up on a large wall, or spread them out on the floor, keeping the different modes together in the order you drew them. The records you made on the back of your drawings will help you recognize the experiments in which you felt most connected. You can return to this sense of connection through the simplest actions.

Regina Krausse, drawing improvisation, weight, charcoal, 14 × 17 in. (top left); touching rocks, eyes closed, charcoal, 14 × 17 in. (top right); rocks and twigs, influenced by touch, 14 × 18 in. (bottom left); trees by a stream, charcoal, 18 × 20 in. (bottom right)
The solid sense of charcoal touching paper (top left and right) evolved into a nearby group of rocks and twigs (bottom left) and later expanded into trees and a stream (bottom right).

Whether through a sense of breathing or spontaneous movement, the touch of your hands on paper, the weight of a rock, or the sense of empty space, it takes only a moment of awareness to come back home.

These moments of sensory awareness remind us that we don't have to be good at drawing, but only to let what we feel be expressed. As we search for this connection, drawing can be a perfect companion, whether you are traveling over the world or staying in the intimacy of your home. The world offers itself to us through drawing, and in turn we can recreate the world from our unique viewpoint. The vision of the world reflected in the paintings of Poussin, van Gogh, and Cézanne evolved from their drawings, coming from direct sensation.

The evolution of a personal style is not only an esthetic concern, limited to artists. In an age that is dedicated to mass production, our search for individual expression acquires a larger meaning. Our perceptual differences define our humanity and demonstrate how rare and invaluable each person is. Individual expression not only brings us into balance in our personal life; it echoes in the world as well. The inner tendencies we have discovered in drawing will become even stronger as we explore our uniqueness through the magic of color, finding our personal harmonies, and connecting with the work of past and modern masters.

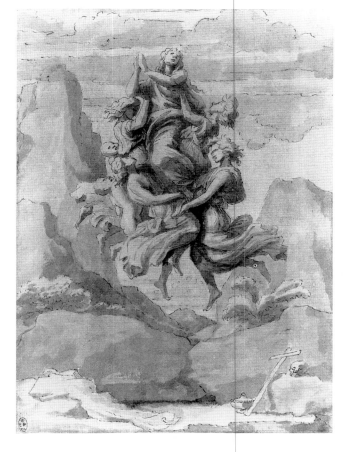

ABOVE: Nicolas Poussin, *The Ecstasy of the Magdalene,* brown wash with black chalk, 10 1/8 × 7 3/8 in., circa 1647 (The Royal Collection © Her Majesty Queen Elizabeth II. Photo: EZM) Rising above a solid rock formation, Poussin's Magdalene is carried by angels in a triumphant challenge to gravity.

LEFT: Richard Conklin, *Mountain Landscape, Late Afternoon,* charcoal pencil, 9 1/2 × 13 in., 1960 Balancing all the senses, Conklin's trees rise from a textured meadow.

from drawing to color: four approaches

I believe study by means of drawing is most essential. . . . It is only after years of preparation that the young artist should choose color.

Henri Matisse

In these pages we can observe the evolution of personal style in four different artists—from the abstract improvisations of inner sensations to value/notan studies of specific places to personal expression in color and painting media. Each person uses drawing in a different way, from the carefully observed subtleties of Sita's studies to Alicia's adventurous explorations in abstraction. The simple value studies of Richard Conklin gave him a tangible way to translate his heartfelt memories into painting.

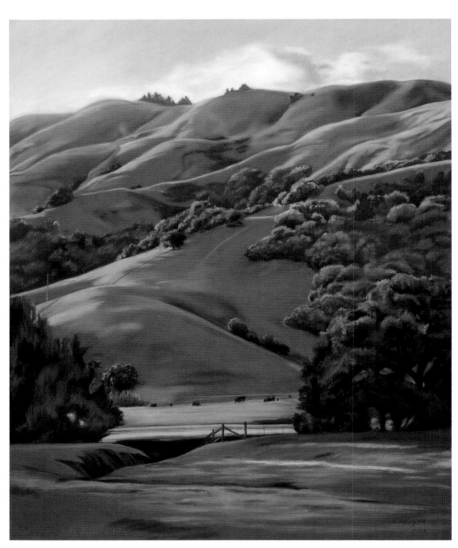

Sita Mulligan, value study, white and black Conté crayon on gray paper, 10 1/2 × 7 in. (above); *Valley Rest,* pastel, 29 × 22 in., 2003 (right)

Sita's value study on gray paper provides a structure for the fleeting nuances of late afternoon light, captured in a photograph and later painted in the studio. The preliminary drawing helps her maintain her personal viewpoint and to unify the many specific details in the scene.

As I stroke color across the paper, it feels almost as though my hands are caressing the land itself, the trees. There is an intimacy of acquaintance.

Sita Mulligan

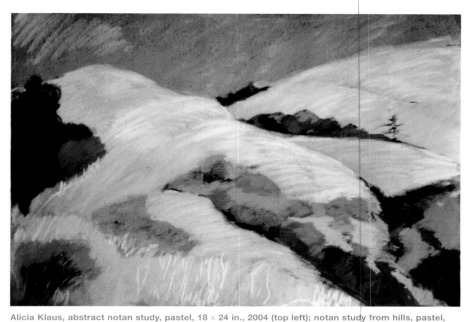

Alicia Klaus, abstract notan study, pastel, 18 × 24 in., 2004 (top left); notan study from hills, pastel, 18 × 24 in., 2004 (left); *Landscape,* **pastel, 22 × 30 in., 2004 (above)**

The elemental intensity expressed in notan studies forms the basis for the vibrant color in Alicia's landscape, which was painted directly.

Richard Conklin, value studies, 2 × 3 in., 1959 (left); *Mountains in the Moonlight,* **oil, 30 × 40 in., 1960 (above)**

Richard Conklin uses the simplicity of his small notan to find the composition for the memory of a moonlit night in the high mountains.

My quick drawings and pastel paintings on location record a spirited dialogue, a vital connection to natural forces that is carried into more developed paintings. Archetypal forms, expressed in abstract sensing improvisations, and quick studies on location have been essential to the evolution of my personal style in pastel painting, bridging my inner sensations with the visible world.

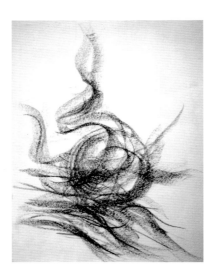

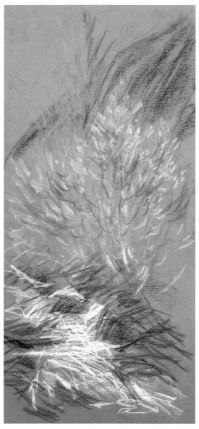

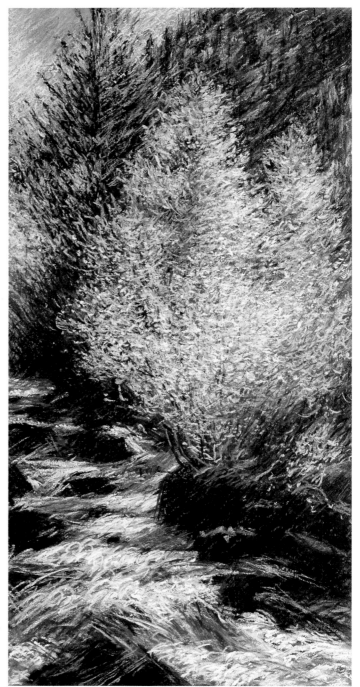

C. S. Siegel, sensing improvisation, pastel, 24 × 18 in. (top right); study for *Aspen and Cascades*, pastel on toned paper, 15 × 6 in. (bottom right); *Aspen and Cascades*, pastel, 35 × 17 in., 2004 (far right) The quick drawing on blue-gray paper (bottom right) captured a fleeting burst of sunlight on aspens and cascading water in a deep mountain canyon. The larger pastel (far right), started the next day at the same time, included more details and layers of light. This larger work was always reaching for that first moment of discovery—a sense of coming home to the archetypal spirit of rising, expressed years before in a sensing improvisation (top right).

We have seen the spontaneous way in which the perception of space and light seems to generate the use of color. Color, just in itself, can be a powerful influence on drawing as well. The vibration of certain color interactions can bring about unexpected and very exiting results to the drawing process. Try this for yourself, drawing with colored pastels or crayons, using them at full strength.

When color becomes a source of drawing and painting, it can echo the brilliant primaries and complements of artists such as van Gogh and Gauguin. When Gauguin asserted, "Before it is anything else, a painting is a flat surface covered with colors arranged in a certain order," he redefined painting. In the paintings of modern masters such as Matisse, color is not only representing light but has become light, radiating its own reality, generating energy and life force. Van Gogh and others continued to use studies in light and dark, while artists such as Monet began only with color, occasionally using pastel studies. Explore these different choices for yourself.

> *I often think that the night is more*
> *alive and more richly colored*
> *than the day.*
> Vincent van Gogh

ABOVE: Vincent van Gogh, *Portrait of Agostina Segatori (The Italian Woman),* oil on canvas, 31 1/2 × 23 1/2 in., 1887 (Musée d'Orsay, Paris. Photo: Hervé Lewandowski. Photo credit: Réunion des Musées Nationaux/Art Resource, New York) The fire of van Gogh's color is supported by a sense of weight, movement, and touching, firmly composed by his value studies.

LEFT: Vincent van Gogh, *The Starry Night,* oil on canvas, 29 × 36 1/4 in., 1889 (The Museum of Modern Art, New York, acquired through the Lillie P. Bliss bequest [472.1941]. Digital image © The Museum of Modern Art/Licensed by SCALA/Art Resource, New York) The extravagant movement of the whirling stars is firmly supported by light and dark shapes, developed through drawing.

Jan Gross, colored paper arrangement (right); color improvisation, pastel, 24 × 18 in. (far right) We can observe the influence of color on drawing and composition with the work of Jan Gross, who began by arranging colored papers in a kind of collage. This color harmony influenced the abstract pastel that followed.

Jan Gross, *Fire in the Desert,* pastel, 8 × 10 in., 2005 We can see the influence of fiery color in yet another composition, a distant mountain in the desert.

Sandy White, colored paper arrangements, 12 × 9 in. (above); *Forest Improvisation*, pastel, 11 × 15 in., 2006 (right)

Color was the primary influence on Sandy's oil pastel drawing, which began after picking a vibrant harmony of colored papers. The colors themselves created a vital form of drawing in which light and dark shapes emerged, but they did not precede the drawing.

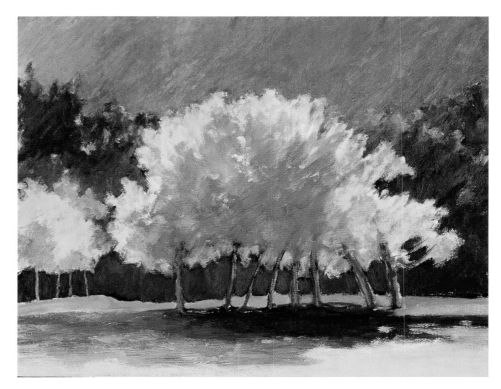

Linda Larsen, notan study for *For K.E.M.*, oil pastel, 4 × 6 in., 2003 (above); *For K.E.M.*, oil on panel, 11 × 14 in., 2003 (right)

The simplicity of Linda's preliminary value study supports the strong color.

spirit of place: eight views of blueberry ridge

In March 2006, I had an extraordinary opportunity to see the power of individual expression in action and to affirm the process of drawing as a natural force. In response to information that a projected water tank could destroy a ridge above my house, I had begun to draw up there, wanting to protect this vulnerable place. A desire to protect moved into awe as I worked, inspired by the moving grasses on the hill and the oak tree in the distance. But as I moved closer to the oak I was overwhelmed. I needed help to express this monumental presence. When my friends joined me I was astonished to discover the many aspects of this powerful presence emerging in their work. Linda drew even closer to the tree, embracing its massive trunk like a lover. Regina expressed the grand expansiveness of the spreading branches. Jean drew the delicacy of the upper limbs and leaves as though she were touching every one.

As we worked together in the changing seasons, we developed a community that not only came to know the ridge better but ourselves as well. We came to recognize each other by our unique viewpoints—from the different places we chose to draw to the distinctive quality of our rhythms and forms. As we met the challenges of the huge oak, the hidden rock formation and the rolling hills beyond, our personal styles became stronger. As others joined us, I was amazed again at the diversity of these new viewpoints.

This creative connection expanded when we exhibited our work in a community center gallery with an opening that included impressions of the ridge by poets and musicians. This public reception also provided an opportunity for the activist group opposing the tank to educate the public. This process of education expanded with articles published in the local paper.

The process of drawing provided an intimate connection with a natural place and translated our personal viewpoints into images that could be widely shared. While the original core of artists had long explored drawing as an inner language, the Blueberry Ridge project gave us the opportunity to bring these inner connections into the world.

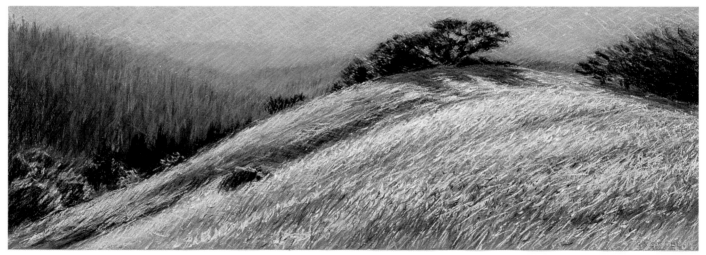

C. S. Siegel, *Blueberry Ridge,* pastel, 15 × 40 in., 2005
I saw the oak in relation to the whole ridge, with waving grass and the hills beyond.

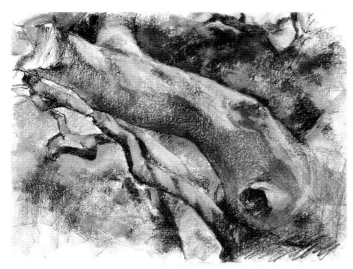

Linda Larsen, *Standing with the Oak,* oil pastel, 18 × 24 in., 2005
Linda expressed the massive presence of the oak.

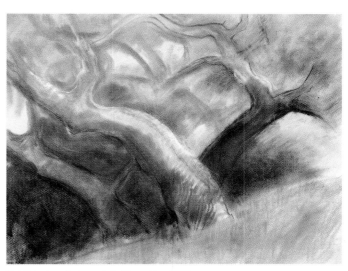

Pat Kriegler, *Oak,* pastel, 18 × 20 in., 2005
Pat found a unified structure in the complicated oak.

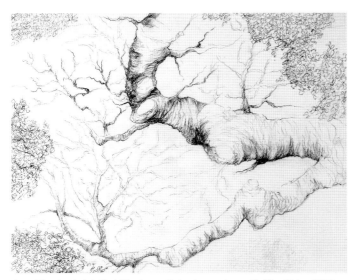

Jean Woodard, detail of *Blueberry Oak,* charcoal pencil, 16 × 18 in., 2005
Jean found the tactile beauty of limbs and leaves, meeting the sky.

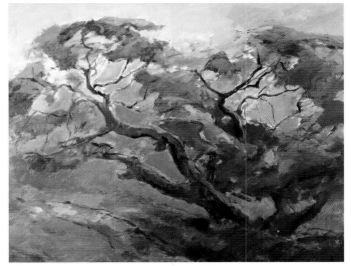

Regina Krausse, *Afternoon Oak,* oil, 22 × 30 in., 2005
Regina found the expressive power of the outreaching limbs and the strength and endurance of the oak.

The works on the previous page were drawn and painted on location, but the pieces below were created later, reflecting not only what the artist saw, but also the inner feeling of the place. The different media carried the vision of each artist further, making the original experience even more vivid.

Gael Hunt, *Luminous Blueberry Hill,* monoprint, 12 × 30 in., 2005
Gael expressed her impression of the ridge in the blazing summer light.

Ayumi Kie Weissbuch, *Moonlight Walk,* acrylic, 22 × 29 in., 2005
Ayumi painted the ridge after a moonlight walk.

Sandy White, *Rock Formation, Blueberry Ridge*, pastel,
29 × 22 in., 2005
Sandy discovered a hidden rock formation.

Although we have focused on the inner spirit and perceptual source of drawing, the drawing media you use can influence your perception, just in itself. As you discover the particular media and paper that match your elemental feeling states, your perception can expand and deepen. Your work can come alive under your hands and attain a tangible, almost magical, presence. But finding and sustaining this creative connection can take time and patience, noticing the subtle changes as you explore the different brands, the different levels of hardness and softness, all tested on different papers. Each variation can either increase your connection with what you see and feel or diminish it. We can be seduced by the promise of life in a particular medium, only to discover its implacable demands and limitations. As you experiment, you can learn much from the techniques and discoveries of others, but eventually you will discover your own way, led by your own needs. In the end, most techniques are born from spontaneous discovery, often unexpected.

After exploring the more traditional drawing materials, such as pencil or charcoal, you may move closer to the realm of painting—using colored media and paper, adding wash or paint, building up layers and/or working larger. As you experiment with the different possibilities of mixed media, questions can arise—what is the relationship of drawing to painting, and what distinguishes them, one from another? The inclusion of the many paintings in this book grows from these questions—exploring the vital interrelationship between the two.

In the Western tradition, drawings were often studies for larger works, different than the final product. Although Rembrandt's drawings and etchings go far beyond studies, his use of crayon, pen, and ink is still distinct from his oil painting technique. These distinctions are not always so clear for twentieth-century artists. For example, the free-flowing oil washes on paper of Emily Carr, painted outside, embody the immediate touch and sense of movement inherent in drawing. These qualities, evident for centuries in the Eastern tradition of painting, emerge in the paintings of modern masters, from Monet to Jackson Pollock. Their direct expression of life force regenerated painting, opening a world of possibilities. As you bring the process of drawing into your daily life and creative work, you too may find yourself expanding the limits of drawing in new ways, free from the expectations and judgments of traditional drawing.

And yet these limits still have immense value. The simplicity of means in master drawings can reveal an unmistakable quality of presence, a direct reflection of the artist's touch. We can feel this presence in the elegant clarity of Jean Woodard's drawing.

But in appreciating this remarkable meeting of pencil, paper, and eye, it is important to remember that visual clarity is not the only measure of value. Whether focusing on specific visual details or improvising with eyes closed, we can all connect with the unique presence of our life force simply by touching a crayon or pencil to a page.

Kay Carlson, *White House Song #2*, watercolor and oil pastel, 32 × 20 in.
Mixed media on gray paper create dimension.

Jean Woodard, tree study, pencil on paper, 8 × 8 in.
The elegant clarity of pencil is evident in this delicate study of a tree.

Whatever style or medium we choose, whether representational or abstract, the natural language of drawing can bring us home to our basic nature, to the spirit of life itself.

Working with the basic drawing media listed on page 28 can get you started in following the experiments in this book, but as you become aware of your unique tendencies, experimenting with a wider range of materials can support and increase your connection with what you see and feel. Although we are emphasizing the inner source of creative expression, the media we use can have a large influence on our process.

Black-and-White Drawing Media

The purpose of a painter must not be conceived as separate from his pictorial means, and these pictorial means must be the more complete . . . the deeper is his thought.

Henri Matisse

Exploration in black, white, and gray can allow you to focus on individual touch and the development of personal shapes and spaces. Especially when drawing directly from what you see, the simplicity of light and dark creates an important bridge between your inner forms and what you are seeing. Each of these media can bring out different feeling qualities, different aspects of yourself.

Pencils made from graphite come in many gradations from hard (H) to soft (5B, 6B). The softer grades are more immediately expressive. Graphite also comes in square sticks, giving the option of using the broad side as well as the edge.

A **kneaded rubber eraser** can be used over and over after kneading. This flexible eraser is versatile and can even function as a drawing tool, creating white lines in toned areas.

ABOVE: **Zea Morvitz,** *Whorl,* **graphite on paper, 48 × 60 in.**
Graphite on paper moves into the scale of painting.

RIGHT: **C. S. Siegel,** *Afternoon Oak on Blueberry Ridge,* **pastel on printmaking paper, 30 × 30 in., 2006**
Many layers of black, gray, and white pastel create a sense of light.

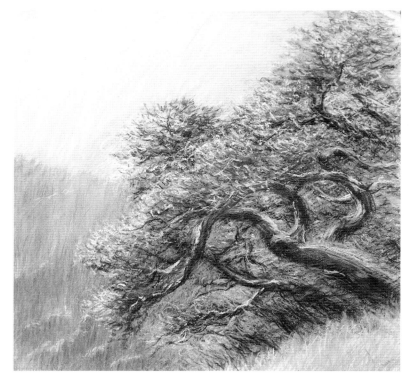

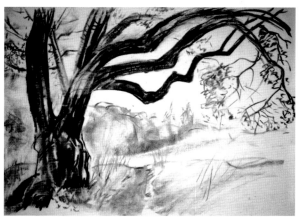

Charcoal is available in vine and compressed forms. The soft, malleable vine charcoal comes from charred twigs. It varies according to the kind and size of wood used. In one summer workshop, pieces salvaged from a burned log left in a grill became like pure gold, as people discovered the tactile beauty of this natural medium. For darker tones, try compressed charcoal, which can range from delicate grays to dense blacks. Many brands of compressed charcoal and charcoal pencils have a numbered range, from dark to light. Black or gray pastels can be used, as well.

Crayons have more wax and are generally denser than charcoal. The subtle voice of black, sepia, and white Conté crayon, made in France, is especially useful for graduated modeling and ranges from hard to soft. Lithographic crayon (used in printmaking) is waxier and also ranges from hard to soft. Caran d'Ache Neocolor crayons are described under "Colored Drawing Media" (see page 174).

Pens used with waterproof India ink can give a range of effects. Cro-quill produces a delicate line. The larger Speedball lettering pens are available in a range of sizes, from C-6 (the smallest) to C-1 (the largest). Felt tip, ballpoint, and other mechanical pens can be useful, but they are seldom archival (permanent) and therefore can fade in time. The use of balsa wood or found sticks dipped in ink can create rich, unpredictable effects. Handmade inks from natural materials can be exciting, as well.

I am unable to distinguish between the feeling I have for my life and my way of expressing it.
Henri Matisse

Paper for Drawing Media

There is a wide range of paper for drawing media, from the less expensive rough newsprint and bond paper to better grades of plate (slick) and vellum (slightly rougher) bristol to the more textured charcoal papers. The better papers come in pads or can be purchased in single sheets. Aquabee or Strathmore bristol (two-ply, vellum finish) are two brands that can sustain layering. Heavier papers used for printmaking are good for drawing, as well. Commonly used brands are Arches Cover, Rives BFK, Folio, and Stonehenge. Colored paper—gray, tan, black—can be useful with white media. Canson Mi Tientes, Crescent, Fabriano Tiziano, and Canford are commonly available brands. Each of these papers reacts to media in a different way and creates strikingly different effects.

Colored Drawing Media

Working with color can bring drawing closer to painting, expressing elemental qualities more fully.

Colored pencils are the hardest and offer subtle, controllable effects but produce intense color only with sustained pressure. Prismacolor is one of the widely used brands. Some brands are water-soluble.

Caran d'Ache Neocolor **colored crayons** come in both water-soluble and wax-based versions, in sets and open stock (individually). They have a good range of colors but tend to melt in the sun. They can be used with water-based paint as well. (See my painting *Stream in Winter* on page 80.)

Oil pastels (also called **oil crayons**) have an oil base and are even more generous with their color. The more expensive brands of oil pastel (Holbein, Neopastel, Sennelier) will produce stronger colors. They come in open stock and sets. Although cheaper brands break more easily, they can be satisfying to work with, especially if the paper has a bit of tooth. Oil pastel can be sprayed with matte fixative to facilitate layering and for permanence. If protected this way, some drawings can be framed without glass.

Soft pastels are made of pigment mixed with a gum or methyl-cellulose binder, as opposed to oil pastels, which are pigment mixed with a nondrying oil and wax binder. They are available in a variety of brands that each have a very different working quality, ranging from the harder sticks of NuPastel, Rembrandt, Grumbacher, and Holbein to the softer texture of Schminke and Sennelier, which are almost pure pigment and cover well. Other brands include Rowney and Unison, both with a wonderful range of subtle colors. It is best to avoid the cheapest brands of pastel, as they have less pigment content and create excessive dust. Most people get one or more starter sets of thirty to forty-five colors in the harder brands and then supplement them with the softer, more pigmented colors, chosen individually from open stock.

In general, it is best to begin with the hardest and then move to the softer pastels, which cover better. The surface of a soft pastel drawing is more vulnerable than oil pastel and needs to be framed under glass. Most pastel fixatives, except Latour and Lascaux brands, darken the work. These are not always available in stores but can be found in the catalogs of art suppliers.

Oil sticks, or cow-marking crayons, which are found in feed stores, are larger than pastels and suitable for covering large surfaces.

Paper for Colored Drawing Media

Besides the papers described for black-and-white media on page 173, there are papers that bring out the most in colored drawing media. Types of colored papers that can be used for all colored drawing media include Canson Mi Tientes papers, Crescent papers and boards, and Fabriano Tiziano papers. All these papers have their individual characteristics and react differently to each medium. Printmaking

Jackie Kirk, *Spring Plum,* colored pencil on black paper, 12 × 14 in.
The intense color of this drawing comes from sustained pressure.

Gail Robertson, portrait, oil crayon, 8 × 10 in.
Oil crayons are generous with color.

papers, such as Rives BFK (white, cream, tan, and gray), Arches 88, Stonehenge, Lennox 100, and different kinds of watercolor paper can be used as well. To facilitate layering, these papers can be primed with acrylic gesso and color. If you are making a ground for painting with pastel, you can include pumice in the gesso, which will give it more tooth. Some grounds, such as Golden brand pastel ground or Art Spectrum, which also makes a colored paper, are made with pumice. Other available colored papers with a prepared surface for use with pastel include Sennelier La Carte papers, Ersta sandpapers, and Sabretooth papers.

As you explore this wide range of media and paper, it may take time to find the combination that works for you. If you find yourself drawn further into this exploration, you may include painting media as well.

Jan Gross, *Improvisation,* collage and pastel on dark green board
On a dark green background, pastel joyously plays against the torn lines of a collage.

Helen Redman, *Katy,* colored pencil, charcoal, Conté crayon, and graphite on colored paper, 30 × 22 in., 1996
The maroon background of Redman's drawing resonates with her model.

C. S. Siegel, *October Aspens, Lundy Canyon,* pastel, 19 × 19 1/2 in., 1999
With many layers of color, pastel can move into the luminosity of a painting.

index